D1199882

Photography
and Landscape

First published in the UK in 2012 by
Intellect, The Mill, Parnall Road, Fishponds, Bristol, BS16 3JG, UK

First published in the USA in 2012 by
Intellect, The University of Chicago Press, 1427 E. 60th Street, Chicago, IL 60637, USA

Copyright © 2012 Intellect Ltd

All rights reserved. No part of this publication may be reproduced, stored in a
retrieval system, or transmitted, in any form or by any means, electronic, mechanical,
photocopying, recording, or otherwise, without written permission.

A catalogue record for this book is available from the British Library.

Cover image: Juha Tolonen, 'Billboard, China, Inner Mongolia', 2010. Courtesy of the artist.

Cover designer: Holly Rose
Copy-editor: Macmillan
Typesetting: Holly Rose
Series Editor: Alfredo Cramerotti
Editorial collaboration: Jane Louise Fletcher

ISBN 978-1-84150-472-8
Critical Photography Series ISSN 2041-8345

Printed and bound by Latimer Trend, Devon.

Photography
and Landscape

Rod Giblett
and Juha Tolonen

intellect Bristol, UK / Chicago, USA

Dedicated to Norm Leslie

Contents

The Editor to the Reader

AS I GO AHEAD

ALFREDO CRAMEROTTI, EDITOR 'CRITICAL PHOTOGRAPHY' SERIES

Since its origins, the relationship between photography and landscape has been political as well as representational: one way, among many, to understand photography as a visual language that constitutes itself as it takes place in every moment and corner of the planet. Photography is, quite simply and endlessly complexly, the common substrata of our daily experience, wherever we live.

What underpins this book is how the making of landscape imagery throughout humankind has formed those very landscapes. The matter is not what landscape photography ordinarily means, since I believe there is little sense in identifying photographic genres. Rather, what is at stake is that places are the stuff that engenders stories, not the other way round. Between the story (of a landscape, in this case) and the image, photography acts by shaping what is both conceivable and actual. Hence my assertion that photography is often a political act, even more so when forming a collective image of a place. Although being a universal language, photography is a very complicated language; it is influenced not only by techniques and processes and their limitations, but also by the cultural and political environment in which it works. Even so, it is not the photographer who takes the centre stage, nor the subject of the photograph; it is the camera's ability to translate and transform the material world.

I may be enriched by a photographic experience in relation to a landscape, or disappointed altogether, but I would not be untouched. Photographic image-making is a process orientated towards the future: a starting point, a moment in which something is put in motion, rather than a final recording act. It is a difference to bear in mind.

Authors' Note

Co-authorship can be attempted through a range of collaborative approaches and styles. This book is a result of our shared fascination with landscape photography. However, the collaboration is driven by the contrasting ways we come to the subject. The positions we adopt can be generalised as those of an eco cultural critic of technology and photography and a conservationist in the case of Giblett and a photographic practitioner in that of Tolonen. The book provides a critical account of photography, but we achieve this objective through different lenses and from different points of view. Giblett's critique of landscape photography is inflected with a clearly green political objective, while in Tolonen's reading the practice of photography and the form of the image play a greater role. Giblett's rejoinder would be that both of these are imbued with politics.

It was thus not our intention or aim in the pages of this book to create a unified point of view about photography and landscape. We have put our heads together to address this topic, and though two heads are better than one (as in the old cliché), we are not speaking with one voice about it, which would not only look monstrous but could also sound discordant. Instead, we are two distinct voices taking part in an ongoing and unresolved dialogue with each other. These two voices are, however, not antithetical to each other so they are not engaged in a dialectical process and they never achieve synthesis between them. This dialogic approach creates a counterpoint between two voices with commonalities and differences, contrasting emphases and lingering resonances, harmonies and disharmonies, whose whole we hope is more than the sum of its parts. We have certainly produced a richer result than if either of us had tackled the topic alone.

The process of writing has largely been to write our own individual chapters as indicated in the table of contents, and own our own chapters, rather than co-writing them and pretending to have a single authorial voice. There is a clear division of labour about who did what as the table of contents indicates. We also have divergent interests and tastes, and differing views about photography and its politics. We have not glossed over these. To a large extent, we complement each other in terms of our areas of interest and expertise as the table of contents, this note and the rest of the book indicate. In fact, this complementarity enables us to address the breadth and depth of the complex and broad topic of photography and landscape, a topic that has not been much addressed previously in these simple terms of their conjuncture. The result is a range and richness in this book that no other book about landscape photography has matched to date. The focus in most previous work on landscape photography has been on photographs by individual photographers and/or in particular styles, regions, nations and periods (as our reference list indicates).

The authors' respective interests in the subject of landscape photography diverge at some historical point in the 1970s. It was during this period that photography began to achieve greater autonomy in art, culture and academia. Crimp (1989: 7) identifies this period as the point when photography is finally 'discovered', over one hundred years after its invention. Libraries, museums and the academy begin identifying properties that are unique to the medium. Photography is redefined and redistributed. Collections are rebranded. Images that were initially about their subject, and filed away accordingly, re-emerge under the sign of the photographer. 'Urban poverty becomes Jacob Riis and Lewis Hine; portraits *of* Delacroix and Manet become portraits *by* Nadar and Carjat; Dior's New Look becomes Irving Penn; and World War II becomes Robert Capa' (Crimp 1989: 7). By 1979, the 'discovery' had been made in landscape photography with Ansel Adams hitting the newsstands on the cover of *Time* magazine. Photography was no longer the handmaiden of other discursive practices operating as document, evidence or information. Instead it was identified as having an independent visual language, one that allowed a host of new masters to be identified.

Via the field of 'photography's masters' Giblett is interested in Ansel Adams (and not in Robert Adams), whereas Tolonen is interested in Robert Adams (and not in Ansel Adams). These two photographers represent the practice of successive generations in landscape photography, as we do to some extent as writers on the topic. When the photography of Ansel Adams was canonised in the popular press in the 1970s in his twilight years, Robert Adams emerged as a leading practitioner

in landscape photography and a new voice in writing about it, particularly in the context of the 'New Topographics' exhibition of 1975. Similarly, Giblett is a well-established author and a pioneer of eco cultural studies with over twenty years of experience in the field whereas Tolonen has emerged recently as a leading practitioner in landscape photography and a new voice in writing about it.

Giblett's interest in Ansel Adams revolves around the question of the latter's environmental credentials, and his use of the established aesthetic traditions of landscape painting. These aesthetics of the picturesque and sublime now dominate the image banks of environmental polity. Giblett suggests this limited aesthetic range cannot represent the diversity of the ecosphere that is essential to the survival of people, other animals and plants, and calls for a photography that promotes diversity and sustainability. However, to this end, Giblett does not wish that photography should return to a (pre-1970) subordinate position where it operates as document, evidence or illustration to support some other extraneous discursive or political practice. Rather, photography and environmental practices in his view should go hand-in-hand, work together and be integral to, and mutually supportive of, each other. Much recent photography does this as evidenced in this book, especially in the final chapter on photography for environmental sustainability.

As a practising landscape photographer, Tolonen has a vested interest in maintaining the newfound autonomy of photography. However, where this greater autonomy features in the critique is in the consideration of form in recent photographic practice. In this case, form is not seen as a measure of an individual photographer's expressive power, rather, it is the visual expression that arises out a process of informal deliberation between a photographer and his peers, the established visual traditions, the contingencies of place, the freedom and limits of technology, and the public. Here, photographic autonomy does not deny culture. Instead, a consideration of form, along with the subject, is how we enter culture via photography. In practical terms the 'autonomy' of photography is just an honorary title. Despite the pleasures and regalia of form, the contemporary photograph is still embedded with its subjects. For Giblett this play with form can overlook the history and politics of photography as a communication technology of the colonisation of time and space in which the form is the content, or as McLuhan said, the medium is the message.

Preface

PART I

ROD GIBLETT

Landscape photography is one of the major formats and modes of photography. I define landscape photography as the creative, photographic inscription of the visual appreciation for the surfaces of the land in the three major aesthetic modes of the sublime, the picturesque and the beautiful. Along with portraiture, the other major mode and format, it has dominated photography from its beginnings. Photography has had a love affair with landscape from its conception, just as it did with the human face and figure in portraiture, and the human body in pornography. Landscape photography was born out of the embrace and intercourse of photography and landscape that also produced 'eco-porn'. Photography was made for landscape; landscapes have been remade for photography; and landscape photography has remade the way land is seen. It is one of the major ways in which modern, technologically savvy people relate to the land and the land is mediated to them.

The technology of photography, starting with the camera, inscribes and reproduces landscape aesthetics. The shape and format of the camera viewfinder is normally in 'landscape' format. Landscape format is the norm for photography. With some exceptions, such as the Box Brownie that had a bet both ways by producing square-shaped photographs, taking a portrait photograph usually required

rotating the camera through 90 degrees. In this respect, portrait photography is abnormal and landscape photography is the norm, though the first photographs were portraits culminating most famously with the *carte de visite*, small visiting card portraits usually measuring 4 1/2" x 2 1/2" (11.5cm x 6.5cm).

Neither landscape photography nor portrait photography lends itself to depicting people working with or on the land. Landscape photography tends to be photography of land without people and to obscure the work of people in making the land what it is. Even when people are included, they are usually engaged in leisure, not work. Landscape photography freezes a moment in time and does not depict the processes – human, other animal, mineral and vegetable – that made the land. Similarly portrait photography tends to be photography of people posed against the backdrop of a landscape or against the background of the land and to obscure the role of the land in making them what they are and sustaining their lives and livelihoods. It also freezes a moment in time and depicts people in static poses. Neither landscape photography nor portrait photography lends itself to what I call photography for environmental sustainability that shows people working (with) the land in sustainable ways. This mode, genre or style of photography comes up against the limits of landscape photography and portrait photography and operates in the interstices between them.

Photography arose in the heyday not only of the assertion of individualism exemplified in the *carte de visite* and portraiture more generally and of individual rights in private property illustrated in landscape painting (as discussed in chapter 3), but also of the expansion of imperialism depicted in photographs of colonised people and places. Photography is an optical technology of empire. Landscape photography renders the land settlable. The colonial enterprise, settler societies and landscape photography are mutually reinforcing. *Photography and Landscape*, as the title suggests, concentrates on landscape photography, particularly in the settler societies of Australia and the United States. It is hardly surprising that the most famous examples of landscape photography and the most famous landscape photographers, such as Ansel Adams and Carlton Watkins, are American, both of whose work is discussed extensively in chapter 5. The century-long heyday of landscape photography is contemporaneous with colonial settling and with portraying the frontier and wilderness of the American West. Although Australia arguably did not have a frontier and wilderness in the same sense (see Giblett 2011), it is not much different photographically in its settling and portrayal of the land with some of its most famous wilderness photographers drawing on American exemplars (as discussed in chapter 7).

Any consideration of photography and landscape should begin with photography itself. The first chapter of *Photography and Landscape* is a cultural history of the technology of photography drawing on some standard histories, especially the work of Walter Benjamin and his concept of aura. He defines aura as the unique experience of, and a sense of distance from, the appearance of an object in time and space. Early photography reproduced aura partly as a function of cameras with slow shutter speeds and long exposure times, partly as a function of the intact innocence, as Benjamin puts it, of the person being photographed. With the development of cameras with faster shutter speeds and shorter exposure times, especially with the 'snapshot' of the Box Brownie, and with the sullied innocence of the subject being photographed, aura withered.

As the camera withers aura, it is a sublimated lethal weapon. The second chapter considers the camera and the relationship between photography and death, particularly via the camera as a sublimated gun for shooting photographs and for not only 'killing' the object but also making alive the subject. The camera objectifies the land as landscape and thereby renders it as a visual phenomenon, reproduces it in an aesthetic of surfaces and lays it out as a kind of cadaver for the heightened perception and viewing pleasure of the cameraman, just as it did for the explorer or settler and still does for the tourist or virtual traveller, who is enlivened in and by this process of taking and viewing photographs. These impacts of the camera are traced via the retelling of a postcolonial story about the gun and 'the wild' by Nobel Prize winning author J. M. Coetzee in his first, rare and out-of-print book, *Dusklands*.

The bio-politics of the camera are implicit in the concept of landscape and the practices of making a landscape. The cultural history of the concept of landscape as a capitalist and colonialist category and its similarities to portraiture is considered in the third chapter. Both modes and formats of landscape and portrait reduce the three dimensions of the living land and human body to the two dimensions of the flat surface of the painting and photograph. This process is arguably a land pathology that denies and represses the living depths of the land that makes life on its surface, and landscapes of its surfaces, possible. Drawing on the work of Michel Foucault, classic landscape photography is analogised as being to land as portraiture is to the body and as medicine is to pathology: a reading of signs on surfaces. Drawing on the work of Aldo Leopold, classic landscape photography is regarded as a land pathology in which self-accelerating symptoms of land destruction are not displayed, but in which public and private property rights are revealed.

Classic landscape photographs of national parks and wilderness areas show two types of landscapes where this land pathology is not displayed and where the unholy alliance between nature, nation and corporation is represented. National parks and wilderness areas were crucial for the formation and maintenance of national identity in both Australia and the United States. National parks and wilderness areas were the principal subject matter in the sublime photographs of Ansel Adams and the picturesque photographs of Carleton Watkins. Their photographs aestheticise (if not sublimate) the land into landscape as a site, sight and object of visual consumption. Chapter 4 is a brief excursion into the sublime, one of the major, modern aesthetic modes of landscape painting and photography. In contrast to Adams's sublime photographs of storm-swept and snow-clad mountains and Watkins's picturesque photographs of beautiful placid pools and sublime towering rocks, Timothy O'Sullivan's uncanny photographs of grotesque formations in the American West take the viewer into the bowels of the earth. Adams and Watkins reproduced from landscape painting the aesthetic categories of the sublime, the picturesque and the beautiful with their capitalist politics of land use whereas O'Sullivan produces an anti- or counter aesthetic of the uncanny to use Freud's term. Chapter 5 considers American landscape and wilderness photography focussing in particular on the work of these three photographers. It considers Adams, Watkins and O'Sullivan in reverse chronological, or genealogical, order in order to show the lineage of descent from Adams back to his antecedents as his sublime photographs were the culmination and sublimation of the work of two of his predecessors, Carleton Watkins's picturesque photographs and Timothy O'Sullivan's uncanny photographs.

Generally, however, we have taken a chronological approach to photography and landscape, though in shifting across national photographies and through space, and in engaging with themes across history and through time we have not always followed a strict chronological progression. We have also, on the one hand, taken a survey approach in some places to considering photography and some of the classic landscape photographs and photographers and, on the other, made a contribution to knowledge in other places by writing not only about photography and these photographs and photographers in new ways, but also in developing new ways of writing about landscape photography. The resulting book is thus both a textbook and a research monograph in an attempt both to be the servant of two academic masters of teaching and research, and to demonstrate the nexus between them as this book arose out of both of us teaching our research interests and undertaking research for our teaching.

One of those areas of interest is American and Australian landscape and wilderness photography. In ways similar to the United States, Australian landscape and wilderness photography has played an important role in the formation of both Australian national identity and in wilderness conservation. These two uses of photography are diametrically opposed as the former celebrates the conversion of the Australian bush into farmland whereas the latter promotes the conservation of the Australian bush. Yet despite these opposing political ends, Australian landscape and wilderness photography employs a similar aesthetic focusing on the picturesque, the beautiful and the sublime drawn from the traditions of American landscape and wilderness photography and, in turn, of European landscape painting. The aesthetic modes of the sublime and the picturesque are used across all three with no regard for, let alone a critique of, their capitalist economics and nationalist politics. I define Australian landscape photography broadly as photographs of both Australian and non-Australian lands photographed by Australians (born here or spent most of their working lives here) as the photographed non-Australian lands had as much to do with the formation and maintenance of Australian national identity as did Australian lands. Chapters 6 and 7 critique these politics of pictures focussing on three prominent examples in the photography of Frank Hurley, Peter Dombrovskis and Steve Parish, amongst others. Chapter 7 also considers the uncanny and Rebecca Solnit's concept of the exquisite in the photography of Simon Neville, amongst other photographers, of wetlands. This chapter concludes by arguing and calling for photography for environmental sustainability taken up in chapter 13 in greater detail.

The photographers of the nuclear landscapes of the American West, such as Richard Misrach and Carole Gallagher, reacted against and rejected the sublime and picturesque photographs of their predecessors Adams and Watkins in Yosemite National Park and photographed the Nevada Test Site just over the other side of the Sierra Nevada mountain range in about the same latitude. They show the blighted and blasted lands of the most-bombed place on earth. The bombing made all Americans 'downwinders', many of whose health suffered as a result, just as the land, and the land's health, did. Other nuclear landscape photographers, such as Peter Goin, photographed the bunkers on the westernmost American littoral of the Bikini Atoll and the militarisation of the land in the Cold War, just as Paul Virilio photographed the German bunkers on the European littoral in the aftermath of World War II. Chapter 11 considers nuclear landscapes, including the photography of those mentioned above, and the nature writing of Terry Tempest Williams who tells the story in *Refuge* of one 'downwinder', her mother, and of

'downwinded' lands in Utah. This chapter contrasts landscape photography that focuses on the effects of the bombing inscribed on the surfaces and products of the land with nature writing that traces the impact of the bombing on the depths and processes of the land and human bodies.

Recent landscape photography, such as the photography of nuclear landscapes, has turned away from national parks and wilderness to industrial landscapes, minescapes, wastelands and disaster zones. Tolonen takes up some of the photography of these places in chapters 8 to 10 (see Part II of this 'Preface'). In chapter 12 I also consider a number of prominent examples of photographs of such places in what I am calling wastelandscape photography. The Asian Tsunami of 2004 took thousands of people to their death in a world of mud and water, or an instance of a native quaking zone as I have called it elsewhere (Giblett 2009). This chapter begins by reflecting on the photographic portrayal of this natural disaster and compares it to the photographs of recent bush fires in Australia, in some cases of arson, a national, rather than natural, disaster, or an instance of a feral quaking zone as I have called it elsewhere (Giblett 2009). Arguably we live in the age of disasters which has been going on for a century or so. Tolonen's journey photography of city sites in the Chernobyl exclusion zone provides the visual archive for undertaking a tentative taxonomy of the natural history of unnatural disasters. For Tolonen the city sites of Pripyat he has photographed are industrial ruins in the sense that these sites were the product of industrial society and are now its ruins and are in ruins.

The unnatural disaster or feral quaking zone of '9/11' was a field day for photographers, amateur and professional alike. Coincidentally the Magnum Photographers were holding their AGM in New York on that day and they produced a book of their photographs of the event, or at least of certain aspects of it. The ubiquity of cell/mobile phones with cameras meant that this was the most photographed event in human history. Chapter 12 goes on to discuss some of the most famous photographs of '9/11' (the event and its aftermath), including Joel Meyerowitz's monumental photographic portrayal of the aftermath, a selection from which toured the world sponsored by the US State Department as 'Bush's Calling Card'. For both Meyerowitz and Edward Burtynsky the sublime figures prominently both in their visual and verbal rhetoric, as it did with Ansel Adams, with none of them alert to the masculinist and reactionary politics of the term. The chapter concludes with a consideration of the photographic minescapes of Burtynsky and suggests that they aestheticise mining and its impacts on and in the earth, though they do demonstrate the monumental or monstrous (depending on

the way you look at them (see Giblett 2011)) threat that the depths of mining pose to human habitation of, and health and livelihoods on, the surface of the earth.

Turning away from aestheticised landscape and wilderness photography and from wastelandscape photography (aestheticised or not), chapter 13 develops and calls for photography for environmental sustainability. This style or genre of photography could produce photographs focusing on people and places, landscapes and land-uses that exemplify principles and practices of environmental sustainability. Such a body of photographs could begin exploring, documenting and developing environmental sustainability by showcasing communities working the land in ways that conserve or rehabilitate biodiversity. These could include Aboriginal people living traditional lifestyles, permaculture practitioners, organic farmers and gardeners, natural energy technologists, or it could showcase products, processes and spaces designed for environmentally sustainability, etc. It could create a new genre of photography, photography for environmental sustainability, or better still, photography for earthly symbiosis. This would show humans living in a more intimate and reciprocal relationship of mutuality with the earth involving what I call bio- and psycho-symbiotic livelihoods in bioregional home-habitats of the living earth (see Giblett 2011).

PART II

JUHA TOLONEN

Do images have the ability to transform our relationship with the land? As Giblett reveals, photography has undoubtedly collaborated with colonial powers in the nineteenth and early twentieth century in creating landscapes that perform for the economic and industrial interests of the settler societies in America and Australia. More recently, pro-environmental groups have used landscape photography to promote the natural splendour of wilderness areas and other sites of natural significance to limit this industrial expansion. So, even recent history suggests that photographs have the ability to influence our perceptions of land and consequently influence the ways we engage with it. Giblett remains faithful to this photographic project. He sees photography retaining an important revelatory function, alongside

many of those who still practice traditional forms of documentary photography. It is with this recognised function that Giblett promotes a photography that works to environmentally sustainable ends. Where previously landscape photography has been used as an instrument for colonial and industrial expansion, and later as an instrument to promote areas of sanctuary that protect them from this expansion, Giblett sees an opportunity for landscape photography to settle into a third ground that promotes both natural habitats and sustainable industrial practices. This is landscape photography with a clear political agenda – *landscape for the environment*.

I am more pessimistic about the efficacy of photography used for political ends today. While Giblett starts from a position with a clear political agenda and is optimistic about the ability of photography to work towards that political end, I enter the world of landscape photography not with political certainty, but rather representational uncertainty. This may be a condition of having absorbed a lot of art photography that questions its own representational practice, as well as being a practising landscape photographer. Landscape photographers undoubtedly have a passion for the spaces they photograph. The sources of those passions vary: the beauty of nature, the attraction of built forms, and the concerns over the increasingly adverse impact we have on the environment. Yet, the passions move beyond just the physical realm of the subject recorded, there is equally a fascination for the marvel of forms transformed by light, time and the camera lens. In the period of high modernism, this transformation would often be used as a sign of the photographer's creativity and genius, evidence of his or her ability to wrench from the technology imagery that transcends the medium and elevates the landscape. This close relationship with both the technology and landscape means the environmental political agenda evident in Giblett's analysis of landscape is not my prime motivation. A fascination for form, combined with speculation on the social and psychological aspects of landscape, also informs my critique. This position distinguishes itself from Giblett's analysis of landscape photography as *landscape and the environment*.

The three chapters that I have written engage with photography that is largely recognised as art: photographs that are intended for display on gallery walls, or for reproduction in art books. The indexical nature of photography ensures that the subject remains vital for interpretation, but as art the aesthetic form of these images tends to be elevated. Giblett is sceptical about the ontological claims of photography to art, not because of any highbrow elitism that looks down its nose at photography, but because whether or not photography is art is an epistemological, historical

and cultural question of definition on both sides. He is much more interested in the politics and pragmatics of how landscape photography is regarded, where it is exhibited, what meanings are made about it and why it has such an iconic status in modern culture, including the conservation movement. I, meanwhile, do not seek to question this status. Instead, I consider how form wraps itself around the subject and the implications this has on the culture of the image.

The photographer traditionally uses the camera as a tool to reveal and re-present the world in image – a world in which the subject has priority. In the 1970s, we start to see photographers adjust their focus so that the subject in the viewfinder gives way to the growing concerns around representational practices. The histories and traditions of photography become legitimate subject matter. Photography begins to question its own myth-making practices. This strategic shift is evident in the work of Cindy Sherman, who critiques the roles that women have traditionally played in photography and film, but it is also evident in some landscape photography from this period also. The history and traditions of landscape photography are targeted, resulting in photography that questions its own tradition. In many cases the subject in the image takes a step back and the aesthetic rendering, or form, of the image becomes more obvious. As part of the postmodern scene, these images are as much about the choices taken in the representation of the subject as that of the subject represented itself. The politics of the image seems most clearly embedded in those choices.

All the images I consider are located within an era of human global development where concerns for the environment have grown steadily stronger, and each of the photographers responds to these concerns through their choice of subject matter. However, their aesthetic choices (framing, cropping, presentation et al) reveal a concern beyond that of just the physical world represented in the photographs. Representation, itself, gets raised to a higher level (in varying degrees) whereby the subject must share the stage with its photographic form. There is an ongoing tension between these two spheres of photography, something that occurs in all photography, but in these cases these tensions are intentionally exploited. Even to the point where form ultimately triumphs over the subject.

Form takes precedence in the images from the 'New Topographics' exhibition of 1975. Chapter 8 identifies some of the critical thinking that has emerged from this exhibition, which is seen as an important temporal marker in the history of recent photographic art practice. The exhibition identified a change in the way many photographers began to consider landscape and the ways to represent landscape

photographically. The neutral aesthetic of the photo-document that was presented in the show has a prominent place in contemporary photographic practice today.

This chapter defends a photographer's preoccupation with form. This is not done at the expense of the subject. I argue, that in the case of the 'New Topographics', exhibition form is promoted to limit the usual reactions to an underwhelming and often maligned subject. Many of the photographers from the exhibition, like Robert Adams, showed a fabled American West, the frontier between civilisation and wilderness, domesticated with new suburban developments. The new buildings and infrastructure did not match the grandeur of the natural landscapes, like those of Ansel Adams, which we associate with the West. Instead, they appeared more like a blot on the landscape – subject matter that did not seem to warrant an exhibition. Coupled with the neutral documentary form preferred by the *New Topographics* photographers, the viewer in 1975 was left guessing at how to react to the pictures. Working against the established traditions of landscape photography, these photographers did not seem to be taking a clear position, even though most had strong convictions. Form, in this case, was an invitation to withhold judgement.

Form displaces the subject in Richard Woldendorp's photography. In chapter 9 I examine Woldendorp's recent exhibition and book *Abstract Earth*. This work is his ongoing exploration of the Australian landscape with a camera, lens and an aeroplane. Woldendorp has established a reputation in Australia for aerial photography and his abstract rendering of the landscape. From a high, mobile vantage point Woldendorp removes the horizon and fills the frame entirely with the forms of the land below. Without the visual anchors of the horizon and sky the images no longer appear like standard landscapes. They take on a painterly quality, like modern abstractions of Australian landscapes. They make the now familiar Australian outback mysterious and strange again. Descriptive text accompanies each image to confirm its genealogy; even then the resemblance to recognisable landscapes can be hard to pick. The form veils the subject. I summon Ross Gibson's notion of the Australian interior as a mythical Badland to investigate whether the veil that Woldendorp casts over the landscape works to settle some of the contentious histories embedded there.

Another subject that commonly provokes adverse reactions is the contemporary ruin of the wasteland. Yet, it has enjoyed growing appeal in a community of photographers recently. Edward Burtynsky's images of mining waste and the scarred landscapes of modern industry are perhaps the most dramatic and popular, producing images that are simultaneously appealing and repellent. The popularity

of the subject in photography however belies its position in the real world. Unlike the masonry ruins of antiquity that hold high cultural value and appeal, the modern wasteland generally inspires few approving comments. Chapter 10 observes the tensions that emerge in the aestheticisation of wastelands. It was previously left to nature and wilderness to provoke feelings of the sublime, now modern industry is equally capable of creating landscapes that induce a sense of awe. However, the common reaction is to eradicate the wasteland, not create a sanctuary for it. While I do not promote the latter, neither do I see the necessity to ameliorate all signs of damage produced in the wasteland, instead I see benefits in expanding our current range of encounters with wastelands. Some of the new photography emerging from out of the wasteland is one step in this direction.

The photographers and subjects that appear in my critique represent moments of development in my interest in photography. As a novice in the field I remember taking pleasure from the abstractions that Woldendorp crafted from the Australian landscape. His work revealed to me how the camera makes it possible to dramatically transform the world. Later, I encountered the work of Robert Adams and Lewis Baltz as they redefined photography of the American West. In their photographs of ordinary housing developments I realised that subtlety can be equally transformative. The housing and industrial projects I had worked on as a tradesman often felt at times like accidental works of art. Adams and Baltz confirmed this for me in their photographs. Finally, the subject of wastelands seems fascinating to a lot of photographers. My interest in them was confirmed when I recognised that accidental beauty existed in sites of deconstruction also. Abandonment added to the allure. As I photographed and researched the subject I recognised a growing interest in modern ruins. Photographers, urban explorers, psychogeographers, planners and architects shared a common fascination for the unique qualities of many abandoned sites. All seemed equally attuned to the transformative potential of the sites.

One of the defining issues of Australia and the world today is resource allocation. As we approach the limits of what the earth can supply our relationship to landscape will need to change. In Australia today, the impact of fire, wind, flood and drought are increasingly shifting our perceptions of land. Previous land management practices have often run against the dictates of climate and environment. And globally, as the developing nations raise their standard of living the pressures of climate and environment will bear down on us further. Photography will undoubtedly have roles to play in future crises. Its largest role today is that of agitation and illustration – polar bears stranded on ice flows to represent rising sea levels, giant

waves bearing down on cities to represent global warming. Current form would suggest such histrionic responses do little to encourage transformations, not just adjustments, in the way we engage with the land. Instead, we will probably need to rely on tragedy and crisis to bring about change. In the meantime, landscape photography cannot escape this context, even when it is enveloped in form. The persistence of this threat will continue to shape landscape photography.

Centre for Research in Entertainment, Arts, Technology, Education and Communications

Edith Cowan University, Perth, Western Australia

PART I

The Background and Context of Landscape Photography

ROD GIBLETT

The Birth of Photography

Photography has a long and checkered history. In this chapter I trace this history from its birth, beginning with the word itself, and ending with its association with death. In the middle I consider the impact of photography on perceptions of space and time and on bodily and mental aptitudes and capacities. Invoked crucially here is the work of Walter Benjamin on the history of photography and his concept/ metaphors of aura and trace. The invention of photography entailed the further diminution of the power of the hand in pictorial reproduction in favour of the eye, the tracing of the shadow of an object on a two-dimensional surface and the loss of aura, the unique appearance of an object in time and space, brought about in and by technological reproducibility.

Photography, as Raymond Williams (1974: 10) points out, means literally 'light-writing'. Although the inventors of the technology did not use the word 'photography', they conceived the idea in cognate terms. In 1826 Nicéphore Niépce coined 'the generic word … *héliographie* or sun-writing/drawing' (Batchen 1997: 63; see also Virilio 1994b: 19). If this, or cognate terms, did not occur to his contemporaries, then at least the idea came to them, or so they said later. In 1870 Hercules Florence claimed that 'in 1832 … the idea of printing with sunlight came to me' (cited in Batchen 1997: 44). The idea is not to have humans (or a human hand) and technology writing (via a pen or other instrument or tool) but light itself so that the process of writing would be free of human interference, and

the object being written would record itself as it were with verisimilitude. Before the automatic writing of the surrealists in the twentieth century, nineteenth-century photography aimed to make light-writing the hand or the instrument that inscribed automatically the lineaments of an object.

The invention of photography had profound effects not only on what Virilio (1989) calls the 'logistics of perception' but also on human physiology. 'For the first time in the process of pictorial reproduction', Walter Benjamin (1973b: 221; 2002: 102; 2003: 253) argues, 'photography freed the hand of the most important artistic functions which henceforth devolved only upon the eye looking into the lens'. With photography, the eye became the dominant organ of pictorial production (rather than *re*production as that came later with lithography) over the hand. Moreover, the hand was reduced to a device for holding and aiming the camera, focusing the lens, adjusting shutter and film speeds, manipulating levers and dials, and ultimately clicking buttons. The hand became the servant of the eye and an appendage to the machine, and the human body became a kind of prosthetic vehicle for the camera that enabled it to get around and take photographs.

Photography gave the human eye greater power, but at the cost of the diminution of the power of the hand. Photography for Benjamin (1973b: 226; 2002: 105; 2003: 256) was 'the first truly revolutionary means of reproduction', not only pictorially but also physiologically with the eye overthrowing and wresting power from the hand in pictorial reproduction and, as Geoffrey Batchen (2008: 9) puts it, 'removing the mediation of the human hand'. For Roland Barthes (1972: 12; see also Giblett 1985: 123) 'God and the emperor had the power of the hand, man has the gaze'. 'Man', that creature of secular humanism, has not only wrested power from God and the emperor, but also shifted the instrument of power from the hand to the eye. Both hand and eye (rather than other areas of the body or other senses) are instruments of sublimation. Sublimation for Norman O. Brown (1959: 291) is 'a displacement upward [from the anal and genital zones] into other organs (above all the hand and eye)'. 'Man' may shift power from hand to eye but 'he' is still operating in a sublimated realm that 'he' shares with, or more precisely, had usurped from, God.

The aim of photography was to print or paint with sunlight, but to paint or write what? This question had been answered before the word had been coined or the idea conceived. The object, or 'what', of photography had been identified decades before the process, or 'how', was formulated, and before the word, or any of its cognates, was coined. In 1799 Anthony Carlisle (cited in Batchen 1997: 30 and 112) described the experiments of Thomas Wedgwood to 'obtain and fix

the shadow of objects by exposing the figures painted on glass, to fall upon a flat surface'. Photography reduces heights and depths to surfaces, converts the three dimensions of an object in space into virtually two. Photography not only records an object in a place in space but also captures and freezes that object in a moment of time. The conjunction of an appearance of an object in time and space constitutes an event. Photography records an event. I define event simply as a moment in the movement of bodies of matter in time and space (see Flew 1983: 115). These bodies are either inanimate like light or animate like humans.

Even if the object is still, light moves through wave and particle motion to produce shadows. Wedgwood concluded that 'the new method of depicting by a camera promises to be valuable for obtaining exact representations of fixed and still objects' (cited in Batchen 1997: 112). Photography fixed a static object and a moment in time on a flat surface. Later photography, such as that of Marey and Muybridge, fixed the sequential movements of a dynamic object in moments of time on a flat surface. With Marey, Virilio (1991: 18) argues, 'light is no longer the sun's "lighting up the stable masses of assembled volumes whose shadows are alone in movement"' but the means of tracking the dynamic movement of masses in space and time. The emphasis, though, in early photography fell not so much on fixing the object itself, but on fixing the shadow of an object. In 1830 William Henry Fox Talbot (cited in Batchen 1997: 91; see also Batchen 2008: 9) referred to photography as 'the art of fixing a shadow'. The object was incidental, or coincidental. It was just required to produce a shadow. The shadow was all.

The art, and act, of fixing a shadow had a profound impact on perceptions of space and time. Photography was, for Talbot, 'a "space of a single minute" in which space *becomes* time, and time space' (cited in Batchen 1997: 91). The appearance of an object in space becomes fixed in a moment of time, and a moment of time is fixed in the configuration and manifestation of an object in space. Time and space are collapsed together in the photographic event. 'The noblest function of photography', one booster claimed in 1864, was 'to remove from the paths of science … the impediments of space and of time' (cited by Ryan 1997: 21). With photography, seeing the world becomes, according to Virilio (1994b: 21), 'not only a matter of spatial distance but also of the *time-distance* to be eliminated'. For their contemporaries, railways annihilated space and telegraphy annihilated time whereas photography for its contemporaries went one step further and produced in its early days, as Benjamin puts it, 'a strange weave of space and time', that he called aura (see also Caygill 1998: 93–4 and 102–103; and Wolin 1982: 187–190 and 237–238).

Photography and Landscape

Considering photography as simply 'light-writing' is good etymology but problematic aetiology for it implies the question of what sort of writing? For Virilio (1989: 81) 'photography, according to its inventor Nicéphore Niépce, was simply a method of engraving with light, where bodies inscribed their traces by virtue of their own luminosity'. Yet in inscribing its traces the engraved body was engaging in a double process split between writing as inscription and writing as trace (see Giblett 1996: chapter 3; 2008b: chapter 1). The body engraved in and by the photograph always leaves its traces, just as living, or more precisely habitation, for Benjamin is 'a leaving of traces' (Adorno and Benjamin 1999: 104; see also Benjamin 1973a: 169). Photography for Benjamin (1973a: 48; 2003: 27) 'made it possible for the first time to preserve permanent and unmistakable traces of a human being', but s/he is not necessarily inscribed in and by the process. Photography is light-writing, but the writing of photography is split between writing as inscription and writing as trace. Benjamin (1999b: 512; see also 1979: 244) argues that 'the first people to be reproduced entered the visual space of photography with their innocence intact – or rather, without inscription'. In other words, they entered it, and their image was reproduced, or traced, with their aura and their innocence intact.

Photography as trace and without inscription is auratic. Benjamin (1999b: 518; see also 1973b: 222 and 224; 2002: 103–105, especially 123n5; 2003: 253–256) defines aura as 'a strange weave of space and time: the unique appearance or semblance of distance, no matter how close it may be'. To what does 'it' refer? Grammatically it refers to 'distance', but how can distance be close, or faraway, for that matter? *That* is aura, the closeness or proximity of distance when distance is overcome, but still maintained. Aura is the experience of an object looming up and receding at the same time. In collapsing time and space together, early photography produced an auratic 'presence in time and space' (Benjamin 1973b: 222).

Aura is akin in this respect to Freud's concept of the uncanny, a strange, spectral presence/absence. Just as the uncanny is the return *to* the repressed content or portion of the unconscious (see Giblett 1996: chapter 2), so the auratic is the return to the repressed of what Benjamin (1979: 243; 1999b: 512; 2002: 117; 2003: 266) called 'the optical unconscious'. And just as psychoanalysis brought the former to light, photography for Benjamin brings the latter to light – literally:

For it is another nature that speaks to the camera than to the eye: other in the sense that a space informed by human consciousness gives way to a space informed by the unconscious. ... It is through photography that we first discover

32

the existence of this optical unconscious, just as we discover the instinctual unconscious through psychoanalysis. (1979: 243; 1999b: 510–511)

Just as the uncanny is by definition invisible but is made sensible, especially through the sense of smell (see Giblett 1996: chapter 2; 2011: chapter 3), so the auratic is the invisible made visible.

Aura is also similar to Freud's concept of symptom in which the surface of the body of the patient (including their behaviour and clothing) bears and manifests the traces of their psychopathology (see Giblett 1996: chapter 4). Aura operates in the circuit of the uncanny and symptomatic: simultaneously returning to the repressed to return the repressed to the surface of the body. Aura is the expression in old photographs of a profound and unique moment in time and a place in space; aura is more than a mere event, but the imbuing of an event with ritual significance that transcends time and space. It is the trace of the performance of a body in eternity. Commenting on a c.1850 photograph of Schelling, Benjamin (1999b: 514) argues that 'the creases in people's clothes have an air of permanence'. Even the evanescent creases in their faces have a similar air of permanence. Aura is the play of permanence and evanescence. Benjamin (1973b: 228; 2002: 108; 2003: 258) suggests that 'for the last time the aura emanates from the early photographs in the fleeting expression of a human face'. The light-writing of photography kills the object in photographing it, but the photograph always bears the traces of the living body of the subject, whether it be human, animal, vegetable or mineral, though it will not necessarily convey its aura.

Trace and aura are similar but Benjamin (1994: 586; 2003: 106; Adorno and Benjamin 1999: 290) asserts that 'the concept of the trace is defined and determined philosophically in opposition to the concept of aura'. Trace is a chemical residue indicating current absence and past presence, whereas aura is a physical quality symbolising present presence. Benjamin (1999a: 447) differentiates them in the following way:

> [T]he trace is appearance of nearness, however far removed the thing that left it behind may be. The aura is appearance of a distance, however close the thing that calls it forth. In the trace, we gain possession of the thing; in the aura it takes possession of us.

In the early photographs, the thing photographed takes possession of us – we do not take possession of it. We bask in its aura. The thing is separate and distanced

from us. The aura for Benjamin (1999a: 314) is 'the aura of distance opened up with the look that awakens in an object perceived'.

Aura for Benjamin (1973a: 147–148; 1973b: 189–190; 2003: 338) is the looking back of the object of the camera (and its 'gaze' and the gaze of the photographer) at the viewer of the photograph:

> What was inevitably felt to be inhuman, one might even say deadly, in daguerreotypy was the (prolonged) looking into the camera, since the camera records our likeness without returning our gaze. But looking at someone carries the implicit expectation that our look will be returned by the object of our gaze. Where this expectation is met … there is an experience of the aura to the fullest extent. … Experience of the aura thus rests on the transposition of a response common in human relationships to the relationship between the inanimate or natural objects and man [sic]. To perceive the aura of an object we look at means to invest it with the ability to look at us in return.

The living body's transposition of aura to the dead matter of the camera was possible in the age of long exposure times but declined with the advent of the snapshot.

Aura may wane as objects become nearer but trace will never disappear as objects become further away. Things may decreasingly take possession of us, but we will continue to take possession of them, and imbue them with significance. The decline of aura is concomitant with the incline of commodity fetishism. With aura, things take possession of us whereas with what Benjamin called 'the phony spell of the commodity' we take possession of things. In this process things will leave their traces (on us and us on them for 'living means leaving traces' (Benjamin 1973a: 169; see also Adorno and Benjamin 1999: 104)) and decreasingly wrap us in their aura. In the later photographs, we take possession of the thing itself – it does not take possession of us. It leaves it traces but we do not bask in its aura. Aura is an energy or force field that all objects possess and that is acknowledged and reproduced in ritual.

Benjamin (1999b: 327–328) distinguishes three aspects of genuine aura: 'First, genuine aura appears in all things, not just in certain kinds of things'. Aura is the sacral quality with which all objects (including everyday objects and subjects) are imbued in traditional and premodern cultures. A vestige of that quality lives on in modern cultures in the fetishism or phony spell of commodities. 'Second, the aura undergoes changes.' Aura is not fixed or eternal, it can wax and wane. The auratic significance with which objects are imbued ebbs and flows without ever becoming

totally bereft of it. 'Third, the characteristic feature of genuine aura is ornament, an ornamental halo, in which the object or being is enclosed as in a case.' The auratic object is framed or contained. It is marked off decoratively and spatially from other objects with which it shares sacrality on a continuum.

The fundamental distinction between the auratic and the inscriptive does not correlate to that between nature and culture, nor orality and literacy, but between the cultures of first, or worked, nature and of second, or worked over, nature (see Giblett, 2011: chapter 1). Aura is pervasive in the former, vestigial in the latter. For Benjamin (1999a: 362) 'the decline of the aura and the waning of the dream of a better nature …are one and the same'. Both go hand in hand with the commodification of nature, the photograph and photography. Nature is drained of sacral significance, and imbued with capitalist value, just as the aura of human subjects and other objects declines, and just as the photography of events rises. For Heidegger, the fundamental event of the modern age is the conquest of the world as picture. Photography contributes not only to that conquest but also to the fundamental event of the hypermodern age: the conquest of the world as commodity.

Aura declines as images of objects are reproduced and as exposure times decrease 'from Niépce's 30 minutes in 1829 to roughly twenty seconds with Nadar [in] 1860' (Virilio 1994b: 21). Aura in photographs is a function partly of the long exposure times and slow lenses and shutter speeds of old cameras, and partly of the subject's intact innocence in old photographs. Yet the two go hand-in-hand as the snapshot produced by cameras with short exposure times and fast lenses and shutter speeds produces both a guilty subject who knows s/he is having his/her photograph taken and a commodified object of the photograph that is bought and can be resold. Capitalist commodities can be decorative, but mass reproduction does not (and cannot) mark them off spatially from other mass-produced objects. Benjamin (1999a: 337 and 343) argues that

> for the decline of the aura, one thing within the realm of mass production is of overriding importance: the massive reproduction of the image.

The aura of a work of art, in Benjamin's (1973b: 223; 2002: 104; 2003: 254) words, 'withers in the age of mechanical reproduction'. Aura is living matter so it can wither, or 'shrivel', as Benjamin (1973b: 233) elsewhere puts it, both like a plant. The photograph is commodified, sold and bought, like the book or painting, and so is dead matter. The photograph is a commodity, or dead matter, by virtue of

light writing the outlines of object on a flat surface. Living matter sublimated into air is transformed into dead matter (see Giblett 1996: Figure 1). The new photograph is split between its status and function as inscription and as commodity. Photography is split between the old photograph and the aura it possesses and the new photograph with its vestiges of aura and traces of the object.

Aura is a kind of divine fire, the living fiery breath of God, or the Holy Spirit, that 'He' breathed into everything in creation according to the biblical book of 'Genesis'. Photography is an attempt not only to wrest fire from the gods, but also to reproduce it. Neale (1985: 25) points out that

> there existed a whole theology of light as the trace of the noumenal in the real, as the mark of spirit in matter.

Divine light was incarnated in the photographic body of the son/sun of God. Solid matter was sublimated into the sublime image in the *camera obscura* only to be incarnated and inscribed in the sublimate of the surface of the photograph. And later animated in cinematic film. Photography was the logical next step to the *camera obscura* whose image was, as Neale (1985: 20) puts it, 'fleeting, intangible, evanescent'. Photography in its beginnings was concerned primarily with recording the event of the shadow rather than the outlines of the object. It was more concerned with the index of the presence of the object than with the object itself.

By invoking the power of the sun in his concept of heliography, Batchen (1997: 63) comments that Niépce incorporated 'a key metaphor for God's divine power and benevolence'. By using the power and light of the sun, photography becomes a kind of secular theo-technology. It is also a kind of industrial alchemy. Photography transforms the solidity and base matter of the photographed object into the gold of inscriptions on the surfaces of the photographic plate, film, paper and disc. Photography is a sublime communication technology. Using light, the light of divine revelation, reason and rationalist technology, analogue photography transforms the base matter of solid objects via a slimy emulsion of chemicals into an evanescent visual image engraved or inscribed on the surface of the base matter of plate, film and paper. Digital photography transforms the base matter of solid objects via the writing of digital code into an evanescent visual image inscribed on the surface of the base matter of disc. Photography sublimates solid matter into the thin air of sun-filled space only to transform and commodify it into the sublimate of dead matter. Photography thereby achieves an almost complete circuit in what

I have called elsewhere the 'pyschogeocorpography of modernity' (Giblett 1996: Figure 1).

By using the power and light of the sun, photography was not so much light-writing as nature writing. Nature is a desacralised or secularised divine force (see Giblett 2011: chapters 1 and 2). The invention of photography stemmed in part from what Szarkozski (cited in Batchen 1997: 18) calls the desire that 'it might be possible to "snatch from the very air a picture formed by the forces of nature"'. Photography stems in part from the Promethean desire to snatch fire from the gods in the heavens and bring it down to humans on earth. The photograph is basically the imprint or inscription of the shadow made by an object suspended in sunlit space or sun-filled air. It is evanescent and ethereal like a mist, an emanation of nature, or a ghost, the relic of a bygone living body.

For light, however, to inscribe an object in a photograph the guiding hand of 'man' is needed to hold the camera and take the shot – though he wanted to abstract himself from the process. By 1838, Batchen (1997: 33–34) relates,

> Daguerre was able to announce the invention of a workable process that he modestly called daguerreotype: 'it consists in the spontaneous reproduction of the images of nature received in the *camera obscura*'.

The daguerreotype represented the outcome of the desire to allow nature to reproduce itself spontaneously, like spontaneous combustion and generation, to reproduce images of itself without human intervention. Human beings and human bodies would be sublimated out of the process, and into the process to become as evanescent and ethereal as they claimed or desired the process to be.

Despite this desire for abstraction, photography also enacted the desire to produce a machine that would reproduce images of nature, like a kind of mechanical God creating Adam in his own image. In 1838 Daguerre claimed that

> the DAGUERREOTYPE is not merely an instrument which serves to draw Nature; on the contrary it is a chemical and physical process which gives her the power to reproduce herself. (cited in Batchen 1997: 66)

Nature is constructed as incapable of reproducing 'herself', though 'she' had been doing it successfully for millennia before photography. Nature is figured as needing the helping hand of gynaecological man, like some kind of artificial inseminator, to reproduce herself.

Photography is 'a Bachelor Machine for a Bachelor Birth' (see Giblett 1996: 50n7) in which the photographer and the viewer give birth together to create a new world. Along similar lines, Barthes (1981: 81) suggests that

> [a] sort of umbilical cord links the body of the photographed thing to my gaze: light, though impalpable, is here a carnal medium, a skin I share with anyone who has been photographed.

The photographer gives birth to a new world out of his brain box and his box brownie, or out of his box of magic tricks (they all amount to the same thing), like some kind of gynaecological magician who weaves a magic spell and wrests from nature her secrets using light, much like telegraphy did with electricity and radio was to do later with electromagnetism. For Barthes photography is *a sort of* umbilical cord that connects the objectified body in the photograph to the subject's gaze. Rather than giving birth to life, photography gives birth to death. And the camera is the device for doing so (as I will argue in the next chapter).

Although William Henry Fox Talbot referred in 1840 to photography as 'an act of "natural magic"' (cited in Batchen 1997: 62; see also Batchen 2008: 9), the magic was modern black magic woven by men ostensibly using nature. Batchen (1997: 92) argues that

> a number [of contemporary journalists] used the term *necromancy* (communication with the dead) to describe the actions of both Daguerre's and Talbot's processes.

Necromancy entailed not only communicating with the dead but also communing with death. Barthes (1981: 9) sees photography as 'the return of the dead', and Batchen (1997: 172) even sees it '*as* death' itself. Death for Barthes (1981: 92) 'must be somewhere in a society'. He wonders whether it is:

> perhaps in this image which produces Death while trying to preserve life. Contemporary with the withdrawal of rites, Photography may correspond to the intrusion, in our modern society, of an asymbolic Death, outside of religion, outside of ritual, a kind of abrupt dive into literal Death. With the photograph, we enter into *flat Death*.

Rather than sexuality (the Victorian orthodoxy of repression), death is the repressed of modern European society and its settler diaspora that returns in the photograph of an object flattened out and deprived of ritual and symbolic significance, stripped of aura.

The photograph is both the recorder and the bringer of death. The appropriately named Cadava (1992: 90–91) describes how, as:

> subjects of the photograph, seized by the camera, we are mortified by it. … the photograph tells us we will die … It announces the death of the photographed … the photograph is a grave for the living dead … [it is] the tomb that writes … [it is] the allegory of our modernity … the uncanny tomb of our memory. Photography is a mode of bereavement. … the return of the departed.

Photography is not so much life that writes with light but the tomb that writes the death of the photographed.

Photography is a tomb for the living dead in that the photograph kills. But the photograph also gives life, or at least a strange kind of afterlife to its subjects. The photograph tells us we will die, but it also tells us that we can have a life after death, engraved or inscribed in its surface. Photography is thus both tomb for the living dead and a womb for the dead living. Photography for Barthes (1981: 82) 'has something to do with resurrection'. The photograph, or other representation produced by a camera, digital or analogue, does not merely kill the human body by reducing it to an object and fixing its lineaments but gives it a strange kind of afterlife as the dead living. And the camera is the instrument to do so, the topic of the next chapter.

The Camera

Photography takes place in and through the camera – no camera, no photography. A camera is the technological device that makes photography possible and gives the eye power over the hand. In this chapter I consider the camera and its power by examining its relationship to the human eye and to the rest of the human body, and to the land it photographs in landscape and wilderness photography. Photography not only 'kills' objects by fixing them, but also 'kills' the subject of the look, and the human eye, by replacing it with the camera that takes the place of the human eye and is thus literally a prosthesis for the human eye. Yet the eye of the camera is fixed and static until the human body moves it around, so the human body becomes a prosthesis for the camera to enable it to get around and take shots. Camera and body form a mutually beneficial composite prosthesis for each other. As the camera 'kills' like a gun by taking aim and shooting, it is a sublimated gun that constitutes the subject who takes the photograph as living and the object of the photograph as dead. In landscape and wilderness photography, the 'out there' of the land is held at distance to protect and immure the 'in here' of the photographer against the incursions and threat posed by the 'out there'. The camera-wielding photographer operates on the logic 'I shoot (to "kill") therefore I am (living)'.

 With the camera, Jean-Louis Comolli (1980: 123) argues,

the human eye loses its immemorial privilege; the mechanical eye of the photographic machine now sees *in its place* ... the photograph stands as at once the triumph and the grave of the eye.

 The photograph stands as at once the monument to the power of the eye and the tomb of the eye just as it stands as the triumph and the grave of the object being photographed. The object triumphs over time and mortality to live on in the photograph only to be mortified by it. Eduardo Cadava (1992: 89) concurs that 'the photographic image conjures up its death ... The home of the photographed is the cemetery'. This was literally the case with David Octavius Hill, who produced a famous series of photographs of people who made the cemetery their home. Photography found its home in the place of the dead because the photograph is the home of the dead that renders the living as dead who become the living dead in the photograph.
 As photography kills, the camera is a weapon. The activities of 'loading' and 'aiming' a camera and then 'shooting' a photograph or an event on film are associated with war and hunting. In short, the camera is a gun. Etienne-Jules Marey's multiple-exposure 'photographic gun' of 1882 looked like a rifle, and was held and 'fired' like one (for an illustration, see Neale 1985: 35). For Paul Virilio (1988: 190; see also 1991: 16–17),

> there is a very close similarity between ... the Gatling Gun, the photographic revolver of Janssen, and cameras. The Colt .45, the chronophotographic gun – all these things are tightly bound up with each other.

The modern camera, Susan Sontag (1977: 14) argues, is 'trying to be a ray gun'. It not only records light, but also shoots events as if it were projecting rays at an object. Chronophotography, 'literally, the photography of time', as Kern (1983: 21) points out, or more extensively, the writing of light-time, shoots events in time and space.
 The camera is a sublimated lethal weapon. The camera in Zoë Sofia's (1992: 381) terms is like 'the gun [which] may be read as a metonym of speedy and lethal penetration across terrain and through flesh, a tendency related to the military investment in technologies of speed', including technologies of communication, I would add, such as photography and cinematography. The camera for Sontag (1977: 14) is sold 'like a car, as a predatory weapon' though, of course, it does not kill like a car so she concludes that it is 'a sublimation of the gun' and 'to

photograph someone is a sublimated murder'. The gun is also an ocular device with a line of sight and fire, and the camera is a device of ballistic projection that shoots and 'kills'. The camera is a gun. Both leave their mark on their user, on his or her body, and on the earth.

The first book by Nobel Prize winner J. M. Coetzee (1974: 82–86), *Dusklands*, is a stunning fictionalised account of South Africa in the pioneering period that includes a long meditation on the gun and the eye in relation to 'the wild', not just wilderness, but also wild animals and plants. I will shortly quote these pages at length as they tell a story in which the characters include not only the explorer Jacobus Coetzee but also the gun and 'the wild' who are central players. They are not just props with which or backdrop against which exclusively human action takes place. The gun and 'the wild' are imbued with agency, though this is limited to a role of supporting and enlivening the explorer in and by his wielding of the gun against 'the wild'. Jacobus Coetzee relates how he

> inhabited the past again, meditating upon my life as tamer of the wild. I meditated upon the acres of new ground I had eaten up with my eyes.

The eyes become an instrument of visual sadism troped in oral terms that devour the landscape. Yet in extending out beyond the gazing eye to master and masticate the landscape, the body loses a sense of the boundaries between itself and wilderness. The wild is boundless; the tamed is bound. Jacobus Coetzee goes on to relate that

> in the wild I lose my sense of boundaries. This is a consequence of space and solitude. The operation of space is thus: the five senses stretch out from the body they inhabit, but four stretch into a vacuum. The ear cannot hear, the nose cannot smell, the tongue cannot taste, the skin cannot feel.

The body is reduced to one organ (the eye) and the five senses are reduced to sight. This reduction reaches its technological mastery in the gun where the line of sight and the line of fire are aligned (as we shall see shortly). For Coetzee in the wild:

> [O]nly the eyes have power. The eyes are free, they reach out to the horizon all around. Nothing is hidden from the eyes. As the other senses grow numb or dumb my eyes flex and extend themselves. I become a spherical reflecting eye moving through the wilderness and ingesting it. Destroyer of the wilderness, I move through the land cutting a devouring path from horizon to horizon. There

is nothing from which my eye turns, I am all that I see. Such loneliness! Not a stone, not a bush, not a wretched provident ant that is not comprehended in this travelling sphere. What is there that is not me? I am a transparent sac with a black core full of images and a gun.

The photographer of 'the wild' could also say 'I am a transparent sac with a black core full of images and a camera'. The tamer of the wild is reduced to an eye and a gun, an ocular weapon. The photographer of the wild is reduced to an eye and a camera, a sublimated ocular weapon. The five senses of the human body are reduced to one, the sense of sight. The gun is a prosthesis for killing, the body a prosthesis for the gun to get around and kill with specifically the eye a prosthesis for the gun to be aimed and the rest of the body a quadruped to carry, hold and fire the gun. Similarly the body of the photographer is a prosthesis for the camera to enable it to get around.

The wild is reduced to an object of sight, as are the objects in it. These objects can in theory be counted and subjected to the mathematical, enumerative imperative and to capitalist accounting. But to be counted the wild has to be killed as the living wild is too mobile, too protean, too vital to be counted. The wild is one; the tamer of the wild divides the one into the many to conquer it, but in the process proliferates its parts into countless infinity:

> We cannot count the wild. The wild is one because it is boundless. We can count fig trees, we can count sheep because the orchard and the farm are bounded. The essence of orchard tree and farm sheep is number. Our commerce with the wild is a tireless enterprise of turning it into orchard and farm. When we cannot fence it and count it we reduce it to number by other means. Every wild creature I kill crosses the boundary between wilderness and number. I have presided over the becoming number of two thousand creatures, omitting the innumerable insects that expired beneath my feet. I am a hunter, a domesticator of the wilderness, a hero of enumeration. He who does not understand number, does not understand death.

The explorer and the settler are slaves to linear time, of the arrow of time on its progressivist trajectory out of a primitive past of the land and people through a narrow defile of the cramped present into the terror of an unknown, but supposedly glorious, future trapped in the prison of modern, mechanically measured time, the time of the watch, of imperial, linear history, of the time it takes to pull the trigger

and see the target keel over, or not, and of the time it takes to travel from point A to point B, from settlement to settlement or from settlement to some unknown, unexplored place or point.

After meditating on 'the wild', Jacobus Coetzee goes on to meditate further on the gun. As the camera is arguably a gun, or at least a sublimated gun, the camera can be substituted for the gun in his account. For the explorer:

> The gun [or camera] stands for the hope that there exists that which is other than oneself. The gun [or camera] is our last defense against isolation within the travelling sphere. The gun [or camera] is our mediator with the world and therefore our saviour … The gun [or camera] saves us from the fear that all life is within us. It does so by laying at our feet [or in our hands] all evidence we need of a dying and therefore a living world.

By shooting and killing animals, or events, the camera and the gun constitute their wielder as living on the logic that 'I kill therefore I am (living)'. The gun and camera constitute the object of the shot as dead and the subject of the shooter as living. They mediate between them. They are sublime communication technologies (see Giblett 2008b).

Rather than the camera or the gun being a prosthesis for the eye, the body of the wielder has become an ambulatory prosthesis for them, a means for them to get around. Coetzee continues:

> I move through the wilderness with my gun [or camera] at the shoulder of my eye and slay [or shoot] elephants, hippopotami, rhinoceros, buffalo, lions, leopards, dogs, giraffes, antelope and buck of all descriptions, fowl of all descriptions, hares and snakes; I leave behind me a mountain of skin, bones, inedible gristle, and excrement [and discarded cartridges of bullets or canisters of film]. All this is my dispersed pyramid to life. It is my life's work, my incessant proclamation of the otherness of the dead and therefore the otherness of life. A bush, too, no doubt is alive. From a practical point of view, however, a gun [or camera] is useless against it. There are other extensions of the self that might be efficacious against bushes and trees and turn their death into a hymn of life, a flame-throwing device for example.

The gun and/or the camera is an appendage to the body and an extension of the eye and of the power of sight. To look, is to shoot, is to kill, is to constitute the shooter as alive. By creating otherness, the self is created – no other, no self. The other is constituted as dead by being shot so that the self is constituted as living in the process. Without death, there would be no life (to state the bleeding obvious), and without the death of the other, no life of the self. The dead other constitutes the living self. 'The other is dead, therefore I am living'.

Unlike the camera, the gun is designed primarily for literally shooting and killing the corporeal. Coetzee goes on:

> But as for a gun, a charge of shot into a tree means nothing, the tree does not bleed, it is undisturbed, it lives on trapped in its treeness, out there and therefore in here. Otherwise with the hare that pants out its life at one's feet. The death of the hare is the logic of salvation. For either he was living out there and is dying into a world of objects, and I am content; or he was living within me and would not die within me, for we know that no man ever yet hated his own flesh, that flesh will not kill itself, that every suicide is a declaration of the otherness of killer from victim. The death of the hare is my metaphysical meat, just as the flesh of the hare is the meat of my dogs. The hare dies to keep my soul from merging with world. All honour to the hare. Nor is he an easy shot.

The other dies that the self may live. Shooting an animal, or another human for that matter too, with a gun keeps the soul of the shooter from merging with the world, and especially keeps the soul of the animal or human merging with his soul in the aura of mutual habitation. Shooting a tree or a landscape with a camera keeps them out there and in here and allows his soul to merge with the world in a romantic, oceanic feeling of the sublime.

Both the camera and the gun are devices for shortening the distance between a machine and its target. The gun is a device for shortening the distance between a bullet and its target. A car is a device for shortening the distance between a driver and his/her destination. The camera is a device for shortening the distance between a photographer and his/her object. The driver may arrive at his/her destination, but the gun keeps the shooter and the shot distant from each other. Similarly the camera keeps the photographer and the photographed distant from each other. Coetzee continues:

The instrument of survival in the wild is the gun [or camera], but the need for it is metaphysical rather than physical. The native tribes have survived without the gun [or camera]. I too could survive in the wilderness armed with only bow and arrow, did I not fear that so deprived I would perish not of hunger but of the disease of the spirit that drives the caged baboon to evacuate its entrails. Now that the gun [or camera] has arrived among them the native tribes are doomed, not only because the gun [or camera] will kill them in large numbers but because the yearning for it will alienate them from the wilderness. Every territory through which I march with my gun [or camera] becomes a territory cast loose from the past and bound to the future.

The camera, like the gun, is a metaphysical weapon of defence against the preternatural wilderness. By taking photographic shots of the landscape, or gunshots at its inhabitants, the wilderness trekker creates a present of this moment in time in the flux of past, present and future. Without these devices for creating events of death in the present, he would be cast loose on, and drown in, the sea of linear time of past, present and future alienated from the cyclical time of the wilderness (see Giblett 2011).

Without the gun and the camera, the wilderness trekker would not only be imprisoned in time, but would also be enslaved to space. Coetzee concludes:

Savages do not have guns [or cameras]. This is the effective meaning of savagery, which we may define as enslavement to space, as one speaks obversely of the explorer's mastery of space. The relation of master and savage is a spatial relation. The African highland is flat, the approach of the savage across space continuous. From the fringes of the horizon he approaches, growing to manhood beneath my eyes until he reaches the verge of that precarious zone in which, invulnerable to his weapons, I command his life. Across this annulus I behold his approach bearing the wilderness in his heart. On the far side he is nothing to me and I probably nothing to him. On the near side mutual fear will drive us to our little comedies of man and man, prospector and guide, benefactor and beneficiary, victim and assassin, teacher and pupil, father and child. He crosses it, however, in none of these characters but as a representative of that out there which now promises to enfold, ingest, and project me through itself as a speck on a field which we may call annihilation or alternatively history. He threatens to have a history in which I shall be a term. Such is the material basis of the malady of the master's soul.

The malady of the master's soul, the soul of mastery rather than mutuality, has its material basis in a body attached to the prosthesis of gun or camera, prostheses for the eye and hand, or car, a prosthesis for walking.

The gun and the camera are devices for overcoming and eliminating distance. The gun is a device for eliminating the distance between a bullet and its target. The camera is a device for eliminating the distance between a recording surface and an event. For Robins and Webster (1999: 240–259) 'the elimination of distance' brought about by 'distance-shrinking technologies', especially communication technologies, have worked towards what they call 'the neutralization of space' and the loss of 'presence at a distance', or aura in Benjamin's terms, replaced by presence at hand.

The development of photography and weaponry changed the relation between the hand, the eye and the weapon. Seeing and killing are joined; the camera is a prosthesis for seeing and shooting events, and the rifle is a prosthesis for killing by seeing. The function of the weapon for Virilio (2002: 53 and 112) is 'first of all the function of the eye: sighting'. With the camera and the rifle no longer do you look the enemy in the eye, unlike fighting an adversary with a sabre or a sword. With the camera and the rifle you watch his/her movements and his/her weapon through the sights of your weapon. No longer do you hold your weapon, such as a sword, away from the line of sight and wield it as an extension of the hand, arm and spine. The line of sight and the surveying or positioning instrument had already been aligned with the technologies of colonialism, the ensigns of empire as Wordsworth called them, such as the sextant, telescope and theodolite. Ensign has several meanings. One of them is that it is a sign of something. Optical technologies are signs of empires. Another meaning is associated with the military, both as a military flag and rank. The ensigns of empire militarise the space around them and the people who use them. Ensign as a verb means to mark, indicate and point out, and to teach and instruct. The ensigns of empire mark the body and the earth as all technologies leave their mark on the body of the user and the earth on which they are used.

The rifle is a prosthesis not only for killing by seeing, but also for eating as it is a consumer of living matter. It transforms living matter into dead matter. The rifle for Marshall McLuhan (1964: 341 and 343) is 'an extension of the eye and the teeth'. It is another instance of the way in which for him 'weapons proper are extensions of hands, nails and teeth' that 'come into existence as tools needed for accelerating the processing of matter', including ingesting, digesting and excreting it. By shooting, the camera and the gun constitute their wielder as living on the logic that 'I kill

therefore I am (living)'. As the gun and camera constitute the object of the shot as dead and the subject of the shooter as living as argued earlier, they mediate between them and so they are communication technologies. In Christian Metz's (1982: 50; see Laplanche and Pontalis 1973: 229–231 and 349–356) psychoanalytic terms,

> the camera is 'trained' on the object like a fire-arm (= projection) and the object arrives to make an imprint, a trace, on the receptive surface of the film-strip (= introjection).

The camera is a device for articulating projection and introjection so that projection outwards via a projectile is linked to introjection inwards via inscription or trace.

By shooting events or targets the subject both kills animal and human bodies (= excorporation) by reducing them to a pile of gristle or a strip of images and consumes bodies (= incorporation) either as flesh or image. The photographing subject is situated at, and constituted as, the point of intersection of photographic projection and introjection, excorporaton and incorporation. If the subject only projected and excorporated, there would be nothing to tell him he existed; if the subject only introjected and incorporated, he would be destroyed by what is outside him. He excommunicates in order not to be excommunicated. The choice for the subject is simple: excommunicate or be excommunicated. Technological and endocolonial communication and excommunication replace theological and colonial excommunication. The subject requires projection and introjection, excorporaton and incorporation, to be interpellated as subject. The gun and the camera provide the technological means to do both. But in order to do so, the gun and camera wielder has become an attenuated body reduced to an eye, and a vehicle to get them around. Rather than the camera or the gun being a prosthesis for the eye, the body of the wielder has become an ambulatory prosthesis for them.

The gun and camera make space and time into events, and thereby master both. They bring events into their purview, make them thereby into targets and constitute them as objects in the discourse of mastery. Without them and the other ensigns of empire, the wielder of gun or camera is truly lost in space. The gun and the camera, the sextant and the theodolite, survey and coordinate space to master it and make it traversable, like the map with its grid of longitude and latitude, the grid-plan town with its rectilinear streets and the grid-iron of drains drying out wetlands (see Giblett 1996: chapter 2). Photography, Ann Friedberg (1993: 30) concludes, 'offered a mobilized gaze through a "virtual real", [and thereby] changed

one's relation to bodily movements, to history, and to memory'. Moreover, I would add, it changed one's relation to the second and third person, to the many, to place, to other living beings, to land. Photography mobilised the eye in the war against nature. Each shot of the camera can be continuous like a machine-gun, but the photograph is static. Photography is unlike cinematography, the mobile eye of the war against nature in which the shots are not only continuous, like a machine-gun, but the pictures are dynamic too.

If, indeed, the camera is a gun and photography is a shot fired with that gun, it is hardly surprising then, that photography played a role in war shortly after its development. World War I (1914–1918), Virilio argues, was 'the first Total War', 'the first truly technical war in Europe' (Virilio and Lotringer 1983: 8-9) and 'the first total war of humanity against man' (Virilio 2000: 55). It was so partly because it was a watershed for both the devastating effects of war on human communication and the close connection between communications technologies and war in aerial photography. World War I for Allan Sekula (1984: 34) was:

> the first occasion for the intensive use of aerial photography for 'intelligence' purposes ... With airplane photography ... two globalizing mediums, one of transportation and the other of communication, were united in the increasingly rationalized practice of warfare ... A third medium of destruction, long-range artillery, was quickly added to this instrumental collage, making possible bombardment – was well as image recording – at a great distance.

Just as transportation and communication converged in railways and telegraphy with their lines running by each other, so they did even more seamlessly in planes and photography. Photography, plane and bombardment, all operating at a distance from their 'targets', made them into a quilt or collage of fields and towns one moment, and then bombed them into piles of rubble and lunar-like craters in the next moment in the ruinous landscape of warfare. 'The secrets of war are written in the air' in two senses as Virilio (1989: 75) puts it. These secrets are evanescent, insubstantial and transient, and they are only obtained by aerial observation and surveillance whether by plane or satellite. The light-writing of photography inscribes on film the ethereal secrets of war written in the air.

The aerial photography of Richard Woldendorp, Edward Burtynsky (both considered in later chapters) and Yann Arthus-Bertrand is thus the problematic inheritor of this military tradition in which the earth is rendered as flat surface, exposed for reconnaissance and intelligence, reduced to an instrumental collage of

form, colour and texture, deaf to the stories of the dwellers on the land below and deprived of the history of the land by being frozen in a synchronic moment in time. Yann Arthus-Bertrand's (2005) monumental travelling exhibition of photographs, *The Earth from the Air*, documents landscapes and human impact on the earth from the aerial point of view. This is a position of military reconnaissance that masters the land and people from above just as Woldendorp (2008) does in *Abstract Earth*. Aerial photography not only has military beginnings and applications but also is a process of abstraction. Indeed, from abstraction to militarisation is only a hop, skip and a jump. Like a map, the abstraction of aerial photography reduces the heights and depths of the earth to surface, to line, pattern, form and colour. It abstracts local place into military space. It does not get down and dirty with people. It does not engage with people living in their bioregions in bio- and psycho-symbiosis with them, though it shows these places in graphic detail from a distance.

Unlike Burtynsky (but like Woldendorp), Arthus-Bertrand does not show mining – a curious omission given that mining is one of the most visible industrial activities from the air – nor, like Burtynsky and Woldendorp, does he show people living in an environmentally sustainable way. All human activity is seen as marking the earth in pleasing patterns, and in largely destructive ways. Like Burtysnky and Woldendorp, Arthus-Bertrand aestheticises the formal patterns, shapes and colours of objects on the surface of the earth. Like Ansel Adams's monumental photography of the American West that provides a consolation to the threat of nuclear war, Arthus-Bertrand's monumental photography of the earth gives solace in the age of climate change, national disasters and earthly destruction. Just as the viewer of Adams's photographs can have his or her conservation cake and eat it too, so can the viewer of Arthus-Bertrand's by appreciating his aerial aesthetics and taking on board his cute environmental message without addressing the disconnect between the two and the politics of pictures. From the pleasing prospects of picturesque pastoral landscapes to the pleasing patterns of aerial landscape photography is not only an abstraction and militarisation of earthly space but also the transformation of the pictorial plane form the vertical to the horizontal in which the conventions of landscape painting are reproduced, which is the topic of the next chapter.

Landscape

The camera objectifies the land as landscape and in doing so renders it as a visual phenomenon for the sense of sight and as a surface for aesthetic appreciation. The land is rendered as a kind of cadaver laid out for the viewing pleasure of the explorer, settler, tourist or virtual traveller. Landscape sets up a subject–object distinction between the viewer and the viewed. It also institutes visual perception as the sole sensory relationship between them. It is a visual experience for the roaming eye/I which/who occasionally stops to take in 'the prospect' from a static viewpoint. In this chapter I consider the history and politics of the concept of landscape in relation to painting, photography and land. I then go on to draw on Michel Foucault's (1973) writing about the body and medicine in *The Birth of the Clinic*. In particular, I refer to his consideration of how the portrait of the internal surfaces of the body (living or dead) reveals the truth of disease to the clinician. I apply Foucault's consideration of the surfaces of the body to landscape and to the surfaces and depths of the land.

The representation of the internal surfaces of the body in medical discourse and anatomical illustration enables the truth of the disease to be revealed to and by the clinician. Similarly the representation of the external surfaces of the land in landscape painting and photography enables the truth about land ownership and property rights (public or private) over the land to be revealed to the viewer. Yet just as the clinician may not diagnose the causes of the symptoms correctly and

may not penetrate the underlying pathology, so the revelation of landed property in and by landscape painting and photography obscures the truth about land pathology, the unsustainable and exploitative relations between labourers and the land, and the internal processes operating in the depths of the land that made the landscape, and landscape painting and photography, possible.

Perhaps this outcome is hardly surprising given the provenance of the word 'landscape'. Barbara Bender (1993: 1–2) argues that the word 'was originally coined in the emergent capitalist world of western Europe by aesthetes, antiquarians and landed gentry – all men'. This smacks of a crude biological essentialism that determined that male aesthetes, antiquarians and landed gentry gave birth to landscape. I would suggest that rather than their biology that their adherence to masculine characteristics and practices of mastery, to capitalist values of ownership and investment and to aesthetic tastes for the sublime and the beautiful, (whether it was in art, or artefacts, or land, or all three), were all factors that gave rise to landscape. Landscape is a capitalist masculine category that explorers, colonists, anthropologists and tourists have imposed on non-capitalist cultures and lands. Recent studies of the anthropology of landscape have thus universalised a capitalist masculine category to all cultures (see Bender 1993; Hirsch and O'Hanlon 1995). The complicity of anthropology with imperialism stands revealed. Colonisation and imperialism take place culturally through the imposition of categories; they are categorical. Neither imperialism nor its avatar in tourism is possible without landscape. Landscape art, J. M. Coetzee (1988: 174) argues, is

> by and large a traveller's [and tourist's?] art intended for the consumption of vicarious travellers: it is closely connected with the imperial eye – the eye that by seeing names and dominates – and the imperial calling.

Landscape is the visible surface of the land that allows the eye the power to wander and to name places, or more precisely to rename, as the places already have indigenous names.

Landscape is on this reading and in this account, the visible and re-nameable surface of the land that renders the depths of the land invisible and mute. It is not the living and speaking depths of the land that 'working country', to reuse Raymond Williams's term, is dependent upon. 'Working country', or 'working agriculture', for Williams (1973: 118-119), is a place 'in which much of the nature is in fact being produced' and is neither portrayed nor lived as a landscape. For Williams (1973: 120) 'a working country is hardly ever a landscape. The very

idea of landscape implies separation and observation'. Landscape is an aesthetic category, a visual experience for the roaming eye/I which/who occasionally stops to take in the pleasing, picturesque prospect from a static viewpoint.

In a similar vein to Williams, landscape for Denis Cosgrove (1993: 282) is 'the surface of the physical earth, the surface upon which humans live, which they transform and which they frequently seek to transcend'. It is a surface of inscription, for aesthetics, grid-plan towns, cities, drains and railways, which obscures what he calls 'the elemental depths of the inorganic world below'. Yet the depths below are more organically productive than the surface above; the depths of the wetland are more organically productive than the surface of the dry land. Landscape reduces land to surface, to virtually two dimensions of length and breadth either in the prospect of the land lying before or in the painting of the landscape standing before one or the photography lying before one. Landscape is then in this reading the dead surface of inscription and production that denies and represses the living depths and processes of the land.

With landscape the surface of the land is set up against the self. The notion of landscape, as Veronica Brady (1998: 433) puts it glossing Judith Wright, 'implies a division between the self and the land'. The land becomes a surface against which the self poses itself, and a screen (psychological, cinematic and televisual) against which it projects its fears and desires, and from which it gains pleasure. Landscape separates subject and object. Landscape is a phenomenological and psychological category of the distinction between subject and object. For Eric Hirsch 'one concomitant of the process of ever-increasing intervention in nature was the simultaneous generation of new ideas of separation, such as that between subject and object', especially between 'the experience of a viewing "subject" and the countryside as a desirable "object" to behold', and to own. Landscape and landscape aesthetics entail separation between subject and object in the very act of seeming to join them.

Landscape is a not a category of the object itself; landscape is not a category of the land, but a category of human visual land perception. 'The landscape' is, as Wolfgang Sachs (1992: 154) puts it, 'the construct of a society that no longer has an unmediated relationship with the soil'. The concept of landscape encodes, measures and reproduces the viewer's alienation from nature. Landscape measures our distance from land. Landscape is capitalist – and by no means universal.

This distinction between subject and object is embedded in the English word 'landscape' whose genealogy has been traced by John Barrell (1972: 1–3; my emphasis; see also Barrell 1980) who relates at length how the term was:

introduced from the Dutch in the sixteenth century to describe a pictorial representation of the countryside ... Later the word came to include within its meaning both this sense and another, more loose [sense] of a piece of countryside *considered as a visual phenomenon* ... [Nevertheless b]oth these senses ... had this in common, that they referred to a tract of land, or its representation in painting, which lay in prospect – that it is to say, which could be seen all at one glance, from a fixed point of view. ... But later still [in the mid-eighteenth century], a more general meaning attached to the word, so that one could now talk of *the* landscape of a place. ... And so we can trace these stages of the word 'landscape': from first denoting only a picture of rural scenery, it comes to denote also a piece of scenery apprehended in a picture, in prospect, and finally it denotes as well land 'considered with regard to its natural configuration'. This extension of the second meaning into the third is, clearly, a most important one. It implies a change in attitude to land something like this: in the first place, a particular piece of land, under the eye is considered pictorially; in the second place, *the whole of natural scenery is considered as having, somehow, a pictorial character* ... The words 'landscape', 'scene', and, to a lesser extent 'prospect' ... demanded, in short, that the land be thought of *as itself composed into the formal patterns which previously a landscape-painter would have been thought of as himself* [sic] *imposing on it.*

Land not composed into formal patterns was not, by definition, landscape. Such land by and large was some sort of wetland, and wetlandscape was an impossibility, a contradiction in terms (see Giblett 1996, especially chapter 1). A case in point is Raymond Briggs's (1977) *Fungus the Bogeyman*, ostensibly a 'children's book'. In the upside-down, topsy-turvy world of Bogeydom 'landscapes [displayed in the National Bogey Gallery] show ditches, dead trees, sewer outflows and black stagnant lakes'. I hazard a guess that no national art gallery in the right-side-up world houses such 'landscapes'. They do house paintings depicting dismal swamps or the black waters of wetlands, but only as the setting or backdrop for, say, the story of Evangeline, or of the runaway slave, or the noble savage. Not only do the Bogey 'landscapes' *not* constitute landscapes in subject-matter and tone, but also they do not constitute a nation's view of itself and of its national territory suitable for displaying in one of its monuments to itself (see Giblett 2011).

The sad and sorry history of 'landscape' in the right-side-up world poses a problem for photography of the land that would decolonise the colonisation of the land. It has not, of course, posed a problem for photography that is complicit

with the colonial enterprise and the colonisation of land in America and Australia. Just as nature had been transformed into natural history, sex into sexuality and disease into clinical discourse, land was transformed into landscape. In all four cases, the depths of the body (of the earth, of the human being) were transformed into surface in a similar colonising enterprise of representing surfaces and reading or repressing depths. Modern medicine constructed what Michel Foucault (1973: xviii) calls 'corporal space (for example, the isolation of *tissue* – a functional, two-dimensional area – in contrast with the functioning mass [and so depth] of the organ, constituting the paradox of an 'internal surface')'. Medical bodily space or earthly physical landscape is constructed as predominantly two-dimensional because it is a construct of the gaze and because those landscapes are represented in the flat surface of either the anatomical illustration or the landscape painting and photograph. Disease and landscape are construed as surface phenomena. Both are pathologies: disease is a pathology of the body; landscape is a pathology of the land. Land pathology is Aldo Leopold's (1991: 212–217) term for self-accelerating symptoms of land disease that depart from the normal life of the land. Leopold was writing during the 'Dust Bowl' of the Great Depression of the 1930s and he was referring to soil erosion as a land pathology. Human disease for Foucault (1973: 6) is 'perceived fundamentally in a space of projection without depth. … The form in which truth is originally shown is the surface in which relief is both manifested and abolished – the portrait'. Landscape is also the surface in which relief is both manifested and abolished and the truth of landed property is originally shown. Just as the relief of the face is both manifested and abolished and the truth of individual identity is originally shown in the portrait painting and photograph (including the *carte de visite*), and just as the relief of the disease is in its 'portrait' too, so the relief of the land is both manifested and abolished and the truth of landed property shown in landscape, whether it be a piece of land seen as landscape or depicted in painting in the same period, or later in the photograph and screen, I would add. All three are flat spaces of projection without depth that reduce depth to surface in representing depth as relief.

The body and the earth, and the depths of both, are projected onto the flat surface of the anatomical illustration, the portrait, the landscape, the photograph and the screen. Time, history and temporality are also frozen in that one moment of representation, diachrony in synchrony, process in simultaneity. For Foucault (1973: 6) 'the first structure provided by classificatory medicine is the flat surface of perpetual simultaneity', or synchrony. Human disease, Foucault (1973: 9) argues, 'only exists in that space, since that space constitutes it as nature'. Nature is

constructed in that two-dimensional, flat surface and frozen moment of taxonomy, landscape painting and photography, just as the human face is in what Foucault (1973: 9) calls 'the fine two-dimensional space of the portrait', and the land is in landscape (see Giblett 2011: chapter 3). As disease is constituted as nature in the two-dimensional space of a portrait, it achieves a status and legitimacy that is difficult to argue with. Similarly classificatory thought constituted natural history as nature at about the same time, and the two-dimensional space of the landscape painting constituted (and later landscape photography re-constituted) land as landscape, as a two-dimensional space. The third dimension of the depths of the land in its living, creative processes beneath the surface of its pleasing prospects and the deadly, destructive processes of land pathology in making nature move to an arranged design, to borrow Raymond Williams's (1973: 124) words, were excluded and occluded.

Landscape painting and photography still bear the traces of the life of the land and of the land pathology that constituted the land as landscape, as aesthetic surface – despite all their attempts to exclude them. Human disease for Foucault (1973: 9), 'which can be mapped out on the picture, becomes apparent in the body'. The surface manifests the depths to some extent, just as landscape painting and photography represent the natural features of the land, however aestheticised and superficial. The landscape painter and the photographer, like the anatomical illustrator with bodily pathology, are not concerned with portraying earthly pathology in their pictures. Like the anatomical illustrator's power to depict the insides of the body and the doctor's right to speak the truth of the disease inside the body, the landscape painter and the photographer are concerned with depicting pleasing prospects and picturesque scenes that legitimate the property rights and practices of the landed gentry and obscure the labour of the other classes that made the land into landscape and the earthly processes that made the land. For Foucault (1973: 10) in medical discourse,

> the essence of the disease, with its structure of a picture, is articulated upon the thick, dense volume of the organism and becomes *embodied* within it.

The portrait of the disease is embodied within the patient to the point that the patient becomes the portrait of the disease. The portrait of the landowner on his land (one thinks of Gainsborough's *Mr and Mrs Andrews* and John Berger's (1972: 106–108) famous, published and televised reading of it) is embodied within the landscape painting to the point that the landowner becomes the portrait of the

land and the two portraits are indistinguishable with each figuring as a metaphor and metonym for the other.

The landowner, like the patient for Foucault (1973: 15), is 'the rediscovered portrait [and landscape] of the disease [and land pathology]; he [*sic*] is the disease itself, with shadow and relief, modulations, nuances, depth' like a landscape; in fact, *as* landscape. The patient becomes the portrait and landscape of disease, and landscape becomes the portrait of the power and privilege of the landed gentry, but not of its land pathology (one thinks again of Gainsborough's *Mr and Mrs Andrews*). In the same period that the body was constituted as a set of visual phenomena and visible surfaces, and subjected to aesthetic and medical examination, the land was also being constituted as landscape and nature was being constituted as natural history, as a conjunction of subject and object wherein the former is a seeing eye/I/subject and the latter a seen it/object in all three. As such, Foucault (1973: 121) argues that 'the whole dimension of analysis is deployed only at the level of an aesthetic' because it only takes place on the surface. Foucault (1973: 19) argues earlier that 'the space in which disease is isolated and reaches fulfilment is an absolutely open space, … reduced solely to the plane of visible manifestations', just as land and natural beings were being reduced to the same sort of plane, but without land pathology being isolated and land reaching fulfilment in an absolutely open space. Rather land pathology was concealed beneath the plane of visible manifestations, confined to the plane of the largely invisible and reduced to the traces of the labour of humans and other beings and processes – animal, mineral and vegetable – that made and remake the land.

Disease and landscape are read on the plane of visible manifestations, not on the level of invisible latencies. The bodies of the patient and the earth become text, the texts of the body and the earth, surfaces of inscription for the law to be read, and not depths of traces to be lived. Foucault (1973: 59) argues that 'it is "the different diseases that serve as the text": the patient is only that through which the text can be read'. The patient is a means to an end, a way to read the text of the disease written in and on their body, and landscape is a means to read the text of the land in the terms of the landed gentry, and not in the terms of land pathology. Doctors, according to Foucault (1973: 89), 'botanize in the field of the pathological', just as the natural historian botanised in the lands of the colonial and geographical, the landscape painter and the photographer illustrated the landscapes of the aesthetic and the *flâneur* botanised on the macadam of the boulevards. Natural history, landscape painting, landscape photography and the medical clinic all employed the gaze to classify the features of the natural and of human beings according to

their visible characteristics and to lay them out on the surface of representation (Foucault 1973: 89).

The medical gaze for Foucault (1973: 135) travelled 'vertically from the symptomatic surface to the tissual surface; in depth, plunging from the manifest to the hidden'. Similarly with landscape aesthetics, the photographic (and later cinematic) gaze travelled from one surface to another, never into the depths, or more precisely never into the depths of the body and the life of the land, only into the metaphysical depths and distance between the latent and the manifest that was not open to the gaze only to surmise, infer and diagnose, the metaphorical 'gaze' or insight (one thinks again of *Mr and Mrs Andrews* with their gazes addressed pugnaciously towards the viewer who is invited to meet them, and perhaps reciprocate in kind in viewing them and their land just as pugnaciously as a set of surfaces like a series of theatre backdrops without depth). Just as the medical eye for Foucault (1973: 136) must 'see the illness spread before it, horizontally and vertically in graded depth', so the landscape eye (including its prosthesis in the camera) must see the body and the land in the same way either raised vertically and erect in front of it in the sublime heights, or spread out horizontally and supinely before it in the pleasing prospects of picturesque surfaces (*Mr and Mrs Andrews* again).

At the end of the eighteenth century the doctor, Foucault (1973: 136) goes on to argue, began to 'perceive what was behind the visible surface … and to map the disease in the secret depths of the body'. At the same time though, the landscape painter (Gainsborough with *Mr and Mrs Andrews*, yet again), and later the landscape photographer (Ansel Adams), represented the visible surface of the land and inscribed the surface of the land without anything much being perceived behind or below it in the secret depths of the earth. The landscape painter, and later the landscape photographer, did not map land pathology in the secret depths of the body but glossed over it in at least two senses. Indeed, Williams (1973: 118) shows how the strongest feeling for the aesthetic and other pleasures of nature in the country were evinced precisely when agrarian capitalism was making its strongest and most irreversible inroads into reshaping the countryside. At the same moment and, indeed, in the same breath and stroke of the brush and pen, and in the sighting of the camera and eye, as nature was being aestheticised, nature was also being exploited economically by hand, tool and machine (*Mr and Mrs Andrews*, not again, and Ansel Adams). The former was a compensatory and disavowing device for the latter.

It was only a century or so after the heyday of landscape painting, but in the heyday of landscape photography, that conservationists, such as Aldo Leopold in the 1930s, diagnosed land pathology. The dead surface of the landscape painting (*Mr and Mrs Andrews*, oh yes, again) and photograph (Ansel Adams) did not make entry possible into the living body of the earth, both like and unlike the autopsy that allowed penetration of the gaze into the depths, on the one hand, of the body, and into the depths, and truth, of the disease, but not into the depths of a living body on the other. Truth lay in the depths, whether it was in dead or living bodies, but it was only manifested and readable on surfaces and in death, not in depths and in life.

Instead of surface, and only relief, depth was added, but only in death. Instead of the landscape of the surface of the body in painting and photography, the depth of the land or the body, and disease, was added, but only the depths of a dead body. Death in eighteenth century medical thought, Foucault (1973: 140) argues, was a truism of both 'the end of life … and also the end of the disease'. Whilst, on the one hand, the truth of the disease was revealed and its course run, on the other, the course of disease and life were only manifested in death. The patient died so the truth of the disease could be manifested; the earth died so the truth of landed property could be manifested. The patient's body and the earth's body were a vehicle and vector for death. Death was the master term for both life and disease, just as the machine made of dead matter was the modern master trope for both the body and the earth (see Giblett 2008a) and for both medicine and politics (see Foucault 1977: 136).

Yet disease in eighteenth-century medical thought, Foucault (1973: 149) goes on to argue, was figured in terms of the land (not machine):

> from the point of view of death, disease has a land, a mappable territory, a subterranean, but secure place where its kinships and its consequences are formed; local values define its forms.

Similarly land pathology has a land whose forms are defined by local values, good and bad, beneficial or harmful. But just as the land of disease opened up by the autopsy is dead, a wasteland, so the land of land pathology is a wasteland. In the eighteenth-century view of disease, the premodern medical mutual trope of the body as land and land as body was repressed into service and made to contend with the by then dominant modern medical master trope of the body as machine. Both views contended in the work of Leonardo da Vinci for whom the body is

both machine and land, and whose work is on the cusp of the transition from the premodern trope of the body as land to the dominant modern Cartesian trope of the body as machine (see Giblett 2008a). In figuring disease as land, the body and the land were seen as dysfunctional, as potentially leading to death, and not as healthy.

The land of land pathology is a wasteland and the wastelandscape photographers are photographers of land pathology. Although the land of land pathology and of wastelandscape photography is not a landscape of surface but shows destructive processes and depths, it is not a living body, just as geology and geography are an autopsy of dead land, and botany and zoology are taxonomies of dead beings, not appreciation for the living body and bodies of the earth in and by many senses, not just sight. Autopsy, anatomy and taxonomy represent the dead living body in the dead, two-dimensional surface of text, illustration and display cabinet, just as landscape photography represents the dead living land in the dead, two-dimensional surface of the photograph.

The surface of wastelandscape photography, for instance that of Edward Burtynsky's minescapes, portrays and betrays the lengths and depths that mining goes to in its greedy lust for resources of ore (see Giblett 2011: chapter 9), just as landscape and portrait painting and photography reduce depth to surface, diachrony to synchrony, life to death (see Giblett 2011: chapter 9). Rather than greed and gluttony characterising the relationship of human to the earth, gratitude for the generosity of the earth acknowledges and cares for the earth as living being (see Giblett 2011: chapter 9). Photographic appreciation of and respect for the living body of the earth, for its depths and processes, is what I call photography for earthly symbiosis (to which I turn in the final chapter). By contrast, classic landscape and wilderness photography, for instance that of Ansel Adams, has been in the business of recording the surfaces and products of the earth in what could be called photography for earthly sublimation in which the depths and processes of the earth are sublimated into the sublime heights of the mountainous (to which I return in chapter 5). Landscape and wilderness photography has operated under the sign of the sublime for some time. The sublime is the topic of the next chapter.

CHAPTER 4

The Sublime

The sublime is such a standard, but loosely used, term in the vocabulary of landscape aesthetics in painting and photography that it is worthwhile making a brief excursus to discuss its history and meanings, especially as the dictionary does not have the space to do so and as it is used in some of the chapters below. The sublime is often considered to be one of the three major and legitimate modes of representation in landscape aesthetics along with the beautiful and the picturesque (see Giblett 1996: chapter 2; 2011: chapters 3 and 4).

The earliest extant writing on the subject of the sublime in the western tradition is the treatise 'On the Sublime' attributed to Longinus (1965). It is believed to have been written in the first century of the common era. In it 'Longinus' enumerates a number of qualities of the sublime. Let me list them. The sublime for 'Longinus':

exerts 'an irresistible force and mastery' (100) (and thus can be considered masculine);

it 'scatters everything before it like a thunderbolt' (100);

it reveals in a flash 'the full power of a speaker' (100);

it 'uplifts our souls' (107);

it fills one with 'a proud exaltation' (107);

it is associated with a sense of 'vaunting joy' (109);

in it 'a noble emotion forces its way to the surface in a gust of frenzy' (109);

it involves 'the production of grand ideas, perpetually impregnating them with a noble inspiration' (109);

it involves catching fire from the inspiration of others (119);

it impregnates one with heavenly power (119);

it inspires one to speak oracles (119);

and it carries one up close to the majestic mind of God (147).

Although many of these qualities associated with the sublime are conveyed by rhetoric in speech, they are also evoked by Ansel Adams's photographs of mountainous landscapes, though the divine aspects are linked with the landscape itself, if not with nature and the nation of the United States.

In the eighteenth century the philosophers Burke and Kant take up and develop the concept-metaphor of the sublime, especially in contrast to the beautiful. For Burke (1958: 57) the sublime is a delight that turns on pain. As the Divinyls say, 'it's a fine line between pleasure and pain'. The sublime for Burke also causes astonishment, 'that state of the soul in which all its motions are suspended with some degree of horror', though for Burke (58) the ruling principle of the sublime is terror and for Kant (1952: 120) the astonishment of the sublime amounts almost to terror. Both Burke and Kant distinguish the sublime from the beautiful. For Burke, the sublime dwells on great and terrible objects, whereas the beautiful dwells on small ones and pleasing (113). In these terms Ansel Adams's photographs of monumental mountains are sublime whereas floral photography is beautiful. Similarly for Kant,

the sublime must always be great; the beautiful can also be small. The sublime must be simple; the beautiful can be adorned and ornamented.

Whereas the sublime has, or is associated with, a broken and rugged surface, the beautiful for Burke has, or is associated with, a smooth and polished surface (114). In these terms, Ansel Adams's photographs of rugged mountains are sublime whereas the smooth pools in Carlton Watkins's photographs are beautiful. For Burke, whereas the sublime concerns or represents vast objects, the beautiful, comparatively small objects. Whereas the sublime is dark and gloomy, the beautiful

is not obscure (124). Whereas the sublime is founded on pain, the beautiful is founded on pleasure and acts by relaxing the solids of the whole system and so is the cause of all positive pleasure (149, 50).

Kant not only distinguishes the sublime from the beautiful like Burke, but also distinguishes between two aspects of the sublime. One of these aspects he calls the dynamically sublime. This aspect of the sublime is the process whereby 'nature, considered in an aesthetic judgement as might that has no dominion over us' (109), 'reveals a faculty of estimating ourselves as independent of nature, and discovers a pre-eminence above nature' (111) in the realms of the transcendental and the extraterrestrial. Indeed, for Kant, the dynamically sublime is the means by which we 'become conscious of our superiority over nature within and thus also over nature without us' (114), over the immanent. The sublime photographs of Ansel Adams make the mountainous safe for consumption in a coffee table book.

By contrast with the dynamically sublime, the mathematically sublime for Kant is the ideas of reason considered in a reflective judgement as might that *does* have dominion over us. It reveals a faculty of estimating ourselves as inferior to the ideas of reason and discovers a preeminence above 'us': 'it represents our imagination in all its boundlessness, and with it nature, as sinking into insignificance before the ideas of reason' (105). The mathematically sublime reveals a faculty for considering not only 'ourselves' but also nature as inferior to the ideas of reason in the realms of the ideational and the rational above, as it were, the transcendental and extraterrestrial. This aspect of the sublime is especially important when considering the history of communication technologies, including photography, as they involve transcending the earthly into the extraterrestrial. From the railway and the telegraph to the satellite and space, the history of communication technologies testifies to this process of transcendence of the terrestrial into the extraterrestrial (see Giblett 2008b).

The 'double mode of representing an object as sublime' (94), as Kant called the mathematically and dynamically sublime, sets up a hierarchical triangulation with the ideas of reason as the privileged term and nature as the denigrated term with 'ourselves' as the mediating term. The mathematically sublime sets up the superiority of the ideas of reason over nature and 'ourselves' whereas the dynamically sublime sets up the superiority of ourselves over nature. On the one hand, 'we' can feel independent of and superior to nature within and without as represented in landscape photography, and on the other hand inferior to the ideas of reason along with nature. 'We' and nature are put in our place vis-a-vis the ideas of reason and 'we' put nature in its place vis-a-vis 'ourselves' and the ideas of reason.

The philosophy of the (mathematically and dynamically) sublime underpins and enables idealist, rationalist mastery of nature.

The concept of the sublime is thus central to western aesthetics, especially in the modern period. Indeed, modern aesthetics for Jean-François Lyotard is 'an aesthetics of the sublime'. Yet the concept is not of merely aesthetic interest but has a wider cultural pertinence to modernity in general and to the role of communication technologies in particular. Lyotard (1989: 199) goes on to remark that 'around the name of the sublime modernity triumphed', not least over 'nature'. Given the centrality of the sublime to the project of modernity, it is hardly surprising to recall that the concept was important for Marx and Engels. In the *Communist Manifesto* Marx and Engels used the metaphor of sublimation drawn from chemistry to argue that in bourgeois capitalism 'all that is solid melts into air'. This phrase has since been taken up by Marshall Berman (1983) to encapsulate the etherealising project of modernity in which the solidities of pre-capitalist social formations evaporate into thin air, not least in and with communication technologies (though Berman only mentions these in passing), including photography (as discussed in chapter 1 above).

The Established Tradition of Landscape Photography

ROD GIBLETT

CHAPTER 5

American Landscape and Wilderness Photography

Photography developed in the heyday of imperialism and during the heightened development of the settler societies of Australia and the United States. Landscape photography played a role in both societies in forming and maintaining a sense of cultural and national identity in relation to the lands that they settled in and from which they dispossessed indigenous owners and inhabitants. The aesthetic modes of the sublime and the picturesque were instrumental in furthering these processes by rendering the land 'settlable' in photography and in fact. American landscape and wilderness photography has lived under the aegis of the aesthetic, and in particular under the twin signs of the sublime and the picturesque, for some time.

In this chapter I trace the genealogy of three major American landscape and wilderness photographers and the use by two of them of aesthetic exemplars from the tradition of European landscape painting. In particular, I consider the applicability of the concepts of the sublime and the picturesque to American landscape and wilderness photography. I argue that Ansel Adams' photographs of towering mountains and plunging canyons are major expressions, exemplars and evokers of the sublime in photography. The sublime involves the depiction

of formless and uplifting spectacles and produces feelings of awe and terror. By contrast, Carleton Watkins's photographs of monoliths and mountains reflected in still lakes at their base express the picturesque in photography. The picturesque presents well-formed depictions of serene scenery and produces feelings of pleasure.

Adams and Watkins reproduced from landscape painting the aesthetic categories of the sublime and picturesque and its capitalist politics of land use. Characterising the work of these two photographers in these terms is not merely of formalist or taxonomic interest but has profound political import for the ways in which land and landscape are seen and commodified even today. Whilst this tradition has been dominant, there have been some photographers who have deviated from it, such as Timothy O'Sullivan whose photographs of chasms and fissures evoke the uncanny. This produces an anti- or counter aesthetic of the uncanny in photography that threatens to swamp and engulf the capitalist enterprise in landscapes and lands that are not commodifiable. The uncanny has a vague form and is both fascinating and horrifying. The successors of all three photographers in the New Topographics and nuclear landscape photographers photograph wastelands across all three modes of the sublime, the picturesque and the uncanny (for these three modes see Giblett 1996: chapters 1 and 2; 2011: chapters 3 and 4).

The principal place all three of these photographers have depicted in photography is the American West. In the West, Martha Sandweiss (2002: 2) argues, 'nineteenth-century American photography found its most distinctive subject'. In the twentieth century American photography continued to retain its most distinctive subject, or object, in the West, though its nature changed in the process from the national landscape to the nuclear landscape. The American West and photography were not only made for each other, but also for Eva Respini (2009: 10) 'came of age together'. The West, Sandweiss (2002: 3) suggests, 'is a fabled place of fantastic topography, exotic people, the place where the nation's future would unfold'. In both spatial and temporal terms, it was the ideal place to represent photographically and for the evolving technology of photography to develop in. As a result, American photography for Sandweiss (2002: 154) 'would realize its most compelling and distinctive subject' in the West, not only in the nineteenth century but also in the twentieth. The western landscape was the American future stretched out before it in pleasing prospect in both the spatial and temporal sense in the age of exploration, only to become a terrifying prospect in the nuclear age.

Ansel Adams

Just as John Muir is a monumental figure in the American conservation movement (see Giblett 2011: chapter 7), so Ansel Adams for Eva Weber (2002: 14) is 'a figure of towering stature in the history of photography'. She goes on to call him 'America's greatest landscape photographer of the twentieth century'. Besides sharing monumental status, Adams and Muir shared in common a landscape aesthetic of the monumental and a conservation agenda, though there were some differences between them. Adams was a long-time member of the Sierra Club that Muir helped to found and that he presided over for many years. Not just a conservation organisation, the Sierra Club for Rebecca Solnit (2007: 235) 'put the aesthetic to political use in a way no other environmental group had'. The Australian Wilderness Society followed suit with no regard for the politics of pictures, and the politics of aesthetics (see Chapter 7). William Turnage (1990: 10) describes Adams in his introduction to a collection of Adams's (1990) photographs of *The American Wilderness* as 'a kind of visual Muir'. This applies to Muir of the mountainous wilderness, and not to Muir of the marsh and swamp wilderness and his encounter with an alligator in Florida (see Giblett 1996: chapter 10; 2009: chapter 2). Weber (2002: 15) argues that Adams's 'underlying motivation' for his Yosemite photographs 'came to parallel the ideas of John Muir'. Or more specifically, Adams's motivation for his Yosemite photographs paralleled Muir's ideas about Yosemite. For Garrard (2004: 69), 'Muir wrote the book but Ansel Adams took the pictures'. This applies specifically to Muir's mountain books, and not his swampy one.

Adams was putting the sublime words of John Muir into pictures that expressed and evoked the sublime. Or more precisely, he put some of Muir's words into pictures. Simon Schama (1995: 9) argues that Adams 'did his best to translate his [Muir's] reverence for nature into spectacular nature icons'. Muir's reverence for nature was couched, however, in two distinct vocabularies: an earlier one produced by his experience in the marshes of Canada and swamps of Florida and a later one in the mountains of the Sierra (see Giblett 1996: 240–241; 2011: chapter 7). Adams translated Muir's reverence for mountains into spectacular nature icons whereas wetlands are neither iconic nor spectacular. Adams did not translate Muir's reverence for marshes and swamps into pictures with one notable exception (my favourite, entitled 'The Black Sun'). Adams's photographs arose out of him experiencing, what Weber calls (2002: 16), 'the high-altitude epiphanies of nature's cosmic unity as described by Muir'. More specifically, Muir described these in his

later life whereas in his earlier life he described the experience of the low-altitude exigencies of nature's grotesque fertility in the native quaking zone of marshes and swamps. Muir was not only a believer in the God of the mountains and the national parks, he was also a follower earlier in his life of the Great Goddess of the wetlands when he went draft-dodging into Canadian marshes where he had a conservation conversion experience with an orchid and later trekking into Floridian swamps where he had a biocentric encounter with an alligator. Adams did not photograph these wetlands, or many others for that matter. As he did not follow Muir into these marshes and swamps, he was a selective follower of Muir and an incomplete illustrator of his words. He did not photograph any wetlands, with one possible exception, but concentrated in his landscape or 'wilderness' photographs on the monumental mountainous and the stunningly sublime, though he did also take some photographs of the small and beautiful. Adams for Jussim and Lindquist-Cock (1985: 22) 'presents us with the towering mountains and sweeping vistas we would tend to associate with a God of sublimity'. They refer to his famous photo 'Clearing Winter Storm, Yosemite National Park' (1944), as an illustration of this point (see Figure 1). The title combines references to the season, weather and place. Each aspect of the title and composition is equally important in the photograph's evocation of the sublime (which relates to the sublime season of winter, to the stormy weather, to the mountainous cloudscape and landscape, and to the hard and rocky place).

Muir eventually became known as the 'father of the American national parks', or at least of the idea for them (Giblett 1996: 240; 2011: chapter 7). Adams is the photographer par excellence of the American national parks, or more precisely national parklandscape (and not wetlandscape). Just as the national park is a nationalised and nationalist landscape (see Giblett 2011: chapter 8), so photographs of them enshrine and display nationalism. Weber (2002: 21) argues that

> according to Adams, this magnificent scenery [in the West and southwest] was a symbol of what the United States was fighting for in World War II – a demonstration of America's 'scope, wealth, and power'.

Lands (ecosystems and habitats) were thereby aestheticised, conscripted and militarised, and so their value in their own right, and their right to be conserved as such, was diminished. National parks were an expression and institutionalisation of 'nature's nation' and Adams was 'nature's nation's photographer', just as Muir was 'nature's nation's philosopher'. By taking classic landscape photographs depicting nature 'in its grand, primordial, and spiritually uplifting aspects', as Weber (2002:

21) puts it in Muiresque (and sublime) terms, Adams was neglecting nature in its humdrum, mundane and physically demanding aspects, including the stuff of work and everyday life. Adams thereby 'helped to define the emerging environmentalist movement' generally, but specifically as sanctuarist, as conserving special, sublime places of recreation and visual consumption, rather than as caring for all places of life and work imbued with sacrality (for the sanctuarist/sacrality distinction, see Giblett 2011).

Adams's mountain photographs are also sublime in the sense that they sublimate the land into landscape, into aesthetic object, the depths of the land into pictorial surface, and into a commodity as he was a professional photographer. Alinder (1985: 17) argues that

> the subjects of these [mountain] photographs are enhanced by visualization to portray a landscape that is *beyond the limits of human experience*. Yet because they are photographs, one accepts the print as true. They are not true to fact, but faithful to Ansel's reverential ideal of nature and of a pure, unspoiled America (my emphasis).

Although Adams and his photographs can be credited with helping to 'save' or conserve vast areas of 'wilderness', this is a compensatory and disavowing device for the exploitation and destruction that was taking place everywhere else. Turnage (1990: 13) argues that 'Adams's life spanned [1902–1984] the most progressive and productive period of nature preservation in human history'. Unfortunately it also spanned the then most regressive and destructive period of nature exploitation in human history, only to be sadly surpassed by the more recent period. This contradiction lies at the heart of our hypermodern condition, especially around the American nation and corporation as the armature of both sides of the contradiction. Nature, nation and corporation meet in the national park. Adams and his work are a useful entrée into this contradiction as he was lionised, not only as a nature conservationist and wilderness photographer, but also as a native son and true patriot. With Adams's photographs, its national parks and wilderness, America could have its conservationist cake and eat its nature cake as well. In other words, it could conserve 'vast tracts of wilderness' whilst ruthlessly exploiting nature everywhere else. It preserved, painted and photographed nature in Yosemite National Park and at about the same time bombed it just over the Sierra Nevada mountain range in the Nevada Test Site in about the same latitude (as the map in Solnit 1994/1999: viii–ix shows, and as discussed below in chapter 7).

Carleton Watkins

Although Carleton Watkins, Adams's nineteenth-century precursor, did not photograph swamps and other wetlands, his views of the mountainous are not as monumentalist, nationalist and sublimatory as Adams's were (if it is possible to quantify these qualities). Although Adams is seen as the direct descendant of Watkins, there are some fundamental differences between their photographs. Watkins is regarded as 'America's greatest landscape photographer of the nineteenth century' (Weber 2002: 67), as 'the founder of the major photographic tradition of landscape on this [North American] continent' (Solnit 2003: 45) and as 'arguably the [American] West's first renowned landscape photographer' (Respini 2009: 12). His most famous photographs of the sequoias and Yosemite were taken during the Civil War and were instrumental in having Yosemite 'set aside' during the war as what Schama (1995: 191) calls 'the world's first wilderness park', though 'wilderness park' sounds oxymoronic. More commonly, it is usually described as 'the world's first national park' (Solnit 1994/1999: 221; see also Giblett 2011: chapter 8). Yet Yosemite was not only set aside during the Civil War but was the result of a previous uncivil Indian war. Before it became a national park, it had been a battlefield in the war against the local indigenous owners and inhabitants in 1851 from which the losing side was progressively removed and the history of this war erased. Yosemite, as Solnit (1994/1999: 222) argues, 'was a battleground before it was a vacation destination'.

Between being a battleground and a vacation destination, it had become a work of art. In fact, to become a vacation destination, it first had to become a work of art. Yosemite, as Solnit (2007: 28–29) puts it, 'would become the great national shrine of nature as a work of art', initially for landscape painting and then later for landscape photography. No place on earth for Solnit (1994/1999: 222) 'is more central to landscape photography and landscape preservation'. The national park is a landscape preserve, rather than a conservation reserve. It is usually set aside for aesthetic reasons (see Giblett 2011). Yosemite, Solnit (1994/1999: 263) argues, 'has been preserved as though it were a painting'. It has not been preserved as if it were a battlefield, though a battlefield should be regarded as a landscape (see Giblett 2009: chapters 4 and 5). Landscape, for Solnit (2003: 80), 'should have been revised a long time ago to include battlefields'.

In *Landscapes of Culture and Nature* (Giblett 2009) I undertake that revision with the inclusion of the battlefields of the Indian Wars, the American Civil War, World Wars I and II, the Cold War and '9/11'. In *Photography and Landscape* I show that landscape photography did include battlefields as shown in the long history from Brady and O'Sullivan and the American Civil War, through Frank Hurley and the World War I, through Richard Misrach and the Cold War to Joel Meyerowitz and the War on/of Terror. Landscape photography did not need to be revised to include battlefields as it had already included them; it is considerations of landscapes from an aesthetic and historical point of view that needed to be revised to include them. From the military point of view, landscapes of the battlefield have been an important part of war for a long time; from the art history point of view, the battlefield has not been an important aspect of landscape for long, yet from the landscape photography point of view, photography of battlefields has long been included; from the critical cultural history point of view, battlefields, bomb-sites, national parks, wastelands, cities and swamps are all landscapes.

Adams acknowledges his predecessor in Watkins who was for Solnit (1994/1999: 237) 'the most widely acclaimed landscape photographer of his day'. Adams (1985: 149) in his autobiography acknowledges that 'Watkins' photographs of Yosemite had great positive effects on the efforts that made Yosemite Valley a state park in 1864'. He included some of Watkins's photographs in the exhibition he mounted in 1940 for the Golden Gate Exposition 'to represent all of creative photography since its beginnings' (Adams 1985: 204). By choosing angle, location and composition (especially framing devices and the mid-point in the frame for the meeting of the reflection and its object in his photographs of lakes and peaks), Watkins created picturesque photographs.

Watkins also showed an interest in trees, which may not have elicited any fellow-feeling in the mountain-loving Adams. Trees also lend themselves more to the picturesque, whereas mountains incline to the sublime. Schama (1995: 190–191) argues that

> more than any other images, Watkins's heroic prints shaped American sensibilities towards Yosemite and the Big Trees [the 'Grizzly Giants'] … Yosemite became a symbol of a landscape that was beyond the reach of sectional conflict, a primordial place of such transcendent beauty that it proclaimed the gift of the Creator to his new Chosen People … Yosemite and the Big Trees constituted an over powering revelation of the uniqueness of the American Republic.

The horrors and the deprivations of the Civil War and its aftermath in post-war reconstruction prompted a displacement of the drive to mastery, the will to power, from the intractable enemy with which one was locked in mortal combat in the Civil War to the conquerable primitive landscape and to a sublime place symbolising the ideal of national reunification and 'the rebirth of the American nation' as Sandweiss (2002: 43) puts it. One of the means of taming the great western wilderness and conveying the sublimity of the place was through landscape photography.

One way to resolve and salve the conflict of the Civil War was by looking to, and at, the West as a place that, as Sandweiss (2002: 57 and 156; see also 73 and 180) also puts it, 'stood above the sectional strife of North and South', and so could be seen 'as the site of national healing and reunion'. To do so, the traditional Amerindigenes had first to be removed from the land and from landscape photography and to be portrayed in portrait photography. They had ceased to be owners and inhabitants of the land and had become ethnographic curios encased in portrait photography. Immigrant settlers of the American West were photographed in situ on the ranch or farm with the land as backdrop. Up in the mountains was largely an unpeopled landscape. Yet Watkins's landscape photographs are not of an unpeopled wilderness, unlike Adams's slater photos of 'the American wilderness'. Yet Adams did photograph people as the Weber book demonstrates, though they tend to be abstracted from place, unlike Watkins who photographed people situated in a landscape.

Just as the Civil War was the nationalist impetus for the declaration of Yosemite as a state park and for the national park movement, and national parks were the place Adams depicted in World War II as patriotic landscapes, so was the Cold War the driving nationalist force behind the wilderness movement (Hammond 2002: 128). The American wilderness was the American domain where the American scene could be seen and contemplated in all its glory and where the American idea could be maintained. These were bulwarks against, and consolations for, the threat of thermonuclear war with the Soviet Union. They were also the place where both the might of America (the land, the nation) was displayed and the land wasted in the testing of nuclear bombs. America displayed its power both to conserve by setting aside land and to destroy it by wasting its own lands. Rather than being conservation sites, both national parks and wilderness are landscapes of warfare because they are places where the nation sought solace, and its national identity, against the threat of war and where it could display its national vigour and power. Adams's taste for what Bright (1989: 129) calls:

the picturesque sublime [was inherited] from nineteenth century European and American painting. This aesthetic was premised on an identification between a mythical Eden and the American landscape and was well suited to the conservative social climate of post-World War II United States basking in its reborn Manifest Destiny as a world superpower.

This aesthetic was also well suited to dealing with the threat of nuclear war in the terror of the Cold War. The West was the place where the United States displayed, and could enjoy, its nationalist might. Just as the United States colonised the West under the doctrine of Manifest Destiny, it could now colonise the world under the same doctrine and use the West as the marker of its power, power to both conserve and destroy, as well as to aestheticise. The doctrine of Manifest Destiny still lives on as former Vice President Al Gore (2008: xix) recently suggested in a conservation call to arms to his fellow Americans that it is 'our ultimate manifest destiny to save the earth'. This is like asking the fox to save the chickens.

Adams was a twentieth-century photographer of this nationalist sublime whereas Watkins was a nineteenth-century photographer of what Mary Warner Marien (1993) calls the corporate sublime. Hambourg (1999: 12) notes that 'the vision of industry comfortably enveloped in nature was an important aspect of Watkins's relation to the world'. Nature and industry were shown in these photographs to be organically harmonious. They were acting out what Leo Marx calls the vision of 'the machine in the garden', or the 'pastoro-technical idyll' of machine and nature in harmony (see Giblett 2008b: 22). There are strong links here with what Marien (1993: 34) sees as the 'commercial or corporate sublime' in Watkins's work by which she seems to be referring to his aestheticised, panoramic photos of industrial landscapes. For Nickel (1999: 20) 'Watkins's subject as a whole was never really "nature" so much as it was "natural resources and their development"', including scenic resources for tourist development I would add. The commercial and corporate sublime of the industrial park landscape of the west is not that far removed culturally from what Marien (1993: 30) calls 'Watkins's soaring sublime' of the national park landscape of the west, especially of Yosemite.

There are certainly sublime elements in Watkins's photography of Yosemite, but (if it is possible to quantify it) they are not as markedly sublime as Adams' I would suggest that Watkins's photos of Yosemite fall into two distinct categories: those taken of mountains or rocks from their base (Nickel 1999, plates 20, 21, 23, 25, 26, 27, 33, 35 and 37); and those 'views' taken from an elevated position across valleys (plates 29, 30–32, 38, 39 and 41). In the former the foreground leads the eye to

the rock or mountain that rises in the background as a backdrop. In the latter the foreground is limited and the valley stretches out before one in panoramic prospect as it does in his industrial landscape panoramas. In all of Watkins's photographs the sky is limited and there are no clouds, unlike Adams who seems to have been fascinated by them as a kind of extension or transcendence of the sublime below in the mountains (and so on earth – however high) into the sublime above in the heavens. Both categories of Watkins's Yosemite photographs are picturesque rather than sublime. Let me illustrate.

One of his most famous photographs is 'Washington Column, 2052 ft., Yosemite' (see Figure 2). Oliver Wendell Holmes commented on this photograph in 1863 that the hilltops are photographed 'not as they soar into the atmosphere [as Adams later did], but as they are reflected in the calm waters below'. This is not a sublime landscape in which the solid is sublimated into air or gas, but a picturesque landscape in which the solid is de-sublimated in the liquid waters below. The exact horizontal centre-line of this photograph is where earth and water meet. The centre of attention is the point of reflection between the mountain and the lake, and not the mountain towering terrifying above the viewer, nor the lake stretched out supinely before the viewer. Joel Snyder (1994: 183) suggests that 'Watkins's fascination with the mirrored surface of Lake Tenaya is emblematic of his rhetorical posture as a photographer. He views his job as the fixing or recording of an evanescent reflection of physical reality and not as the construction of an idealised landscape' – unlike Adams I would add. Unlike the sublime, which smacks of eternity (infinity in time), the picturesque quality of Watkins' photograph conveys temporality (a moment in time). Landscape (painting, photography and a piece of land viewed as landscape) is as much a matter of time as of space, as the double spatial and temporal meaning of 'prospect' suggests (see Giblett 2011: chapter 4). Landscape is not only a 'land-scape' of the surface of a place in space but also a 'time-scape' of the colonisation and commodification of the past, present and future (see Giblett 2008b: chapter 1; 2009: chapter 9). Both the time-scape and the space-scape stretch out before the viewer either pleasingly or displeasingly.

Using water as a means of reflection on a landscape, on oneself and on one's position and situation in it has been a trope in art and literature of the western cultural tradition for a very long time, going back at least to Narcissus who fell in love with his own reflection in a pool of water as if it were of another person and not of himself. Water, Novak (1980: 40) notes, has 'a special significance in American landscape painting', and in American landscape photography I would add, 'unifying both surface and depth in its reflection of the world above'. Watkins's

photograph is no exception as it reflects the heights above and represses the depths below, rather than unifying them (as Luce Irigaray argues (see Giblett 1996: 7)). Watkins's photograph is not sublimatory; it is repressive. The calm, enamelled surface of the water reflects what is above and does not convey what is below. It is impenetrable, not permeable. It inverts the sublime rather than deconstructs it.

Timothy O'Sullivan

Timothy O'Sullivan's photographs do not fit easily into any aesthetic category, especially those of the picturesque and the sublime.[1] For this reason, and for the reason that he was also attached to exploratory and surveying expeditions as a documentary photographer, his work is often categorised as scientific photography. The categorisation of O'Sullivan as a documentary photographer partly boils down to the fact that his photographs are often anti-aesthetic, and in a two-term system of science versus aesthetics, the anti-aesthetic quality of some of his photographs place them ineluctably in the realm of the scientific. If this binarism is abandoned in approaching his photographs and other categories and terms are invoked, his photographs can be read in much more nuanced and productive ways.

O'Sullivan is regarded by Respini (2009: 11) as 'the most celebrated' of the photographers attached to these scientific expeditions and his work is seen by Jurovics (2010: 9) as 'one of the most important and influential photographic accounts of the American interior'. For Robert Adams (1994: 149), O'Sullivan is the greatest of what he calls the nineteenth-century photographers of 'landscapes of space' because he was 'interested in emptiness, in apparently negative landscapes, in the barest, least hospitable ground' (150). Joel Snyder (1994: 191), while subscribing to the scientific view of O'Sullivan's photographs, describes them in terms that resonate with Adams's photographs. He describes how O'Sullivan's photographs of the Great Basin of southwestern United States 'portray a bleak, inhospitable land, a godforsaken, anaesthetizing landscape' that 'verge upon being anaesthetic – they stun and they numb' (1981: 49). They even portray an anti-aesthetic landscape that could be summed up in one word – wilderness (see Giblett 2011).

In his earlier book on O'Sullivan, Snyder (1981: 7) places O'Sullivan's photography firmly in and of the wilderness. O'Sullivan for him is a photographer of the area beyond the frontier. This placement is conveyed not only by the title of the book (*American Frontiers*), but also by the opening sentences of the book

in which Snyder describes how 'O'Sullivan crossed the frontier in 1867' and 'left it for the last time in 1874'. In the intervening seven years he produced over one thousand photographs of what Snyder calls 'an immense, unknown region of the American wilderness'. Unknown for whom is an interesting question because this region from the Missouri River to the eastern slopes of the Sierra Nevada and from the Mexican border to the Canadian border was not unknown to, for and by the Amerindigenes of the mega-region. This region is constituted not only as unknown, but also as a landscape that Snyder calls 'unmarked, unmeasured and wild'. In other words, it is unmapped, unsurveyed and untamed. It is constituted as 'un-', by what it is not, not by what it is, the home of the plains, prairie and desert Amerindigenes. This is part of the point of the concept of wilderness – to make the unknown known, to map the unmapped, to survey the unsurveyed, to tame the wild, to make meaning out of the meaningless (see Giblett 2011: chapter 5).

In both his earlier book and later book chapter on O'Sullivan, Snyder (1981: 46 and 1994: 195) comments on the grotesque elements in O'Sullivan's photographs. In particular, he describes how one photograph, 'Geyser Pool, Ruby Valley, Nevada' (see Figure 3), shows a man lying at 'the mouth of a grotesque vent in the ground'. Snyder (1981: 46) argues that 'the mode of juxtaposition is weird in the non-pejorative sense'. Without naming it by name, Snyder is invoking what Freud called the uncanny with which I have previously and elsewhere associated the grotesque (see Giblett 1996: chapters 2 and 6). The ambiguity and anthropomorphism of the vent as either or both an earthly and bodily term with its mouth and lip figures the earth as body. In a typical masculinist inversion, the lower and nether are displaced and inverted into the upper regions of the body (see Giblett 2011: chapter 10; 2008a: 186, 8). The arsehole of the earth becomes the mouth whereas the vent is associated with the grotesque lower earthly stratum often associated with wetlands (see Giblett 1996: chapter 6), but here associated with steam vents, both of which lead into the interior of the body of the earth, the grotesque lower bodily and earthly strata, the native quaking zone.

Snyder (1981: 46) goes on to describe how in another photograph, 'Hot Springs Cone, Provo Valley, Utah' (see Figure 4):

the disembodied head of a man seems to grow out of a tufa mound that seems, itself, to grow out of the ground. O'Sullivan wanted to give a clear indication that the mound was hollow and placed the figure standing within it. The way his head emerges over the lip is both strange and mystifying.

Snyder (1994: 195) in his later book chapter describes how in this photograph:

> [T]he grotesque, disembodied [seemingly decapitated?] human head that sits atop a tufa cone is … chilling, discomforting, weird. Part of the figure has disappeared into the earth; it seems to have been swallowed whole by nature and is incapable of resisting.

Such fears of ingestion and incorporation in and by the earth are associated with any place that can consume, such as the swamp, the mine and the cone (for the swamp, see Giblett 1996; for the mine, see Giblett 2011: chapter 9). All three are places in which the body is placed in the depths of the earth, or at least below its surface. All three places are, in a word – Freud's word – uncanny. The uncanny is experienced wherever fears of an orally sadistic nature that the monstrous can ingest and digest one in its grotesque lower bodily or earthly strata are played out (see Giblett 1996; 2008a).

In similar vein (both a bodily and earthly metaphor), Snyder (1994: 197) goes on to describe how O'Sullivan's photographs depict 'geologic monstrosities and grotesqueries' and are 'both fascinating and mysterious' and 'anti-picturesque', which places them to some extent in the upper realms of the sublime and Snyder concedes that they can be analysed in those formal terms. Snyder (1994: 199) prefers, though, to analyse them more in other terms and to contrast O'Sullivan with Watkins:

> [T]he difference between the photographs of Watkins and … those of O'Sullivan is the difference between the familiar, known and understood and the alien, unknown, and unintelligible.

In other words, the difference is the difference in a word between the picturesque and the uncanny, both of which are different from the sublime photographs of Ansel Adams, and of 'nature's nation'.

For Adams nature was black in rock and tree and white in cloud and snow. For Page Stegner (2010: 4) in her introduction to the most recent exhibition and catalogue of O'Sullivan's survey photographs, 'this is Nature red in tooth and claw', invoking Tennyson's cliché for Darwin's theory of evolution by violent natural selection. Yet this cliché was drawn from the 'jungles' of deepest, darkest Africa and the slums of the capitalist city (see Giblett 2011: chapter 12), and not from the dry and light American West where 'Nature' is arguably white in skull and bone, like

a skeleton in death. Stegner (2010: 1) noted earlier that O'Sullivan's photographs appear to be an extensive record of 'a stark, arid, bony landscape'. In O'Sullivan's photographs nature is black in rock and white in sand whereas in Watkins's nature is black in rock and water, and white in sky.

Stegner (2010: 4) notes twice that O'Sullivan's photographs do not evoke the sublime and 'do not chronicle the sublime', but are of a place 'with all its mysteriousness and inhospitality intact'. This is indeed a place inhospitable, if not unhomely. It is certainly not a picturesque place as depicted in O'Sullivan's photographs, as Jurovics (2010: 11 and 27) also notes twice, though also conceding he was 'not immune to the effects of the picturesque'. They are neither sublime nor picturesque and certainly not beautiful, though they sublimate the horrors of war, as Jurovics (2010: 40) notes that 'the chaos revealed by the West's geography was less threatening – and ultimately less dangerous – than the disorder and violence he had seen on the battlefield' of the Civil War as depicted in his most famous photograph, 'A Harvest of Death, Gettysburg, Pennsylvania' (1863) (see Figure 5). The American West has generally been the site onto which the bruised and battered national psyche could displace and assuage the depredations and horrors of the Civil War. The American West, especially Yosemite, was particularly the place where the national psyche could be healed in the national park landscape of the sublime splendours of mountains, columns and waterfalls. Later the American West became the most bombed place on earth where the ground zero endgame of the mutually assured destruction of the Cold War was played out in part as depicted by the nuclear landscape photographers, the topic of chapter 7. The American West is both a kind of sublimated and de-sublimated battlefield.

NOTE:

1 Yet Sandweiss (1983: xvii) contrasts O'Sullivan and Watkins in terms of the sublime in the following way: 'while O'Sullivan's landscapes recall early nineteenth century notions of a sublime full of fear, gloom, terror, and awe, Watkins's bridge the later nineteenth-century ideal of a quiet and contemplative sublime and the more modern sense of landscape as a compendium of abstract shapes'. A footnote at this point refers to Snyder's book on O'Sullivan. Although it is important to acknowledge the abstraction in Watkins's later work, the quiet and contemplative qualities of his earlier work are more pastoral and picturesque than sublime. There is nothing quiet and contemplative about the sublime. It is more noisy and disruptive than quiet and contemplative. The qualities of O'Sullivan's landscape photography outlined here are sublime for Snyder in his book (1981: 45), but scientific, and not sublime, in his later book chapter.

CHAPTER 6

Australian Landscape Photography

Like American landscape photography with its nationalist overtones, Australian landscape photography has played an important role in the formation of Australian national identity, particularly in celebrating the conversion of the Australian bush into farmland for present uses, whereas Australian wilderness photography promotes the conservation of the Australian bush and deserts as they were at some arbitrary point in the past. Yet despite these opposing political ends, Australian landscape and wilderness photography both employ a similar aesthetic drawn from the traditions of American landscape and wilderness photography and of European landscape painting. The aesthetic modes of the sublime and the picturesque are used across all three with no regard for their politics. This chapter critiques these politics of pictures focussing on the prominent example of the photography of Frank Hurley who is for Roger McDonald (2009: 3) 'Australia's most celebrated early landscape photographer'.

Landscape photography of Australia, and by Australians of other places, has played an important role in the formation and maintenance of Australian national and cultural identity in the celebration of iconic landscapes. Whether it is Steve Parish's multitudinous and ubiquitous touristic landscape pornography (which I

discuss in the following chapter), or Frank Hurley's photographs of the feral quaking zone of trench warfare (which I discuss in this chapter), Australian landscape photography has been, and still is, central to how many Australians see and define Australia, and themselves. Yet the place and role of landscape photography in Australian life has not been well researched or documented. Recently Helen Ennis (2009: 17) has concurred that

> research on various aspects on photography in Australia is flourishing, but to date there have been no major historical exhibitions or publications [including those she has curated herself (Ennis 1999; 2004; 2007)] devoted exclusively to the subjects of photography and landscape.

Of course, there was a flurry of interest in, and books about, Australian photography during the bicentenary of white settlement in 1988 which discussed landscape photography (Newton 1988; Willis 1988), but only intermittently and spasmodically (see Batchen 2001 for a review of both Newton 1988 and Willis 1988).

More recently, Helen Ennis's *Photography and Australia* published in 2007 has a chapter on Australian landscape and wilderness photography. It is limited, though, not only for reasons of space but also definitionally as she does not consider Frank Hurley's famous photographs of World War I trench warfare, nor his photographs of the Antarctic taken during the ill-fated Shackleton expedition. She also does not consider (strangely) Max Dupain's (1986, 1988) two volumes of pictorialist photographs of Australian people and landscapes. The mainstream and ubiquitous touristic photography of Steve Parish is not considered at all.

This situation of patchy and spasmodic attention being paid to Australian landscape and wilderness photography compares unfavourably with the American situation where there is a wealth of research about its landscape photography (as we saw in the previous chapter; see also Jussim and Lindquist-Cock 1985; Weber 2002). Some of its leading landscape photographers, such as Ansel Adams, are national heroes (Adams 1985; 1990; Alinder 1985). The closest Australian equivalent compositionally and stylistically to Adams would be Olegas Truchanas or Peter Dombrovskis, but they are Tasmanian conservation heroes rather than Australian national heroes. There is a direct lineage between Adams and Dombrovskis as Greens Senator Bob Brown (1998: 6) says that Ansel Adams was 'a photographer Dombrovskis particularly admired'. Dombrovskis's photographs similarly for Ennis (2007: 67) 'stylistically owe more to North American than

Australian traditions'. She cites Adams, Watkins and the Sierra Club publications as 'particularly influential'.

Like Adams, both Dombrovskis and Truchanas were avid conservationists (Bonyhady (1997: 237) calls them 'environmental photographers'). Yet, unlike Adams, they photographed in one state of Australia (Tasmania) whereas Adams photographed in many states (predominantly western, though) of America. In mitigation, Dombrovskis and Truchanas died untimely early deaths whereas Adams lived into his eighties. Truchanas has had a book devoted to his work (Angus 1980), which sold over 40,000 copies (Bonyhady 1997: 247) and so has Dombrovskis (1998). Both have also been the topic of a recent documentary screened on ABC television (McMahon 2003). Stylistically, however, Adams is much closer to Max Dupain (1986: 139; 1988: 28) as both photographed predominantly in black and white. They were also born within a decade of each other, Adams in 1902, Dupain in 1911 and share a common historical aesthetic of the panoramic.

Australian landscape photography for the purposes of this chapter is defined as the creative, photographic inscription by Australian photographers of the visual appreciation for Australian or other land largely free of built structures in the aesthetic modes of the sublime, the picturesque and the beautiful. This definition implies landscape photography of the country and not the city. More specifically, in the Australian context, and terms, it means photography of 'the bush', the outback and the desert (and not until recently swamps and other wetlands (e.g. Simon Neville in Giblett and Webb 1996, discussed in the following chapter). It also implies more recently, drawing on a term from the American context, wilderness photography. Australian landscape photography has been concerned primarily with Australian lands, but in some instances lands not Australian photographed by Australian photographers will be included in this definition as they were crucial in the formation of Australian nationhood. Frank Hurley, for example, travelled and photographed widely, including his work with Douglas Mawson and Ernest Shackleton to Antarctica and to the Europe of World War I. Australian photographers include those born here or who spent the majority of their working lives here.

This definition of Australian landscape photography as photography of the land by Australian photographers is broad enough to include the rural landscape of farm and farmhouses and other buildings, such as shearing sheds, which played such an important part in the cultivation of the Australian bush and mateship mythologies. This definition, however, is narrow enough to exclude city and suburban scapes and crowd scenes (built landscape and its inhabitants). People are not excluded, but the

static tableau of small family groups and groups of workers in some sort of social solidarity in a rural or small town regional setting are preferred over the random collection of individuals in an urban setting of the largely built environment (e.g. Cazneaux's cityscapes). Landscape photography in both America and Australia has recently morphed into, or spawned, wilderness photography. This is largely of a 'pristine', unpeopled landscape very remote from cities and usually often inaccessible to all but sophisticated transportation (helicopter, air-boat, four-wheel drive vehicle) or to the 'diehardy' by more traditional means (canoe, kayak or walking in rugged or inhospitable terrain).

Previous work on Australian landscape representation has been concerned primarily with painting and writing (e.g. Bonyhady 1985; 2000; Hills 1991; Giblett 2011 and its reference list). The relationship generally between photography and colonialism has been considered (Ryan 1997), but not in relation to Australia, though the role of photography in exploration has been discussed in a couple of articles, but again not extensively, nor systematically (Carter 1988; Rossiter 1994). Some work on Australian landscape painting has discussed photography in passing (Bonyhady 1985; 2000). Some recent work on Australian photography has also discussed landscape photography in passing (Conrad 2003; Davies 2004; Ennis 2004). There has been no systematic exploration of Australian landscape and wilderness photography in a monograph that analyses critically its social and cultural role and creatively produces photographic alternatives. Of the limited research to date related to this topic, one Ph.D. thesis completed at the University of Exeter in the UK (Quartermaine 1987) includes a couple of chapters on it. Two extensive bibliographies of work on Australian photography indicate no monographs or Ph.D. theses devoted to the topic to date (Willis 1988: 288–295 and Downer 1999: 192–197). Recently a Ph.D. thesis on the photographic sublime in Tasmania from 1982 to 2000 has been completed (Stephenson 2001), but this is relatively limited in stylistic, geographical and historical scope as this description of its spatial and temporal range indicates.

Part of an exploration into Australian landscape photography would test the limits of applying models of interpretation drawn from American landscape photography (and from the European landscape aesthetic more generally) to Australian landscape photography. In the previous chapter I argued that the works of three prominent American landscape photographers, Ansel Adams (1985; 1990), Carleton Watkins (Nickel 1999; Palmquist 1983) and Timothy O'Sullivan (Snyder 1981; 1994), fall largely within, and subscribe to, the modes of the sublime, picturesque and uncanny. The current chapter will argue that these modes are

applicable also to Australian landscape photography. It will also argue for a shift away from the aesthetics of landscape photography of the sublime and picturesque towards what could be called a conservation counter-aesthetic of photography for environmental sustainability (see Giblett 2011). Finally, it will argue for a shift from a nationalist mythology of landscape photography of 'the bush' to a new national mythology of photography for environmental sustainability.

The picturesque as an aesthetic mode has its parallels in Australian pictorialist landscape photography from the 1860s to 1930 with two distinct phases: an earlier soft-focus, impressionist style of depiction; and a later style emphasising bright light and spaciousness (Ennis 1999: 136). Max Dupain's landscape photography from the 1930s clearly demonstrates this shift (Dupain 1988). His early landscape photographs are soft, dreamy, impressionistic and self-avowedly pictorial (20–23); his later ones are often panoramic and brightly lit, even at night. Both phases of what Ebury (2002: 35) calls 'the natural Pictorial school descended from the nineteenth-century picturesque tradition'. Ebury's view needs to be nuanced given the differences in style between the early and late phases. Perhaps, though, his view simply attests to the durability of the picturesque mode across these shifts in style, which is still very much with us in contemporary landscape photography. In the earlier phase Willis (1988: 60) argues that

> many landscape photographers working in Australia in the 1860s and 1870s organised their landscape images according to the conventions of the picturesque, seeking out elements such as framing trees, foreground logs, winding paths and rivers. These were the means by which nature, conceived of as original wilderness, could be tamed and rendered visibly manageable.

Indeed, Willis (71) argues later that

> scenic views performed a …. normalising function, assuring [the erstwhile settler?] that the antipodean landscape was not rugged and inhospitable but picturesque and pleasing to behold.

And so, ripe for settlement.

Invoked crucially here is 'the pleasing prospect', if not the 'commanding prospect', in which the land was not only aesthetically pleasing for pastoral leisure but also economically viable for pastoralist industry (see Giblett 2011: chapter 4).

The photograph entitled *View Wolgan Valley* by Charles Kerry and Co. (see Figure 6 and Willis 1988: 80, Figure 44) represents what Willis calls

> a transition between the vision of the landscape as scenic view and that of the land as site of settlement and development. Devices of the picturesque are deployed to make pastoral properties aesthetically pleasing.

Landscape is an aesthetic object, the surface of the land, whereas the land, its depths, is an object of economic exploitation and of land pathology (as we saw in a previous chapter) as well as the agent of the processes that make the economic possible. The economic base rests on a land foundation and has an overdetermined aesthetic superstructure. The aesthetic and economic go hand in hand and support each other, no more so than in the bush and mateship mythologies in which 'the small-scale landholder' (Willis 1988: 84) battles big squatters, big banks, big government and the big land to carve out a small, economically viable, socially ascendant and aesthetically pleasing farm in a beautiful setting or location (see Giblett 2011).

View Wolgan Valley, as the title implies, is of a particular place but increasingly, Willis (1988: 78) argues,

> views were no longer simply of a specific place, but increasingly came to signify "Australianness". At this point [from the late 1880s to 1910] landscape photography began to intersect with ideas of an emerging nationalism.

It also began to intersect with early tourism. The bush, mateship, nationalism and tourism were strongly associated in the landscape photography of Nicholas Caire, John Watt Beattie and John William Lindt (Willis 1988: 85–90). Caire, according to Willis (1988: 86–87; see also Pitkethly 1988; Thwaites 1979), was 'a keen explorer who wrote pamphlets and gave talks about the beauties of the bush, as well as producing picturesque photographs of rivers, waterfalls and fern-tree gullies. Many of his photographs were used to promote tourism' as most locations were 'little more than 80 kilometres from Melbourne and easily accessible by rail. His photography was used to promote these locations as places that city day-trippers could visit to enjoy the beauties of nature'. His photographs were later used by Victorian Government Railways to promote tourism.

The 'pictorialist' tradition of Australian landscape photography that dominated from the 1860s to the 1930s thus falls firmly within the domain of the picturesque

(see Josef Lebovic Gallery online). Indeed, pictorialism is to photography as the picturesque is to painting. Willis (1988: 142) enunciates some of the key conventions of what she describes as 'the pictorialist aesthetic'. These include that

> there had to be a single dominant highlight, which should not be too close to the edges or the centre. Horizons could not cut the picture in half: either landscape or sky had to dominate.

By and large Australian landscape photography in picturesque mode conforms to these conventions. Even in those apparent exceptions, such as the Anson brothers' photograph of *Lake St Clair* c. 1880 (see Figure 7 and Willis 1988: 61, Figure 33) in which the horizon divides the photography roughly in half, the two sections are not exactly the same size and the framing devices of a log in the foreground and overhanging branches to the left and right with a point of land in the lake in the centre as the point of interest means that the bottom half of land and water dominates over the top half of the sky. It conforms to the conventions of picturesque painting and establishes the norm for pictorialist photography and its cultural and political functions.

Australia initially forged a sense of cultural and national identity in the 1890s through the bush mythology of the *Bulletin* school of writers and the Heidelberg school of painters (see Giblett 2011: chapter 6). World War I (1914–1918), Lloyd (1998: 10, 182 and 213) argues, was 'perceived as a rite of passage to nationhood' so that 'Australia had become a nation during the war'. This may be overstating the case, albeit from an international point of view, as the Boer War (1899–1902) and Federation (1901) had already forged a sense of Australian national (if not nationalist) identity into full-blown nationhood. Perhaps with World War I it was tempered in the heat of battle and became full-grown internationally. Photography played a crucial role in documenting and presenting a nationalistic view of this war in a pictorialist style. After World War I, Willis (1988: 145) argues in a section devoted to 'Pictorialist Australia':

> the view that Australia had forged its nationhood through the sacrifice of its manhood on the battlefields of Europe was widely promoted and the need to define that nationhood became crucial … The Australian landscape, which was widespread in both popular imagery and high art, came to be imbued with national sentiment.

The Australian landscape, though, was not just Australian lands but the lands on and over which Australians had fought and died. Frank Hurley and many other Australian photographers (see Bean 1923; Lakin 2008: 60–99) documented the tempering of Australian nationhood on, and in, the battlefields of World War I. The Australian national landscape was not just the rural landscape of Australia 'at home' but also the landscape of European trench warfare abroad, photographed in an Australian nationalistic style. What Willis (1988: 146) calls 'a more aggressively nationalist style of "Australianness" [was] equivalent to bright sun light'. This could be depicted at home, or away as in Hurley's sunburst through the clouds over the battlefield in his most famous composite photograph, *Morning after the Battle of Passchendaele* or *An Advanced Aid Post* (see Figure 8 and Willis 1988: 185, Figure 114; Lakin 2008: 60).

Hurley's composite photograph comprising two of his own photographs, one of a sunburst through clouds and the other of a battlefield, is arguably the most famous and most controversial Australian war photograph ever produced (for the two images that make up this composite see Jolly 1999: Figures 3 and 4). The composite, and not the battlefield scene alone in the bottom half of the photograph, made it into the recent history of Australian war photography (Lakin 2008: 60) whereas the battlefield scene, and not the composite with its sunburst, made it into the official history of the war as Bean (1923: vii and Figure 403) distinguished between

> photographs for the historical record, and the taking of them for propaganda or for the press, [which] were to some extent conflicting activities. Captain Hurley devoted himself to the latter work.

Hurley cast himself in the grander role of the purveyor of nationalistic sentiment. His devotion to this work was not without conflict with Bean and 'Authorities' as Hurley (1917: 52 and 58–59; see also Jolly 1999) records in his diary that he:

> had a great argument with Bean about combination pictures. [I] am thoroughly convinced that it is impossible to secure effects, without resorting to composite pictures ... Our Authorities will not permit me to pose any pictures or indulge in any original means to secure them. They will not allow composite printing of any description, even though such be accurately titled, nor will they permit clouds to be inserted in a picture.

Perhaps with good reason as Hurley's composite, with what Willis (1988: 184) calls 'its sublime backlit clouds rising over a scene of death and devastation', aestheticises the landscape of trench warfare, or more precisely, the artificial wetland and feral quaking zone of the Western Front (see Giblett 2009: chapter 4). For Hurley, as Ennis (2004: 143) argues, 'the battlefield was sublime', perhaps the last thing 'Authorities' wanted. The battlefield was indeed included in landscape under the sign of the sublime.

Yet rather than a field of battle, this scene is a depiction after the event of what Willis (1988: 187) calls 'fields of mud', 'a flattened, rubble-strewn, burnt-out, and ravaged landscape'. This landscape of destruction is the mud and slime of the feral quaking zone of the wetwasteland of trench warfare commented upon so often by World War I writers such as Henri Barbusse in *Under Fire*, Ernst Jünger in *Storm of Steel* (see Giblett 2009: chapter 4), and photographed by Australian photographers too (and described by Hurley in his diary) (see, e.g. 'The Swamps of Zonnebeke', by an unknown photographer (see Figure 9 and Bean 1923: Figure 400 plus other 'swamps', Figures 372, 394, 396, including Chateau Wood (also in Lakin 2008: 78–79)). By contrast, in Hurley's composite photograph of Passchendaele the sublime and the slime counterpose each other in one composition and show their complementarity encapsulated in the portmanteau word s(ub)lime in which, as Sofoulis (as the deviser of the portmanteau) argues, slime is the secret of the sublime (see Giblett 1996: chapter 2). In Hurley's composite the slimy land dominates the photo as it takes up two-thirds of its area (and so conforms to the pictorialist rule of thirds (Willis 1988: 142)), but the slimy land is surmounted and transcended by the sublime sky in the top third. The overall effect for Willis (1988: 184) of this and other photos by Hurley is 'to glorify war'. The slime and mud of the depths of the earth and the wetwasteland of the hell and gore of trench warfare below are sublimated into the heavens and glory of heroism above. Slime is not just the secret of the sublime but its 'dirty secret', the uncanny counter to the landscapes of the sublime.

The wasteland of trench warfare is anti-aesthetic and an industrial waste product (the product of industrial technology) similar to the wasteland of mining. Both are artificial quaking zones where the uncanny rears its ugly, monstrous head, though Hurley also sublimates it into the heights of clouds and sunshine. For Willis (1988: 52), 'the spectacle of mining presented a kind of landscape not widely represented by painters so photographers had few compositional devices on which to draw'. The landscape of mining does not conform to the conventions of the picturesque and sublime. How then to depict it in photographs? Richard Daintree's *Swiss Tunnel at Jim-Crow Diggings* 1858–1859 shows what Willis (1988: 53, Figure 27; see also

Carew 1999: 157) describes as 'a land gouged into, turned over and re-formed into a strange vista of bare earth, tree stumps and mullock heaps'. This is not a pleasing prospect but the displeasing prospect of a sadistic wasteland. Mining overworks the depths of the earth (see Giblett 2011: chapter 9). Minescapes are terrifying prospects, the topic of chapter 12 below.

Australian Wilderness Photography

The sublime is central not only to Australian landscape photography of World War I trench warfare (as we saw in the previous chapter with the work of Frank Hurley) and to American wilderness photography (as we saw with the work of Ansel Adams in chapter 5), but also to Australian wilderness photography whose lineage can be traced back to the sublime (as we will see in this chapter). This is especially the case with probably the most famous Australian wilderness photograph, Peter Dombrovskis's 'Morning Mist – Rock Island Bend' (hereafter RIB; see Figure 10 and http://nla. gov.au/nla.pic-an24365561). Australian wilderness photography can be contrasted, on the one hand, with Steve Parish's multitudinous and ubiquitous touristic landscape pornography ('eco-porn'), and on the other with Simon Neville's exquisite, to use Rebecca Solnit's term, wetland photography. All these photographs have a politics of pictures, not only in the sense of trying to conserve the places they depict, but also in the sense of the politics of the pictures themselves in their use of aesthetic conventions of depiction. People are largely absent from all these photographs, or if they are present, they are shown engaged in leisure pursuits and 'passive recreation' and not actively working the land to gain and sustain their own livelihoods. This is what I call photography for environmental sustainability.

Photography theorist and critic Geoffrey Batchen (1992: 48; see also Bonyhady 1997: 249–253) in an article entitled 'Terrible Prospects' has described RIB as 'the Save the Franklin advertisement'. In fact, it was the *vote* for the Franklin and against the Liberal-National Party government advertisement in the 1983 Federal Election (see Batchen 1992: 47). For Batchen this photograph 'works in terms of the sublime'. It is not a pleasing prospect, but a terrible prospect in both the temporal sense of the future stretching out before one (the damming of the Franklin River would be terrible, too terrible to contemplate) and the spatial sense of the landscape lying before one (see Giblett 2011). For Batchen (1992: 48; 2001: 54) it is not only 'an expertly constructed piece of conservation kitsch' and 'chocolate box photography', but also a photograph whose 'awful sublimity' makes it 'one of the rare photographs that has made an almost demonstrable political impact on its viewers'. In the later reference Batchen deletes 'almost'; so confident had he become during the intervening decade that RIB had had a demonstrable political impact. Indeed, Bob Brown (2004: 28; see also Bonyhady 1997: 253) says that 'old hands in Canberra tell me that this is still the most effective election advertisement they have ever seen'. This ability of photography to engage with the political at the level of voters' election preferences means that it is not confined to the merely artistic and that it crosses the border between aesthetics and politics.

For art historian Tim Bonyhady (1993: 172), RIB became 'the visual embodiment of a turning point in Australia's environmental and political history'. It also embodied a turning point in the production and consumption of photographic images of Australian landscapes. It was the culmination of a flood of conservation and touristic landscape images in books, calendars and diaries (Bonyhady 1997: 248). From Dombrovskis to Parish's (nd) ubiquitous, touristic landscape pornography, there is a clear line of descent. Dombrovskis for Mulligan and Hill (2001: 69) 'raised the art of wilderness photography in Australia to a new level' – just as his work has been raised to sacred, iconic status. The Wilderness Gallery on Tasmania's Cradle Mountain has a special, dimly lit room devoted to Dombrovskis's work whereas all the other rooms are well lit. Dombrovskis's images, with RIB being the prime example, for Batchen (2001: 53)

probably contributed more than any other to the eventual transformation of the word *wilderness* from a pejorative to a positive term in the Australian lexicon.

This is a very large claim indeed that can only be backed up by further research. Recent work on wilderness in the Australian context does not discuss Dombrovskis at all (see Giblett 2011: chapter 5).

Another art historian, Ian McLean (2002), gives an alternative reading of RIB. He picks up, like Batchen, the sublime elements in the photograph, but also relates them to what he sees as its abject elements using the terminology of Julia Kristeva. The sublime and the abject are two sides of the same coin with the sublime lifting one above what is below and the abject pushing one down into what is below (see Giblett 1996: chapter 2). The sublime takes one up and away from what is old, familiar, familial and long forgotten; the abject returns one down into it. For McLean RIB 'memorialises a cosmogenesis in which the waters of the Franklin River, swirling beneath the cliffs of 'Mother Earth's supine body suggest the originary *chora* [or receptacle – in other words, the womb] from which life is born'. Yet cliffs can hardly be supine so this earth is not the benign mother earth of agriculture. Rather she is the Great Mother, or Goddess, who is both creative and destructive and who precedes and refuses Mother Earth (see Giblett 2011: chapter 1).

Rather than the earth as Great Mother, in Steve Parish's landscape photography the earth is a young porn star depicted in picturesque mode. His landscape pornography depicts, often in double-page spreads in pornographic magazine-fashion, a number of landforms or landscapes, including concave bays (e.g. Wineglass Bay with classic feminine shape (Parish nd: cover, 4–5)) of a receptacle, a *chora* or young virgin; curvaceous rocks and smooth rock formations (1, 22–3, 26–9); dark caverns with jagged teeth around their mouths (8, 33); languid surfaces of still water, including Kakadu wetlands (40–1, 44–5); mirrored pools or floodplains of narcissistic contemplation and cosmetic infatuation (37, 44–5, 46–7); milky inlets of water between long legs of land (18–9); hairy bushes with vegetation in whorls (10–1, 53); deep and seductive gorges (32–3); rounded, voluptuous hills (37); bridal-veil waterfalls set either demurely amongst the rugged bones of the land or in lush, fern-fringed glades (38, 40, 42–3, 57, 60–1); sequestered pools of water (46–7); snowy peaks and hills (54), and so on, all shot in stunning colour. Not surprisingly, his 'primary goal is to turn the world on to nature' (Parish nd: 64). Whether this turn-on is supposed to result in copulation or masturbation is not clear.

In drawing a comparison between nature photography and pornography in an essay appropriately entitled 'Uplift and Separate', Rebecca Solnit (2003: 200) notes the similarities between the two as

both are souped up, sleek, passive ... in which the chaos of thought and action have been replaced with a stale vision of delight.

She goes on to enumerate seven features of the 'nature photography genre' (201–202), or nature pornography genre, or 'eco-porn':

No human beings or their traces – that is to say, no history;

Nothing dead, sick, rutting, dying, or a in state of decay – that is to say, no natural history;

Water's main purpose is to mirror, with glasslike perfection, the landscape looming above it;

Repetition and pattern are good;

Colours should be bright;

All animals are lovable and attractive;

The photograph itself should be so clean as to never call attention to its own creation, but rather to *Creation*.

Although Parish (nd: 3, 10, 20, 50) shows humans, there is still no trace of the history of human use of the land depicted in his photographs, and no depiction of human action besides sitting, standing or walking, in other words, all engaged in passive recreation and not actively working (Solnit's first feature). There is no natural history too as there is 'nothing dead, sick, rutting, dying, or in a state of decay', Solnit's second feature, unless it is the crumbling rocks of the hills of outback Australia (Parish nd: 24–25). There are no dead, sick, rutting or dying animals, and no dying or decaying plants.

Parish also conforms to the third feature of the use of water in the genre of nature photography, which is to mirror the land behind, or to fall from the land above (as we have seen), though he does also depict 'the beautiful and wild sweep' of beaches (20–21) and the wetlands of Kakadu (44–45). He also conforms to Solnit's (2003: 4) fourth feature in which 'repetition and pattern are good', such as in his photographs of Purnunulu National Parks whose beehive-shaped and striated rock formations lend themselves to reproducing this feature (Parish nd: 36–37).

Bright colour is Solnit's fifth feature and one which Parish is only too ready to oblige with on many pages and in fact is one of his hallmarks. Sixthly, 'all animals

are loveable and attractive' as are Parish's (7, 9, 16, 17, 48, 58–59). There are no insects or reptiles in this book. Finally, for Solnit (2003: 202) 'the photograph should be so clean so as to never call attention to its own creation'. Parish largely conforms to this generic feature, though he concludes this book with a photograph of himself bare-chested and immersed nipple-deep in a wetland or river holding up and looking through his phallic camera with an erection of a telephoto lens (Parish nd: 64). He is obviously turned-on to nature! Eco-porn indeed.

Photographs of the native quaking zone of swamps and other wetlands have, until recently, been fairly thin on the ground. Parish's wetlands are aestheticised, as are to some extent Simon Neville's and others', though they also show dark and muddy swamps, and watery tree-graveyards (in Giblett and Webb 1996). It was, however, a deliberate ploy on the part of the editors (myself included) in designing the photography for this book, the first and still the only book about Western Australian wetlands, to aestheticise wetlands (as they largely have not been), to simultaneously anti-aestheticise them (as they have largely been), and so to try to deconstruct and decolonise conventional landscape aesthetics by doing both. Some of Neville's and others' photographs of wetlands are beautiful, some are not, or are both. This ambivalence can be summed up, as Rebecca Solnit (2003: 207–215) does, in the term exquisite. She proposes 'the Exquisite' as 'a new aesthetic category' for 'the aesthetic of unimproved conscious female bodies' (207). I propose extending her aesthetic category of the Exquisite to the aesthetic of unimproved sentient water bodies, such as in Neville's wetland photographs, whether it is the embowered woodland wetland of Parry Lagoons (in Giblett and Webb 1996: 18 and 19), or of Lake Toolibin (98), or the tree-lined and serpentine 'Everglades' of Lake Kununurra (27 and 30).

The Exquisite for Solnit (2003: 211) 'revels … in the transgressible boundaries of the female, the liminalities or permeabilities that are denied in the masculinized ideal body', especially, I would add, in the fascist body (see Giblett 2008a), the cold, hard, impenetrablable body. The exquisite revels also in the transgressible boundaries of the female commons of the wetland, in the liminalities between land and water, or in the permeabilities between solid and liquid that are denied in the masculinised sublime city and found in the feminised slimy swamp, such as in Neville's photographs of wetlands, whether it be the estuarine 'delta of Venus' of the 'False mouths' of the Ord River (in Giblett and Webb 1996: 23; see also Map: 45), or the gleaming, blue-grey of the cloacal, intertidal and fertile mud of Crab Creek and Roebuck Bay (38–39).

In addition, the Exquisite for Solnit (2003: 212) 'affirms the biological body against prior artistic norms' and 'restores … the squishy, mobile, mutable stuff of bodies in process'. The Exquisite for me also affirms the body of the earth against the prior artistic norms of depicting (or not) wetlands, and restores the same messy stuff of the body of the earth in the processes of birth, life, death and regeneration in slimy swamps, such as in Neville's photographs of wetlands, whether it be the muddy Mandora Swamp in the pastoral region of Western Australia in which carcasses of cattle are decomposing in the bog just out of frame (in Giblett and Webb 1996: 46), or in Jiri Lochman's 'tree graveyard' of saline-affected Lake Taarblin in the Wheatbelt region of Western Australia (99).

Moreover, the Exquisite for Solnit (2003: 212):

> operates in this zone where the repulsive and the beautiful intersect, or rather in the zone where what is conventionally considered most beautiful – the female body [or water body] – and what is conventionally considered most repulsive – also the female body [or swamp or marsh] – intersect.

The Exquisite also operates in the native quaking zone of wetlands, such as in Neville's photographs of Lake Preston with its depiction of open water between clumped reeds in the foreground like a maze of winding paths inviting and leading the viewer out through them to the larger body of water beyond (in Giblett and Webb 1996: 94), or of the vast Ord River floodplain with the river wending its way across the foreground and reappearing in the background, the only double-page spread of the book (albeit found on the cover) with the floodplain so dry and dotted by so much vegetation that it is not really a turn-on.

Thus the Exquisite for Solnit (2003: 214–215) is 'an aesthetic in which the beautiful meets the repulsive, insofar as the damp messes and tangles of biology are repulsive'. The Exquisite also operates in the quaking zone between the beautiful and the repulsive damp messes and tangles of marshes and swamps and their biological processes, such as in Lochman's contrasting photographs of Forrestdale Lake on facing pages, one with a blazing crimson sunset (a native quaking zone), the other with dried-out exotic *Typha* reeds (a feral quaking zone) (in Giblett and Webb 1996: 82 and 83).

Finally, the Exquisite for Solnit (2003: 215) operates in the psychological realm of the Abject. The Abject also operates in the anti- or counter-aesthetic realms of the uncanny, grotesque and monstrous, so the Exquisite as an aesthetic category is also linked to anti- or counter-aesthetic ones via the Abject. The uncanny,

grotesque and monstrous operate in Clay Bryce's photograph of the 'stromatolites' (actually thrombolites) of Lake Clifton best described as living fossils or rocks, and in Simon Neville's photograph of graffiti on a rock, a petroglyph in short, alongside Duncan Highway just outside of Kununurra that states defiantly 'Wagyl lives' (in Giblett and Webb 1996: 31). The Wagyl is the water-spirit being of the Noongar people of southwestern Australia (O'Connor cited by Giblett and Webb 1996: 4). The Wagyl lives despite all the Western Australian wetlands that have been drained, filled or otherwise destroyed (see also Mudrrooroo's, 'A Snake Story of the Nyoongah People: A Children's Tale' in Giblett and Webb 1996: 33, 36–7).

Australian landscape and wilderness photography is both art and politics (including cultural and gender politics). That is part of the reason why it has received so little critical interest and been so poorly researched as it does not fall neatly into either of the categories of art or politics. Australian conservationists and green politicians (e.g. Brown as we have seen), historians of Australian conservation (e.g. Mulligan and Hill), Australian art historians (e.g. Bonyhady), and historians of Australian photography (e.g. Willis) acknowledge and make passing reference to the power of wilderness photography, but the conjunction of these elements of politics, conservation and art in Australian wilderness photography has not been explored, especially in relation to environmental sustainability. These concerns have tended to be addressed in and by their siloed discourses and disciplines and not explored or entered into dialogue across a common area of interest. The approach proposed here will hopefully remedy that situation by being inter-discursive and trans-disciplinary in a cultural studies approach. This approach does not mean taking the moral or academic high ground from which to survey the field aloofly from above. It means rather taking the 'low ground' where discourses and disciplines mix and flow into each other, and engaging with the messy processes where art, politics and conservation mix.

Green politicians and conservationists are happy to reap the benefits of such photographs as RIB without questioning the politics of the pictures and the cultural traditions of the modes of depiction they employ, and deploy. Progressive art historians are probably equally happy to bemoan the fact that wilderness photography is, as Bonyhady (1993: 171) puts it, 'one of the notable omissions from the collections of most Australian art museums', largely because it is not regarded as art. RIB and the 'Save the Franklin' ad are housed in the National Library of Australia presumably because of the latter's social significance as a political poster (as Batchen's discussion above suggests; see also Bonyhady 1993: 171). RIB is not

housed in the National Gallery of Australia, presumably because of its perceived lack of artistic value.

Neither conservationists nor curators have really explored the relationship between art and wilderness photography. Is wilderness photography notably absent from Australian 'art museums' because its politics is green? What is the relationship between wilderness photography, green politics and art acquisition policies at Australian 'art museums'? The whole question of whether photography is art is, of course, an old and tired one that is of merely taxonomic interest at the ontological and art historical level, but of great political and cultural interest at the epistemological and practical levels. In other words, whether photography is art is largely a matter of definition (on both sides); how it is classified and how then that classification functions culturally and politically is of much greater import. This chapter focuses more on the latter than the former.

The sublime, picturesque and the uncanny do seem to have their analogues in Australian landscape and wilderness photography. Landscape photography in tourism, conservation and culture has played an important role in forming and maintaining national identity. It has played, and still plays, an important, but undervalued and misunderstood, role that is oblivious to the cultural politics of pictures that underpins them. What role it will play in developing environmental sustainability in Australia is another question. Representing the natural environment as an aesthetic object does not promote environmental sustainability.

Landscape photography (including environmental and wilderness photography) plays an important role in how modern urban people see the land and live in relation to it. In this regard it is related to developing an environmentally sustainable Australia at a number of different levels through looking both back into the past and forward into the future. In relation to rural landscapes, photography has been important in developing and maintaining the bush and mateship mythologies. These stereotypical images of a pastoral, and pastoralist, country helped to create a theory and practice of land use, a way of seeing and doing, which is increasingly being seen as unsustainable. On the other hand, touristic and wilderness images of remote or accessible sites fuel the tourism industry and the conservation backlash of the 'setting aside' of sanctuaries of 'pristine' places may become unsustainable too (see Giblett 2011). Both touristic and wilderness images exploit the land they photograph and create unrealistic expectations of aesthetically pleasing or aestheticised landscapes that bear little relation to the lives of people, indigenous and not, who live on or near them and who rely upon them for their livelihoods.

Elsewhere I have argued for a shift from the desire and drive for mastery over 'nature' to being and living in mutuality with the living earth (see Giblett 2011). In conservation and ecology, this entails a shift in emphasis from the setting aside of special places in sanctuaries, such as national parks, to the sacrality of all places, rural and urban, pristine and spoiled (see Giblett 2011). These shifts from mastery to mutuality, from sanctuarism to sacrality, could be developed in relation to photography. Environmental sustainability comes down to everyday land practices in local places involving what I call bio- and psycho-symbiotic livelihoods in bioregional home-habitats of the living earth (see Giblett 2011). Photography for environmental sustainability could document and display Australians engaged in biological and psychological symbiosis in gaining and sustaining their livelihoods in their bioregions. This would mark a similar shift in photographic practice as I have argued in environmental theory and practice, which would lead to changes in land practices to ones that are environmentally sustainable. The postmodern, political and psychoanalytic ecology I develop in *People and Places of Nature and Culture* (Giblett 2011) and earlier (Giblett 1996) could be developed in a new photography that would address the historical, social and psychological dimensions of environmental sustainability and promote their interdependency.

There is little Australian landscape or portrait photography that depicts people engaged in environmentally sustainable land use in everyday life that would promote it to the wider community. Quite the contrary has in fact been the case. For example, Max Dupain's (1986; 1988) two volumes of photographs of Australia and its landscapes do not include any photographs of Australians engaged in working the land other than in the agricultural and pastoral industries. They do not show Aboriginal people hunting or gathering, nor Australians gardening, one of the most popular leisure activities of urban Australians. This is surprising as much of his work was shot in the 1940s and 1950s when the vegetable (or 'veggie') garden was a standard feature of the Australian suburban backyard. In the broad sweep of his panoramic and pictorialist photographs, biodiversity is lost in the monoculture of archetypal rural and bush settings that celebrate these nationalist mythologies. To find a photograph of a vegie garden by a recognised landscape photographer in a major collection, such as the National Library of Australia, we have to go back to c.1887 and Nicholas Caire's photograph of his allotment in Gippsland (Conrad 2003: 12–13). Yet this scene with its rectilinear grid of plots hardly constitutes environmental sustainability, but nevertheless it is an attempt at a degree of self-sufficiency.

Many photographers before Dupain, such as Caire, had a nationalist fixation with trees (see Bonyhady 2000: 248–252; Conrad 2003: 99–113). Many photographers since Dupain document and celebrate the biodiversity of Australia. They focus on, and document, individual species in isolation from their habitat or surrounds. Few, if any, promote sustainability in relation to it. Proponents of environmental sustainability have not considered the role of landscape and wilderness photography in either inhibiting its development by depicting inappropriate pastoral or unpeopled landscapes, or in promoting its development by producing images of people working with the land in sustainable ways that conserve biodiversity. Just as landscape photography helped to form and maintain the Anglo-Celtic Australian national identity steeped in the bush and mateship mythologies, so photography for environmental sustainability could help to form and maintain a new international identity showing land as the stuff of everyday livelihoods in bioregions with people working (not overworking) the land in bio- and psycho-symbiosis. Such a body of photographs would begin exploring, documenting and developing environmental sustainability by representing communities working the land in ways that conserve or rehabilitate biodiversity. These could include Aboriginal people living traditional lifestyles, permaculture practitioners, organic farmers and gardeners, natural energy technologists, or it could showcase products, processes and spaces designed for environmentally sustainability, etc. It could create a new genre of photography, photography for environmental sustainability, the topic of chapter 13.

Images

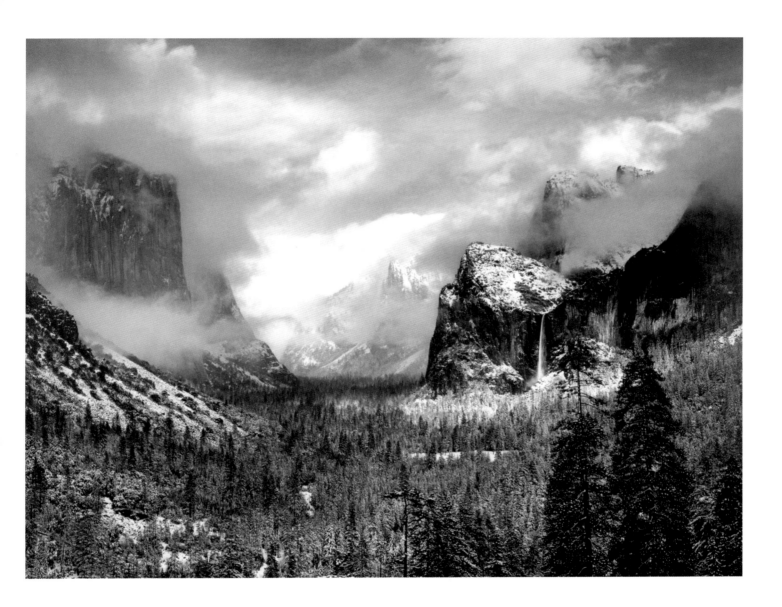

Figure 1. Ansel Adams, 'Clearing Winter Storm, Yosemite National Park, California', 1944. Collection Center for Creative Photography, University of Arizona. © The Ansel Adams Publishing Rights Trust.

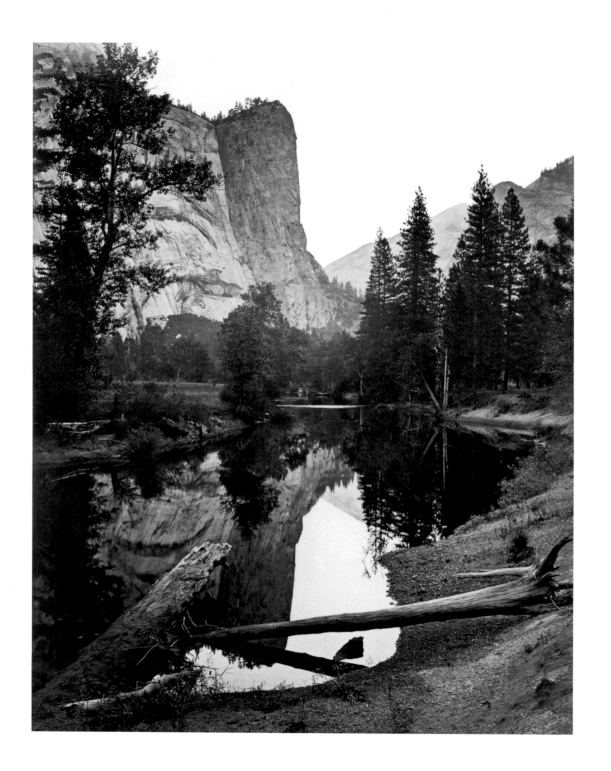

Figure 2. Carleton Watkins,
'Washington Column, 2052 ft.,
Yosemite', 1872.

Figure 3. Timothy O'Sullivan,
'Geyser Pool, Ruby Valley,
Nevada', 1868. The National
Archives.

Figure 4. Timothy O'Sullivan, 'Hot Springs Cone, Provo Valley, Utah', 1869. The National Archives.

Figure 5. Timothy O'Sullivan, 'A Harvest of Death, Gettysburg,' 1863 Albumen Silver Print, 17.8 x 22.1 cm. The J. Paul Getty Museum, Los Angeles.

VIEW WOLGAN VALLEY. 2581. KERRY. Photo. S

Figure 6. Charles Kerry and
Co., 'View Wolgan Valley,
Sydney, Australia',
c. 1884–1917. Tyrell
Collection, Powerhouse
Museum, Sydney.

Lake St Clair - from South End - 1896

Figure 7. Anson brothers,
'Lake St. Clair – from South
End', c 1880. Courtesy of
Tasmanian Museum and Art
Gallery.

Figure 8. Frank Hurley. 'The morning after the battle of Passchendaele [Passendale] showing Australian Infantry wounded around a blockhouse near the site of Zonnebeke Railway Station', October 12, 1917. National Library of Australia.

Figure 9. Unknown Australian
official photographer, 'View
of the swamps of Zonnebeke
on the day of the First Battle
of Passchendaele', 1917.
Australian War Memorial.

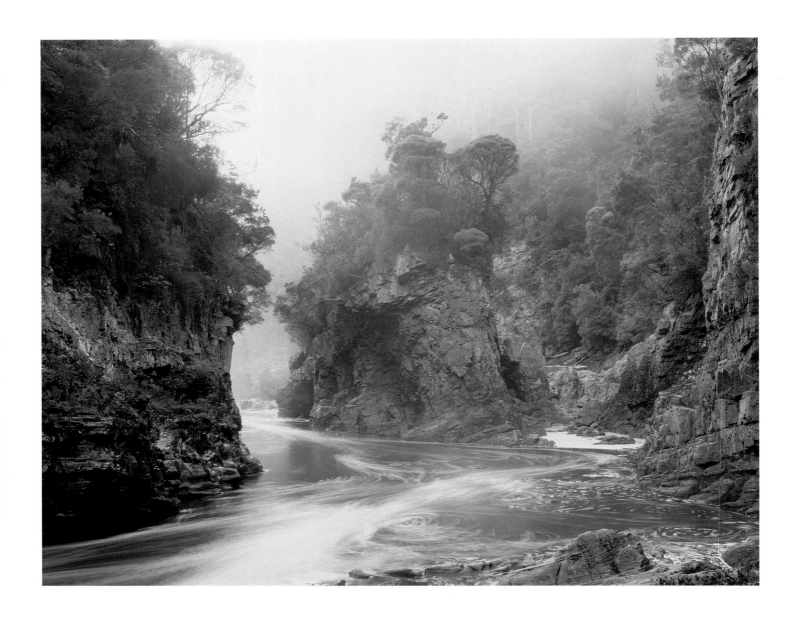

Figure 10. Peter Dombrovskis,
'Morning Mist, Rock Island
Bend, Franklin River,
Southwest Tasmania', 1979. ©
Peter Dombrovskis Pty Ltd.
Courtesy Liz Dombrovskis.

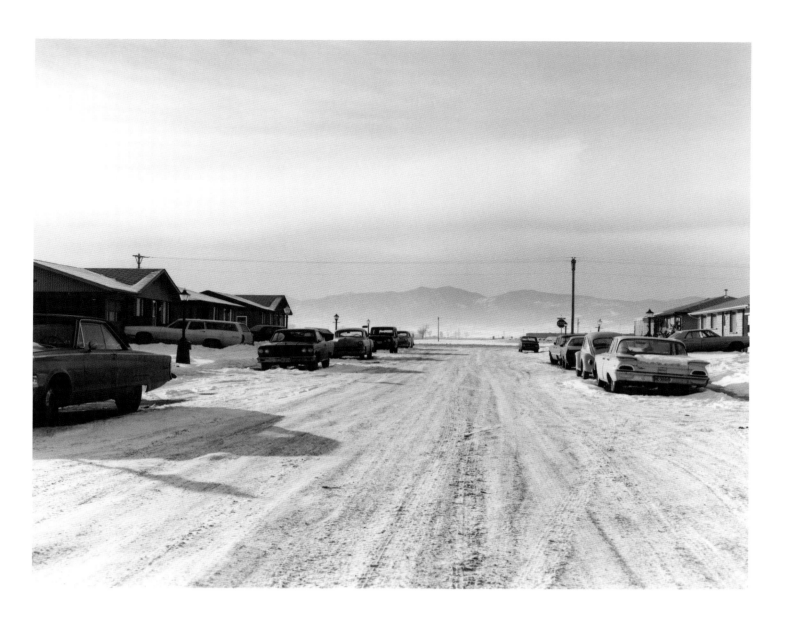

Figure 11. Robert Adams,
'Longmont, Colorado', 1973.
© Robert Adams. Courtesy
Fraenkel Gallery, San
Francisco and Matthew Marks
Gallery, New York.

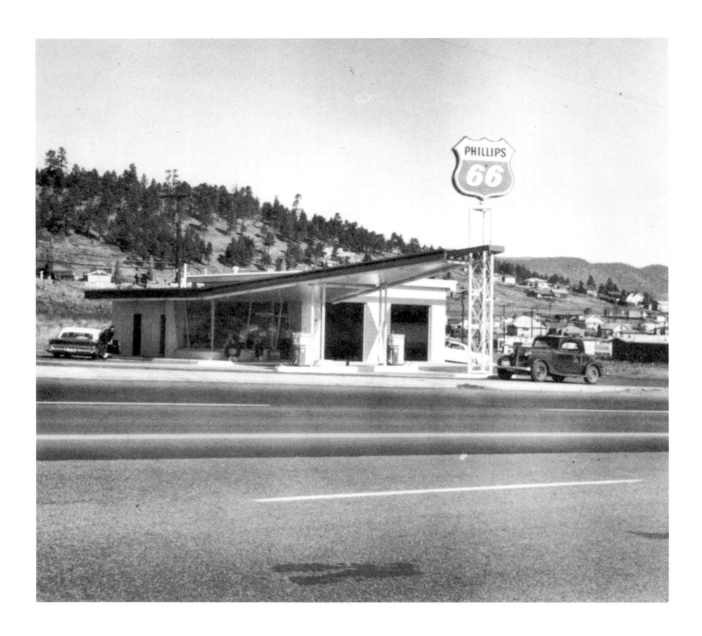

Above: Figure 12. Ed Ruscha, 'Phillips 66, Flagstaff, Arizona',
1962. © Ed Ruscha. Courtesy the artist and Gagosian Gallery.

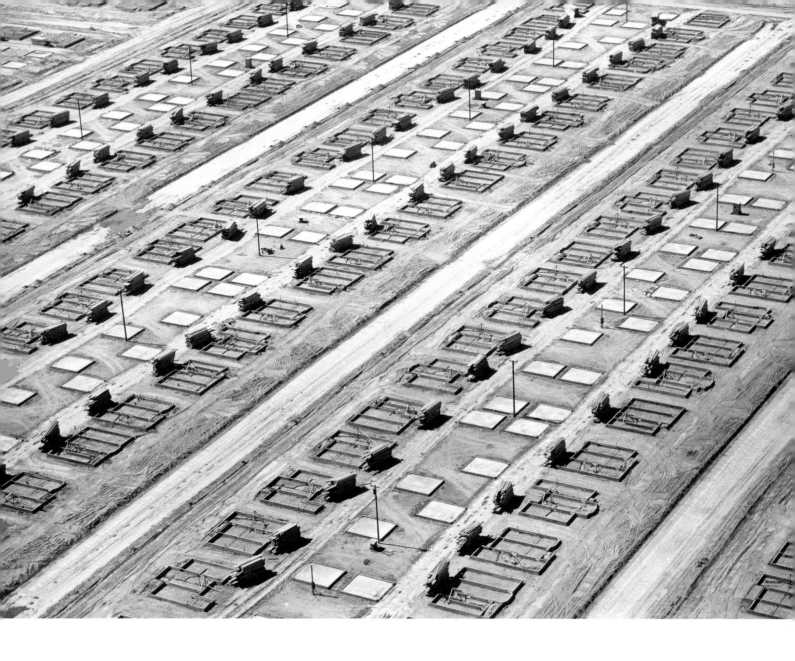

Above: Figure 13. William A. Garnett, 'Foundations and Slabs, Lakewood, California', 1950, Gelatin silver print, 18.9 x 23.8cm. The J. Paul Getty Museum, Los Angeles.

Left: Figure 14. Joe Deal, 'Untitled View (Albuquerque)', 1974. © The Estate of Joe Deal. Courtesy Robert Mann Gallery.

Right: Figure 15. Frank Gohlke, 'Landscape, Alberuerque, New Mexico', 1974. Courtesy the artist and Howard Greenberg Gallery.

Figure 16. General chart of Terra Australis or Australia [cartographic material]: showing the parts explored between 1798 and 1803 by M. Flinders Commr. of H.M.S. Investigator. National Library of Australia [MAP T 1494].

Figure 17. Richard
Woldendorp, 'Dead Trees
along Creek, Northern
Territory' (from *Abstract
Earth*, 2008). Courtesy of the
artist.

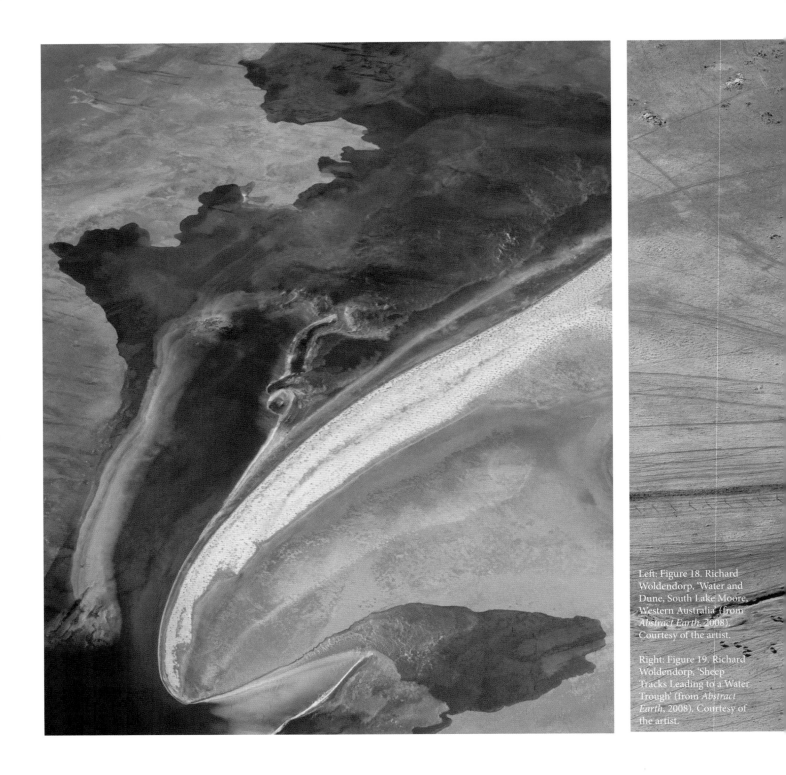

Left: Figure 18. Richard Woldendorp, 'Water and Dune, South Lake Moore, Western Australia' (from *Abstract Earth*, 2008). Courtesy of the artist.

Right: Figure 19. Richard Woldendorp, 'Sheep Tracks Leading to a Water Trough' (from *Abstract Earth*, 2008). Courtesy of the artist.

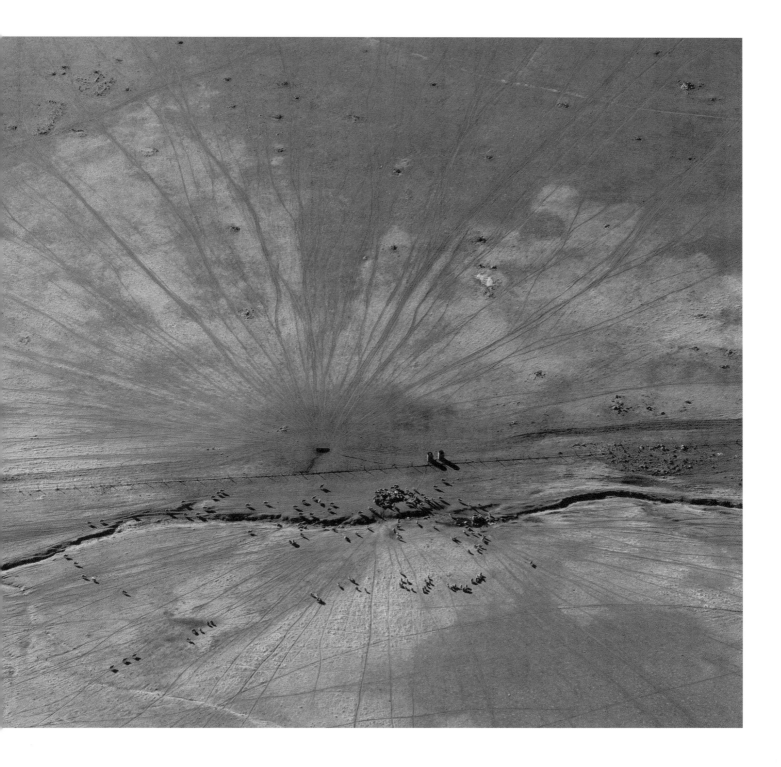

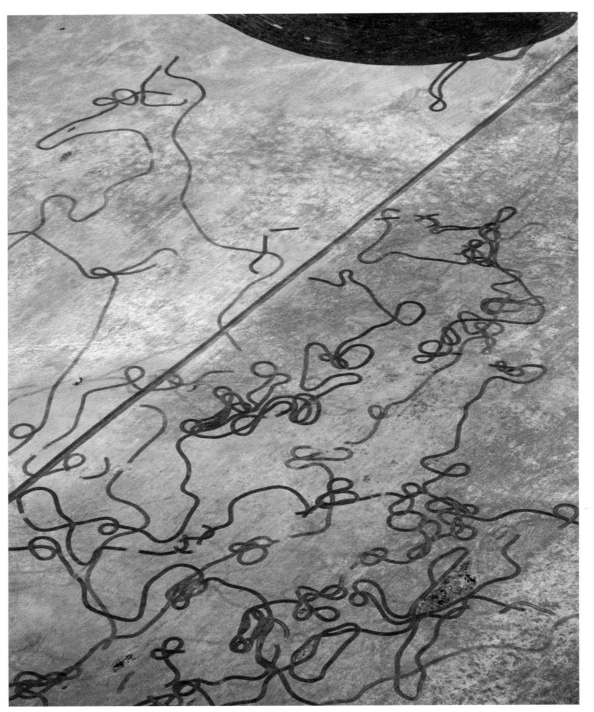

Left: Figure 20. Richard Woldendorp, 'Stump Picking on New Farmland' (from *Abstract Earth*, 2008). Courtesy of the artist.

Right: Figure 21. Juha Tolonen, 'Lounge, Abandoned Hotel, Poland', 2004. Courtesy of the artist.

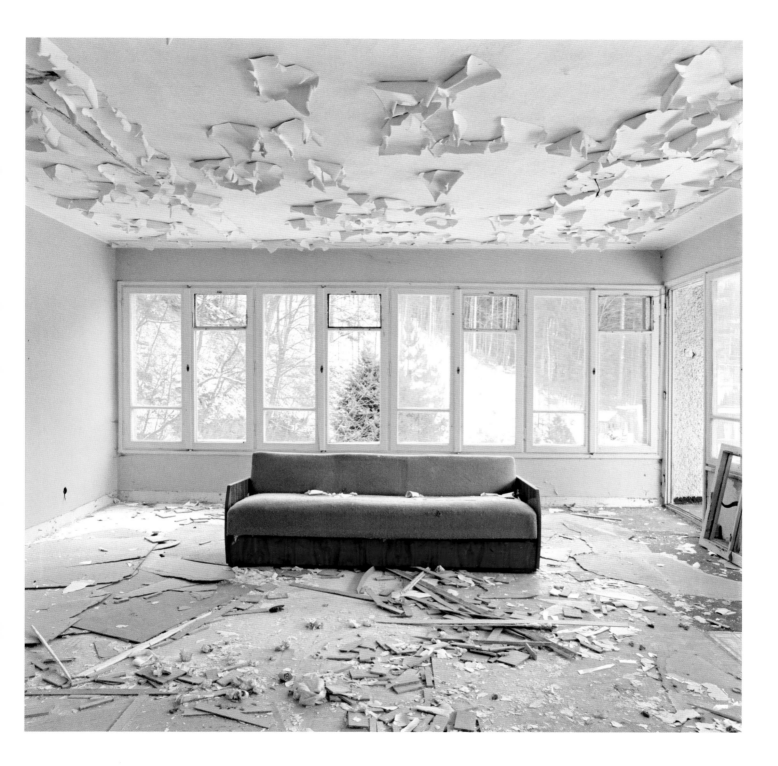

Figure 22. Joel Sternfeld, 'After a Flash Flood, Rancho Mirage, California', 1979. Courtesy of the artist and Luhring Augustine, New York.

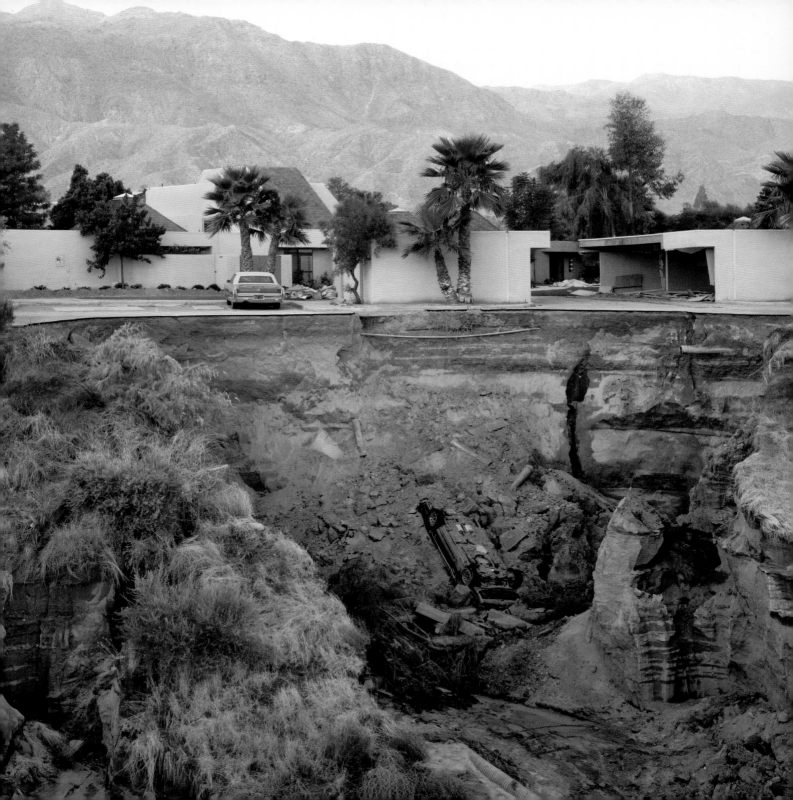

Figure 23. Juha Tolonen,
'Cooling Tower, Kernwasser
Wunderland, Germany', 2003.
Courtesy of the artist.

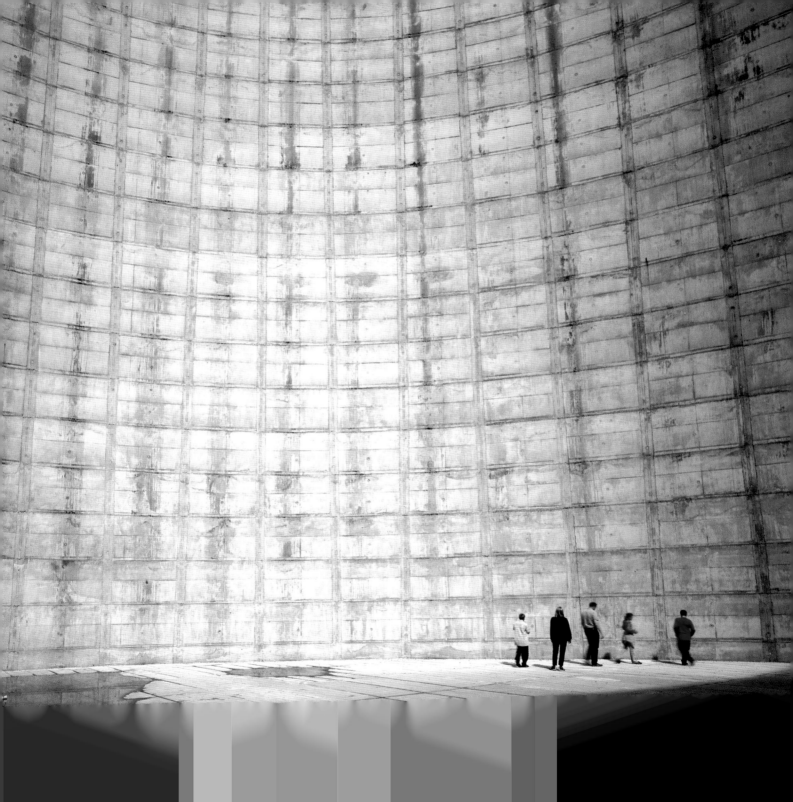

Figure 24. Juha Tolonen,
'Roman Ruin, Germany', 2003.
Courtesy of the artist.

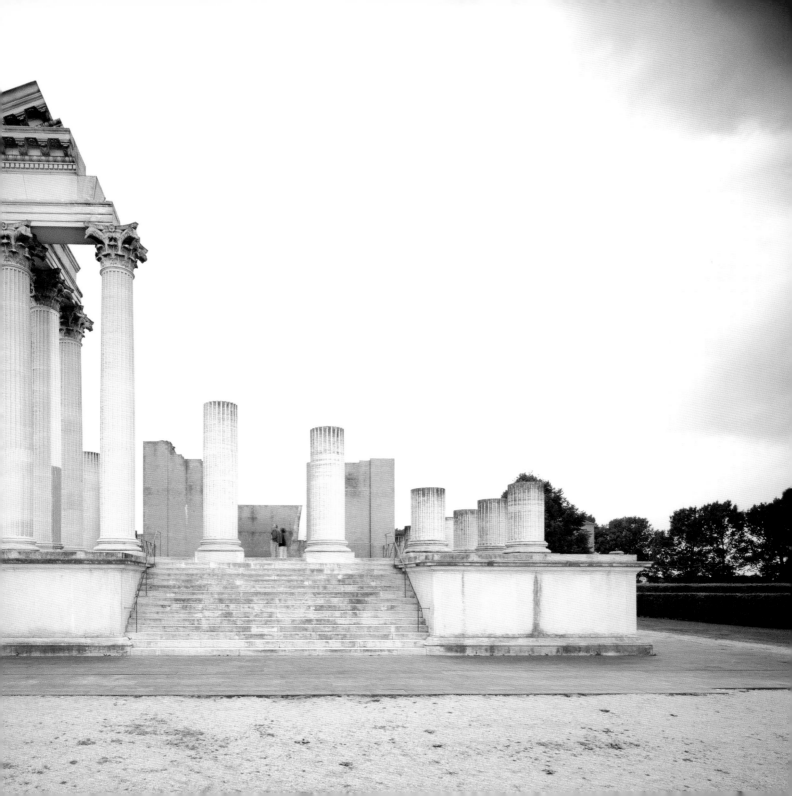

Figure 25. Juha Tolonen, 'Gymnasium #2, Pripyat-Chernobyl, Ukraine', 2003. Courtesy of the artist.

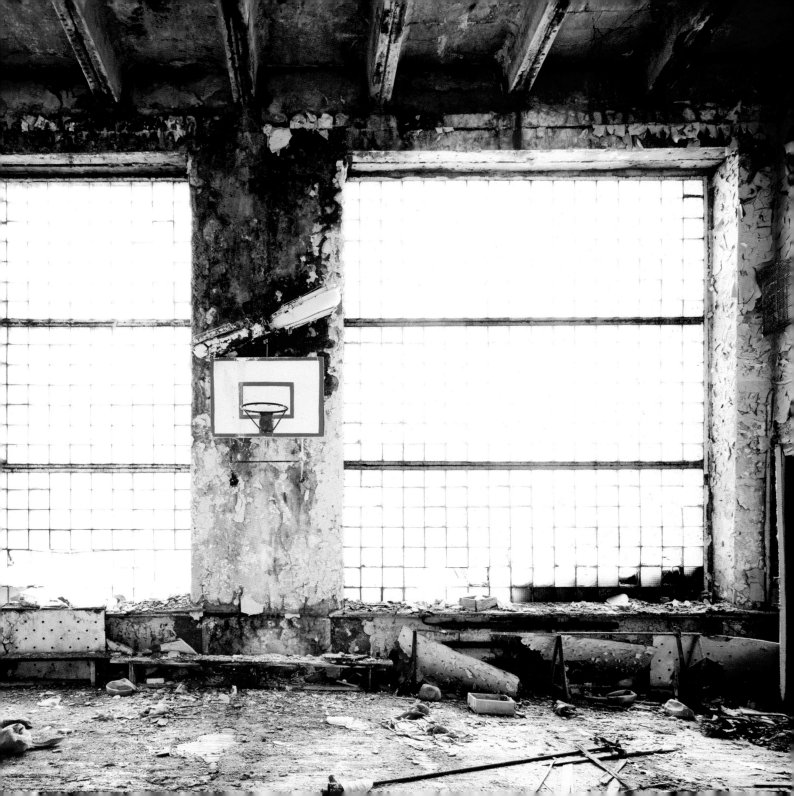

Figure 26. Edward Burtynsky, 'Nickel Tailings #34, Sudbury, Ontario', 1996. © Edward Burtynsky, courtesy Nicholas Metivier, Toronto/ Howard Greenberg & Bryce Wolkowitz, New York.

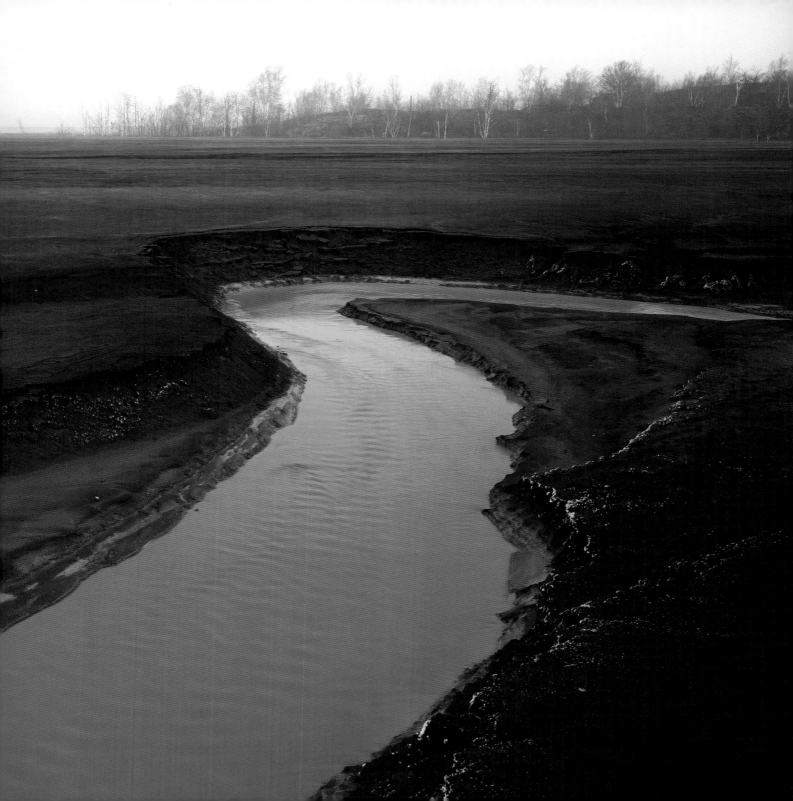

Figure 27. Richard Misrach, 'Detonation Crater, Wendover Air
Force Base, Utah', 1989. © Richard Misrach, courtesy Fraenkel
Gallery, San Francisco, Marc Selwyn Fine Art, Los Angeles and
Pace/MacGill Gallery, New York.

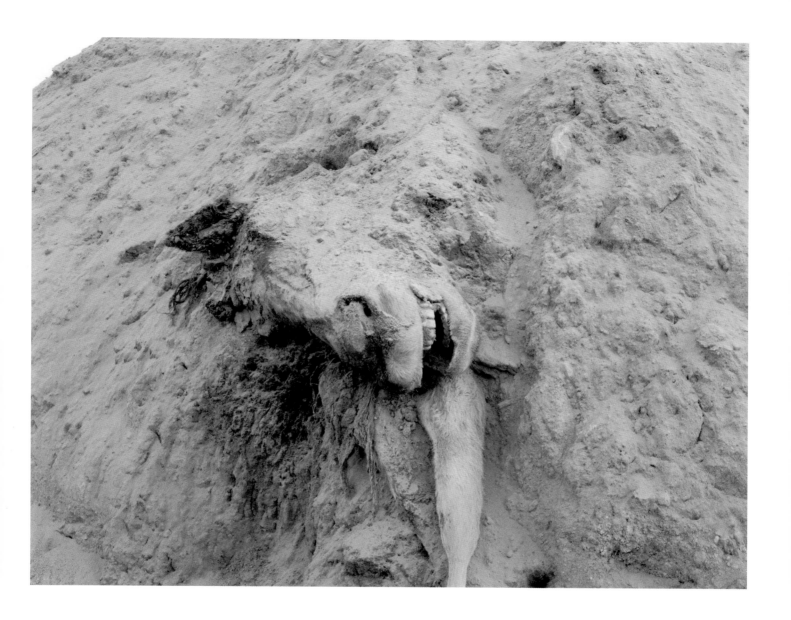

Figure 28. Richard Misrach, 'Dead Animals #327', 1987/88. ©
Richard Misrach, courtesy Fraenkel Gallery, San Francisco, Marc
Selwyn Fine Art, Los Angeles and Pace/MacGill Gallery, New
York.

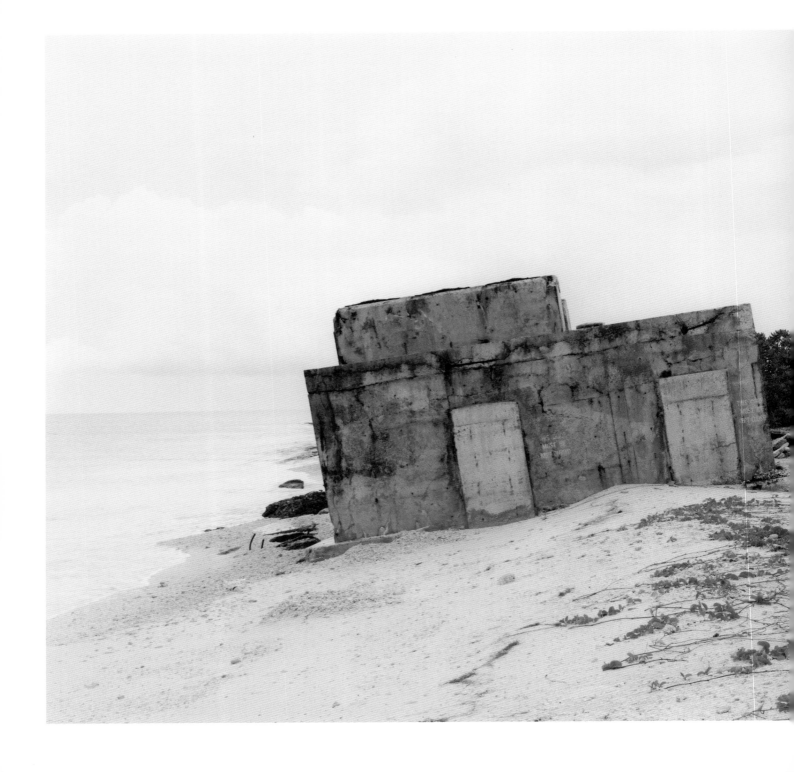

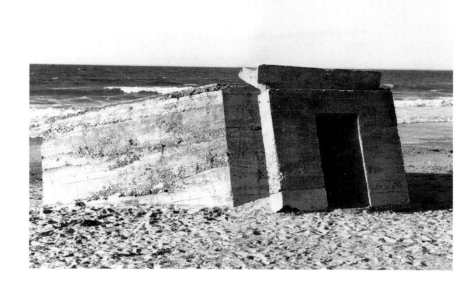

Figure 29. Peter Goin, 'Nuclear Bunker'. (This was Station 77. The left door was the entrance to the timing and firing distribution station; the right door led to the telephone switchboard; and the structure on the roof (Station 1511) housed camera mounts. These were constructed for Operation Redwing (1956) on Runit Island, Enewetak Atoll. Shifting sands have caused this bunker to lean towards the water.)

Above: Figure 30. Paul Virilio, 'Empty Framework, Abandoned, Tilted into the Sand Like the Skin of an Extinct Species'. In his *Bunker Archaeology*, G. Collins (trans.), New York: Princeton Architectural Press, 1994, 174–175.

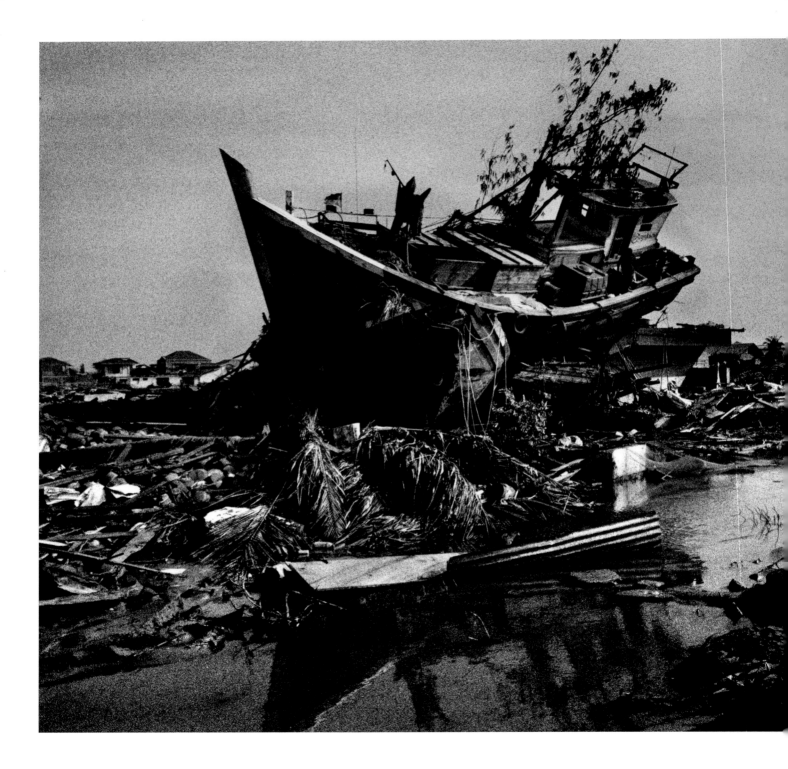

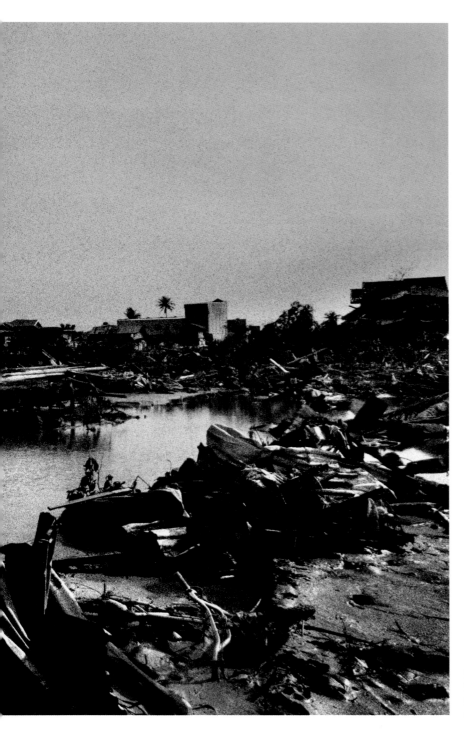

Figure 31. Dean Sewell,
'Asian Tsunami, Banda Aceh,
untitled #1', 2005. Occuli/
Agence Vu.

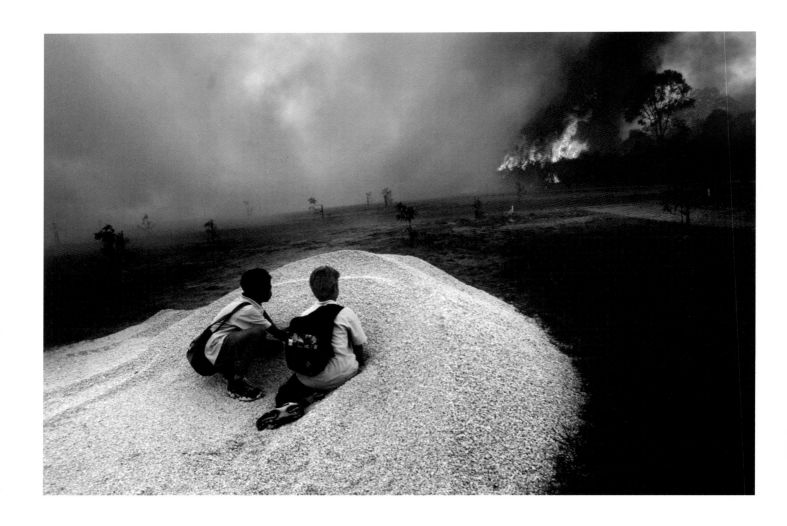

Figure 32. Nick Moir,
'Australian Bush Fire Series',
2001. Occuli.

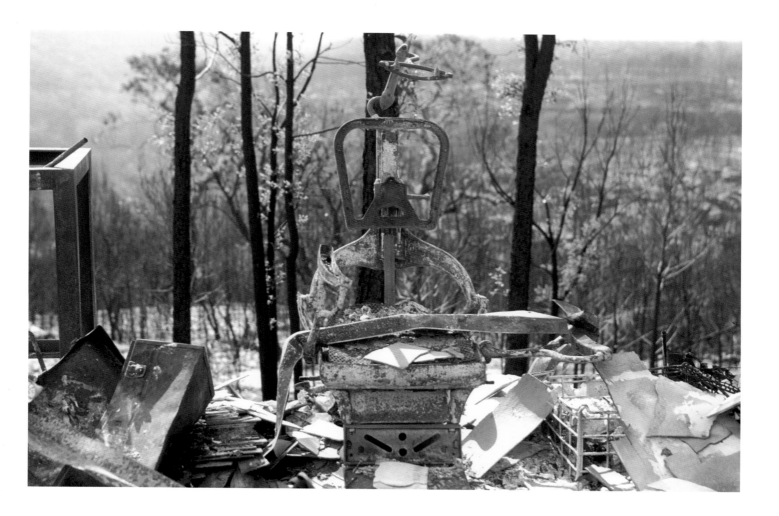

Figure 33. Michael Langford,
'Australian Bush Fire Series',
2003.

Figure 34. Juha Tolonen, 'Sculpture by Reactor #4, Chernobyl Nuclear Power Station', 2003. Courtesy of the artist.

Figure 35. Edward Burtynsky,
'Super Pit #4, Kalgoorlie,
Western Australia', 2007. ©
Edward Burtynsky, courtesy
Nicholas Metivier, Toronto/
Howard Greenberg & Bryce
Wolkowitz, New York.

Figure 36. Mike Gray, 'This Monkey's Gone to Heaven', 2009. Courtesy of the artist.

Figure 37. Talhy
Stotzer, 'Shopping
Mall, Dalian,
China', 2009.
Courtesy of the
artist.

Contemporary Photographic Practice in Landscape

JUHA TOLONEN

New Topographics: Withholding Judgement

While wilderness photography has been largely excluded from the circuits of Australian art, in the United States wilderness and the landscape traditions have been genuinely embraced by both art practitioners and cultural gatekeepers alike. The photography of Ansel Adams stands out as the prime example of its success there. In the previous chapter we saw how Australian wilderness photography suffered from a crisis of identity. The highest profile pictures were politically charged and consequently it was not the art galleries that picked them up, but rather the curators of social history collections, the latter more seemingly able to deal with the messy mix of art, politics and conservation. In the United States these elements still combined in the wilderness tradition, but they were more clearly defined, and perhaps supported by a greater emphasis on art. In the 1970s as Australian wilderness photography was sharpening its political edge, landscape photography in the United States was expanding its art credentials.

In 1975, a modest exhibition, titled 'New Topographics: Photographs of a Man-Altered Landscape', was shown at George Eastman House International Museum of Photography and Film in Rochester, New York. At the time, there was little indication of the impression the show would leave on the world of landscape

photography. Yet this unassuming show arrived at a time of significant change in the world of photography, art and theory. The palates of those in the cultural and academic institutions had begun to respond favourably towards critical photography, and many photographers began to adapt their output accordingly. Since then, photography has flourished as pleasing fodder for both art and cultural critics alike, culminating in photography that functions as both theory and art.

The 'New Topographics' exhibition embodies the period of American photography when its practitioners became overtly aware of the photograph's artifice and construction. Up to this point the main subjects of popular landscape photography, especially the frontier regions of the American West, had been consistently presented within a narrow aesthetic range, most commonly as picturesque and sublime. The photographers in the 'New Topographics' show were well aware of the established traditions and were keen to investigate alternative ways of representing landscape. Thirty-five years on, the exhibition can be seen as 'the seminal event in which photography's landscape paradigm shifted away from the sublime, ushering in a new era of theoretical approaches' (Nordstrom 2009: 70). Curiously, for these early postmodern days, it was a sentiment towards objectivity that was the common uniting element in the work of the participants.

In the 1970s, a practitioner in landscape photography was faced with a century of tradition in the medium, one that seemingly followed a set trajectory, which had culminated in the iconic sublime and picturesque imagery of some of America's national parks, perhaps best represented by Ansel Adams. There was clearly a preferred visual language and subject matter in landscape photography and a mould had been established. Many of the 'New Topographics' photographers wanted to break from this set tradition, and began to seek out alternative ways to represent landscape. The region from where they would draw their subject matter would remain the same for many of the 'New Topographic' photographers, namely the American West, but their framing, cultural references and general aesthetic choices reveal a break with the established tradition. These choices culminated in images that seem to be tackling issues of form and representation, often ahead of any concerns for the important social and environmental contexts they photographed in. Interestingly, as Lange notes (in Salvesen 2009: 57), the successful take-up of the 'New Topographics' style has reached such proportions in art photography today that in some cases it has been pushed to the point of absurdity 'so that "abstract categories such as serial sequence, order, and structure become the actual subject matter of the image"'. Critics, like Deborah Bright, have tried to interrupt this trajectory, demanding that the spaces that appear in their

landscapes are properly contextualised. Semiotically speaking, she would save the referent from being overwhelmed by the form of the sign, opening the way for the subject of the photograph to return to its rightful political and environmental context. What this chapter seeks to do is to map out some of the critical trajectories or positions that have developed around the 'New Topographics' exhibition, paying particular attention at the end to Deborah Bright's 1989 essay 'Of Mother Nature and Marlboro Men'. What I argue for is that this deferment of the subject that occurs in a lot of the New Topographic work is an important part of a process of withholding judgement, not as an end in itself, but for the sake of providing a space in which we can better contemplate the complex trajectory of contemporary life, especially as we find ourselves increasingly buffeted by economic, social and environmental forces that are seemingly beyond our control.

Ten photographers took part in the original 1975 exhibition: Robert Adams, Lewis Baltz, Bernd and Hilla Becher, Joe Deal, Frank Gohlke, Nicholas Nixon, John Schott, Stephen Shore and Henry Wessel, Jr. A new revised version of the show, travelling globally from 2009 to 2012, includes the work of Ed Ruscha (see figures 11-15). His recent inclusion into the 'New Topographics' exhibition recognises an important precedent to the collective work in the original show. His series of books on gas stations, parking lots, apartments and strip developments, released in the 1960s, reveal a detached gaze that is also clearly evident in 'New Topographics'. Titles such as 'Twentysix Gasoline Stations', 'Some Los Angeles Apartments' and 'Every Building on the Sunset Strip' are indicative of his lack of apparent emotional commitment to his subject matter, a trait that, at first glance, is shared with many of the images made by the original 'New Topographics' photographers.

The emphasis on topography in the title invites the viewer to make a few assumptions about the show. Topography describes a practice that is based in science rather than art. Objectivity and neutrality are implicated more than notions of subjectivity and transcendence common in modernist art and landscape photography. This position appropriates the mechanical eye of the camera and makes claims on the objectivity of the instrument, while simultaneously denying the subjective presence of the image-maker. The image in this case is not unlike the map or chart created by the cartographer – a neutral observation of the relationship between objects in the land and the lie of the land.

At the core of the show is an apparent desire to document or describe the landscape accurately. A viewpoint, as the curator of the original exhibition, Bill Jenkins (1975: 7), concurs, is 'scientific, rather than artistic'. There is, of course, an implicit irony in such an approach. The new generation of artists in the early postmodern era

were clearly aware of the artifice and subjectivity of the photographic image. So, the reference to topography in the title of the show can be seen as having an ironic application. Simple irony, however, was not a common motivation for those in the exhibition. Robert Adams (in Chevrier 2009: 108) has even stated the opposite by insisting that 'we need to discover a non-ironic world'. Topography, and its claims on objectivity, was not employed to service truth in this case, but to service style. The success of this application is well illustrated by the propensity for the viewer to register the form of the image prior to the subject matter. This deferment of the subject is indicative of the shift in photographic practice and criticism during this period, a delay that has also been the subject of criticism itself.

The subject is implicated in the subtitle of the show – 'Photographs of a Man-Altered Landscape'. Its secondary position in the title echoes the deferment of the subject in the image, but with the main title it provides us with a guide to reading these pictures. Landscape photography has been dominated by images of idealised nature with limited signs of human interference, yet in this exhibition we encounter landscapes where signs of human intervention dominate the image. These photographs challenge the cultural conventions of landscape in terms of the preferred subject. In them, the natural world is pushed to the margins, or altered in such a way that we start to encounter an uncanny world where the familiar style and content of landscape photography starts to give way to a space that we expect to be familiar, but comes across as alien. The 'man-altered' landscapes of the title are represented often by the familiar sight of suburban development, but these constructions do not seem to settle comfortably into the landscape. Instead, they appear as intruders on the scene.

One reason for this appearance of intrusion is offered by the exhibition's allusion to an earlier period of American landscape photography. The various nineteenth-century survey projects of the American West undertaken by photographers like Timothy O'Sullivan, Eadweard Muybridge and William Henry Jackson sought to document the topography of the 'new' lands. The wild mountain vistas and fertile valleys were ready subjects for these survey photographers to transform into sublime and picturesque scenes for the classification and promotion of recently colonised American land. Respini (2009: 11–12) recounts how much photography from this period 'pictured the West as free for the taking, justifying the occupation of territory that had in fact been populated for millennia'. She continues:

The photographs [of the survey projects] shaped an image of the West as ripe for settlement and industrialisation and helped define an American photographic landscape tradition that would endure for generations.

The 'New Topographics' exhibition provided the public with an update on the settlement process of the American West.

A common mistake occurs in identifying the 'New Topographics' exhibition exclusively as a response to landscapes of the American West. While the West formed a significant component of the exhibition, urban landscapes, new and established, from across the United States, were represented. Despite this broad range, critical mileage can be gained by adopting a more selective focus and figuring the West as the dominant subject. This will allow us to follow some popular critical trajectories from the show. Salvesen (2009: 12) notes that the show 'did not pretend to chart an orderly terrain. It was more like sketchy directions hastily scrawled at a gas station'. Despite this, it was only the Bechers and Nicholas Nixon that made no direct reference to the American West; all the other photographers had shot on location in the western states. As a result, there is often a clear photographic lineage that is traced from the nineteenth-century landscape photography of the American frontier by Carleton Watkins, Eadweard Muybridge and Timothy O'Sullivan, through to the heavy tonal drama of Ansel Adams after the closing of the frontier, eventually culminating in 1975 with the 'New Topographics' show that 'revisits the frontier' after its successful colonisation.[1]

In their return to the frontier, the photographers from the 'New Topographics' also brought with them some of the earlier sensibilities associated with the documentary nature of the photographic medium. Although, this time, they did not invoke the document for objective expression. Instead, it provided a new generation of photographers with a style that set them apart from the established order of landscape photography. For Lewis Baltz, the style of the photo document gave the appearance that it had no author. For Robert Adams, the 'pictures should look like they were easily taken' (Jenkins 1975: 6–7). On the surface the photographers appear to have a modest temperament, but of course they and the public had simply become increasingly aware of the artifice of the photographic medium. During this time, as photography and its relationship to truth was questioned, along with the project of modernity, rather than exploiting the medium through augmentation and spectacle, and emphasising its artifice, the photographers of the 'New Topographics' stylistically went the other way. They seemed to intentionally complicate the medium and the emerging critical arguments by pursuing the manufacture of images that appear excessively neutral and objective. Szarkowski notes how photography tends to maintain its capacity for objective representation:

The nineteenth century believed – as perhaps we still believe – that the photograph did not lie. The photographers themselves, struggling to overcome the inherent distortions of their medium, knew the claim, strictly speaking, was false; yet, with skill and patience and some luck the camera could be made to tell the truth, a kind of truth that seemed – rightly or not – to transcend personal opinion.(Salvesen 2009: 38)

By the 1970s, modernist notions of transcendence were readily criticised. Photographers in landscape had a choice: add to the increasing stockpile of images that were indebted to the now established canon, or attempt to scramble a path out of the thicket of popular landscape photography. Turning to the documentary form (and fiction) of the medium provided a new group of landscape photographers with some traction to achieve this aim.

Augmentation, abstraction and drama were abandoned for a visual language that settled into the everyday and mundane. The larger formats common in landscape photography were still employed, but they simply projected the bland lines, details and forms of modern suburban and commercial projects rather than the grand designs of nature. The new urban spaces of America's expanding middle class seem quite ordinary in their appearance. They could be described further as neutral, indifferent, objective, dull, ambiguous, flat, cool, detached and bland.[2] Some of these adjectives indicate a suspension of judgement on behalf of the viewer while others seem to be demanding the images be more forthcoming. The paradox of the pictures as Salvesen (2009: 37) notes is that they are both boring and interesting. The apparent emptying of meaning can provoke the viewer into actions of signification.

Nordstrom (2009: 73) suggests that

the very minimalism and ambiguity that the work in the exhibition shared allowed it to serve as a *tabula rasa* on which a variety of interpretive perspectives would be inscribed over time.

This is one of the qualities of the exhibition that has allowed it to remain on the cultural radar for so long. Critics, curators, practitioners and theorists are only too eager to make their claims on the seemingly barren ground of the 'New Topographics'. This is despite Jenkins's (1975: 7) earlier assertions that the show he created was presented in a style that is more anthropological than critical. Subsequently, this critical vacuum has steadily been filled.[3]

The American settlement of the West is often seen as being predicated on the philosophy of Manifest Destiny. This is the nineteenth-century 'belief that the United States has a God-given right to explore, conquer, and claim new territories' (Respini 2009: 13). Much of the photography from 'New Topographics' is interpreted as a critical visual account of the success (or failure) of this settlement, despite visual claims to objectivity. The vast spaces of the American West were often figured as lands of opportunity, with a bounty ready to be unlocked with enterprise and energy. Of course, the realities that the advancing population encountered did not always match the myth of plenty. The 1930s Dust Bowl, featured in the work of Dorothea Lange and Walker Evans, is indication of one of the failures of earlier industrial settlement. However, it was not failure that registered on the ground glass of photographers in the 'New Topographics' exhibition. They focussed on the landscapes that were a direct consequence of the successful implementation of the American dream. The post-war economic boom provided for increasing middle-class prosperity. And as the middle-class expanded the American suburb became the dominant feature in the landscape.

In the 1950s, commercial photographers were employed to promote this suburban expansion. Like some of the survey photographers of the nineteenth century before them, photographers, like William A. Garnett, were employed to raise the public profile of new suburban developments in the West. Garnett photographed Lakewood – one of the largest planned communities in California: a grid of 17,000 homes built on 3500 acres of land. Taking to the air, a bird's eye view offered a strategic vantage point to record the vast tracts of new housing. His aerial time-lapse photography revealed the rapid expansion of mass-produced housing on the western landscape. Devoid of people, his images were an open invitation for the burgeoning middle-classes to fulfil the promise of the West and share in its newly constructed abundance.

A developer's dream, however, can be an aesthete's nightmare. Garnett's images effectively illustrate the monotony and uniformity of suburban development that critics often decry, even to this day. Images that are destined for promotion and propaganda can also be channelled for the purposes of critique. Peter Blake's 1964 assessment of Garnett's images – 'interminable wastelands dotted with millions of monotonous little houses on monotonous little lots' (Respini 2009: 17) follows Malvina Reynolds's condemnation in song of the popular new landscape – 'little boxes made of ticky-tacky little boxes all the same'. These types of comments, which are still cast today at new housing developments, bristle with sanctimony and are criticised by some as an elitist position that is dismissive of populism.

The new suburbs were, after all, filled by an expanding (private and aspirational) middle class that often placed aesthetic concerns well down the list after those of convenience, efficiency, comfort and affordability. When Waldie (in Respini 2009: 17) speaks of the suburban grid in Garnett's images as being simultaneously beautiful and terrifying, it would be naïve to think that that terror was only a result of concerns isolated in sustainability. The masses have often been seen as an ongoing threat to established orders. Waldie describes Garnett's pictures as celebrating 'house frames as precise as cells in a hive and stucco walls as fragile as unearthed bone' (in Respini 2009: 17). The 'fragile walls' admit a concern for sustainability, but the 'rows of houses reminiscent of the order of a hive' contain the threat of a potential swarm; a swarm that is a threat to both the natural and cultural orders.

Garnett's pictures preceded the advent of pop art. The entrance of pop art into the major art institutions was a challenge to traditional and modernist aesthetic hierarchies. Previously the world of popular and commercial design had little access to the lofty realms of the gallery. For the pop artists middle-class expansion, and all the commercial gloss and expedient design that came with it, was not something to be mocked and dismissed out of hand. Instead it provided a fantastic new cultural landscape to mine for art's sake. This new creative class was welcoming of the swarm; sanctimony was passé. It was the work of Ed Ruscha, a major proponent of pop art, which provided the clearest precedent to the work contained in the 'New Topographics' exhibition. 'Ruscha embraced the commercial vernacular of the road and the strip as a uniquely Western (and specifically Californian) cultural language' (Respini 2009: 15). His series of deadpan books from the 1960s focussed on everyday architecture and the design of the street. The books were neither a celebration nor a condemnation of the subject. Instead, the structures and signs that compose the modern urban landscape were presented in a detached and unlaboured way so that they simply seemed to state 'I am here'. In these landscapes there did not seem to be any urgency to call for judgement.

So, it would seem peculiar at first to make these same aesthetic choices to photograph a landscape for which one has a strong passion. Robert Adams, a prominent figure from the 'New Topographics' exhibition, is recognised as an environmentalist who is critical of much urban development in his home state of Colorado (Salvesen 2009: 36). Yet, Robert Adams adopts a similar neutral style to that taken up by Ruscha. Aesthetic neutrality it would seem does not necessarily imply political neutrality. Instead, the aesthetic distance that the 'objective' view provides allows the contradictions that are a part of contemporary urban design to

come to the fore. For example, the tension between the beauty and terror recognised in the commercial photography of William A. Garnett is intentionally exploited in some of the work from 'New Topographics'. Salvesen (2009: 36) notes that 'the fact that so many artists of the time cultivated a detached stance suggests its expressive power, or (more cynically) a lack of viable alternatives'. Salvesen continues:

> In essence, the photographers of New Topographics were applying practical reasoning to produce unassailably objective images. According to the logic of preference, indifference is an equivalence relation, extremely stable in its symmetry, reflexivity, and transitivity. The visual analogue would be these photographs, which reconcile beauty and ugliness, love and hatred, progress and degradation, and a host of other contradictions. They epitomise the paradox of indifference in being both boring and interesting. (2009: 36–37)

Reconciliation between these elements may not however be desirable, particularly when the lifestyle choices we tend to make have adverse environmental outcomes. Ugliness, hatred and degradation are not just parts of an aesthetic equation. They are judgements increasingly made from an environmental position where the threat of anthropogenic climate change looms.

This position of aesthetic indifference, where the forces of progress and degradation are seemingly reconciled, is clearly open for critique. Bright (1989) challenges the emphasis that is given to the formal qualities of the 'New Topographics'. For her, the adopted position of apparent aesthetic indifference equates to political indifference. There may well be an expressive power that the photographers are exploiting, but this does not translate to any political power. Bright observes particularly how various art institutions, which strive to promote the 'expressive power' of art, are overly sensitive to the formal qualities of art. Essentially, they act as gatekeepers to the art world ensuring that overtly political art is seldom aired through a process of silencing and self-censoring. The photographers from the 'New Topographics' may have political views about landscape and the environment, but they remain largely unexposed, hidden from view by their preoccupation with form, an effect that is exacerbated by the lens of the gallery.

Bright is tired of the mythical landscape traditions in cinema and photography that compose landscapes within simple geographic or aesthetic categories. Although 'New Topographics' is seen as a challenge to landscape traditions, Bright sees the exhibitors work as succumbing to alternative aesthetic forms

and neutering any potential for the development of the practice of landscape in photography. She calls for a new type of landscape photography that overtly reveals the political conflicts embedded within all landscapes. Bright (1989: 129) cites J. B. Jackson's reference to a landscape that he has called 'a field of perpetual conflict and compromise between what is established by authority and what the vernacular insists on preferring' to illustrate where the photography of landscape should be headed.[4] A new empowered landscape photography would make clear the links between competing interests and reveal the networks of power that allow a particular interest to prevail.

Bright highlights the work of Lisa Lewenz to illustrate this point. Lewenz's images of the Three Mile Island nuclear power plant explicitly shows the links between the public and the private spheres.

> Rather than the fantasy of a landscape world beyond society, or only marginally related to society, Lewenz creates an analysis of landscapes as a social production. (Bright 1989: 136)

These images did not enter the censored space of the gallery, but were instead produced for a calendar that highlighted significant days in the controversial history of the global nuclear industry. By mass producing the calendars (as opposed to limiting editions at the request of a gallery), and selling them at an affordable price, Lewenz's work is potentially made available to a larger public.

Bright effectively sees the 'New Topographics' as a missed opportunity to open up an imagery that has social criticism and political revelation as its raison d'être. She sees little value in the questioning of the status of the photographic document, particularly via questions that foreground form and style as essential issues. Instead, adopting a stance common amongst many postmodern critics, she demands that the images are viewed in appropriate social and political contexts; this not only includes the context of the original subject matter photographed, but also the context in which we view the images. The anodyne white cube of a gallery can relegate the social and political contexts of the very landscape in question to the background.

Bright shares a common concern with the photographers from the 'New Topographics': how to get landscape photography out of the cul-de-sac formed by a century of subjective and aesthetic habits? And like them she reckoned on the expressive power of the documentary tradition to provide a way out (although Bright does not admit this outright). The 'New Topographics' photographers

turned to the form, or style, of the document to provide a clearing, whereas Bright retains faith in the political and revelatory power of the photo-document as a way to transform the genre of landscape photography.[5]

Bright also sees the established art-historical models of landscape photography as limiting. She suggests that disciplines outside of the tradition may show how the practice of landscape photography can be opened up. In fields such as cultural geography, urban planning and landscape architecture 'the environment is approached analytically; photography is used to make focused cultural statements' (Bright 1989: 139). Bright makes specific mention of Robert Venturi's and Denise Scott Brown's 1972 architectural study *Learning from Las Vegas* to highlight the changes in attitude towards landscape and the built environment in other disciplines. This book was a study of the unique symbolism, design and form of emerging vernacular architecture exemplified in the strip developments of Las Vegas. Urban sprawl, strip malls and loud and dominant signage are usually maligned in architectural and intellectual circles. Venturi and Scott Brown sought to challenge the usual reactionary responses by withholding their judgement and assessing whether there is anything to be learned from the forms to be found in this modern landscape. Bright, in her essay, applauds the inventiveness of *Learning from Las Vegas*, but she does not elaborate on how we could apply its model into landscape photography.

It has been noted by others, however, that the 'New Topographics' exhibition does share some characteristics with Venturi and Scott Brown's study. Salvesen (2009: 23) recognises a common fascination with ordinary and everyday design. *Learning from Las Vegas* sets a precedent where 'the didactic intent was to promote visual literacy [and a] connoisseurship of the everyday' by turning to the 'ugly and ordinary'. The 'New Topographics' follows Venturi and Scott Brown's explicit rejection of 'modernism's pretensions to transcendence' by turning away from the glorified landscapes of the American West – landscapes that had been used to simultaneously boost American nationalism and the emotive power of the landscape photographer. Their focus on the rising tide of post-war urban expansion in the West similarly recognised the significance of middle-class construction and design practices that are often maligned in more elite cultural circles.

Learning from Las Vegas shares with the 'New Topographics' a fascination for ordinary and everyday design. However, there is also a common philosophy of withholding judgement that should also be considered. Particularly as it counters Bright's assertion that the 'New Topographics' quest for form was misplaced. For Bright, the focus on form is a dead end, reducing the potential to expose the

networks of power that are essential to any landscape. For example, she is critical of what she sees as Robert Adams's acquiescence to destructive mining practices and the explosive urban development in his home state of Colorado. Instead of actively exposing his discomfort with these developments, he provides pictures that seek to resist interpretation by focussing instead on form. Bright appropriately asserts there is no form outside of interpretation. However, form itself can be a valid interpretation, especially when it is employed to delay judgement. Salvesen (2009: 58), using Venturi and Scott Brown, states 'the so-called problem of style can now be seen as a solution. In the manner anticipated by Venturi and Scott Brown in 1972: "withholding judgement may be used as a tool to make later judgement more sensitive. This is a way of learning from everything"'.[6]

The 'New Topographics' exhibition does not rise from common reactions of discomfort and displeasure at modern urban developments, even though some of the photographers have expressed concerns about the direction and extent of new development. Neither do the images proselytise or preach to the converted about aesthetic and environmental negligence. In the established landscape traditions of the American West the form of the photograph tended to merge with the form of nature, the two would often be treated as one and the same, and the degree of unity would provide a measure of the artistry of the photographer. In the landscapes from the 'New Topographics' the form of the photograph was often amplified by the withdrawal of recognisable natural forms. These natural forms were implied through the choice of representation (e.g. large format photography and formal composition), but they made little impression on the film grain. This absence upset the traditional balance between the form of the photograph and the form of the subject, and as a consequence there were a couple of likely outcomes: the viewer could reject the images out of hand, or alternatively, the viewer was enticed to stay longer with the images and consider the new relationship between the photograph and the subject of the everyday.[7] In the latter case, they were effectively reserving their judgement for a period of contemplation. It was not only the amplified form of the photograph that emerged in this encounter, but also the recognisable and underwhelming forms of modern daily life. The viewers' prejudices were not overtly targeted.

In 1975, the preferred subject of the 'New Topographics' had not yet had the time to settle into the firm grasp of photographic form (or vice-versa). Neither did the subject invite the grasp of the viewer as a lot of documentary photography seeks to do. Instead, the subject of post-war urban development was presented as invitations to consider both the current state of the photograph and our relationship

to the new built environment. Photography is often pursued to grasp at objects: to preserve a moment, to record detail, to provide evidence, despite the limited efficacy of such actions. Meaning is always under negotiation. Emerson provides an illuminating statement of the human relationship to the world of objects:

> I take this evanescence and lubricity of all objects, which lets them slip through our fingers when we clutch hardest to be the most unhandsome part of our condition. (in Vinegar and Golec 2009: 11)

However, it is not the evanescence and lubricity of objects that is unhandsome, but our grasping at them. And, it is this grasp that has been at the heart of the photo-document. In *Learning from Las Vegas* and 'New Topographics', clutching is foregone for receptivity and responsiveness. There is an exchange of the 'unhandsome' condition of the 'coercive' drives of modern architecture (and by extension, the coercive drives of the photo document and landscape traditions) for the 'handsome' condition of being responsive to the intricacy and wonder in given environments' (Vinegar and Golec 2009: 11). The 'New Topographics' photographers' adoption of objectivity as a style in their photography did not reproduce the grasp of the photo document, if anything, it acted to limit it. Objectivity in their case was employed to promote the suspension of judgement.

The revival of the 'New Topographics' as a global travelling exhibition suggests a lingering fascination for the photographs. The subsequent success of the photographers who have come out of the Dusseldorf School of Photography, many of whom have been clearly influenced by the style of the 'New Topographics', has undoubtedly affected this interest. Research for another day would explore how 'withholding judgement' applies to this new work, to see whether it produces the same results. Meanwhile, Salvesen (2009: 58) identifies a noble effect in the original images:

> These photographs of man-altered landscapes forestalled nostalgia and prevented an escape into the past – instead, they forced viewers to remain in the present and think about the future. *New Topographics* had redemptive aspects in its renovation of landscape photography, attention to cultural landscape, and depiction of heedless land use. Its key message is not revelation but responsibility.

Bright espouses a desire for a revelatory photography, which is the aspirational domain of much documentary photography, but with this approach there is no guarantee that revelation will lead to responsible action; the images are often all too easily accommodated into the daily inertia. A message of responsibility does not guarantee change either, but it has a much softer and less patronising voice. It does not cut, but it perseveres. The persistence of the 'New Topographics' exhibition is evidence of this.

1 Such a lineage extends a ready history of American landscape photography that was first canonised by Beaumont Newhall, and later added to by John Szarkowski. As Salvesen (2009: 37) describes:

> Newhall established Western survey photography [of the nineteenth century] as an originary point for the 'straight' aesthetic both he and [Ansel] Adams considered to be quintessentially modern, photographic, and American.

Years later, in 1963, Szarkowski at the Museum of Modern Art in New York would trace a continuum from O'Sullivan to Art Sinsabaugh. More recently, in 2009, the Museum of Modern Art in New York expanded this catalogue to include present day photographers in the exhibition and catalogue *Into the Sunset: Photography's Image of the American West* (Respini 2009).

2 The book that accompanies the new version of the exhibition begins with a transcription of a conversation between two viewers at the 1975 exhibition. Some of these adjectives are used and implied in their description of the exhibition (see note vii).

3 The removal of traditional aesthetic language provides an open theoretical space upon which critics can then project their established philosophical prejudices and positions. For example, as Salvesen (2009: 52) notes, we have these positions available based around cultural criticism and photographic practice:

> non-engagement (Walker Evans), egalitarianism (cultural landscape studies), eclecticism (*Learning from Las Vegas*), irony (Ed Ruscha), anti-Romanticism (Robert Smithson), activism (environmentalism), and anonymity (nineteenth-century survey photography and other utilitarian documents).

Another important reason for the exhibition's endurance is the adoption of the style of 'New Topographics' in the years that followed the exhibition, particularly by those from the Dusseldorf School of Photography, like Andreas Gursky, Thomas Struth, Thomas Ruff and Candida Hofer. Importantly, Bernd Becher – the only European photographer in 'New Topographics', along with Hilla Becher – was the recognised head of the school.

4 Increasingly it seems that the interests of the vernacular and authority have become aligned (evident in the expansion of the suburbs). The conflict arises more between the available resources of the planet and the demands of the consumer.

5 In 1977, two years after the first 'New Topographics' exhibition, Larry Sultan and Mike Mandel released *Evidence*, a book of 50 photographs that were collected from various archives of government, commerce, research and education institutions. The photographs were originally taken to serve as objective and transparent documents, namely to act as evidence for whatever purpose deemed necessary by the institution. Recontextualised and isolated in an art book, the images lose their documentary power, and their veracity is questioned. Context is essential for a photograph to retains its documentary power, however context is not fixed to the image.

6 While *Learning from Las Vegas* did provide a clear precedent for the 'New Topographics' in its philosophical stance, there is a distinction to be made in the treatment of their respective subjects. Vinegar and Golec (2009: 12) remind us of Tom Wolfe's response to Las Vegas: 'Las Vegas (What!) Las Vegas (Can't Hear You! Too Noisy) Las Vegas!!!' Venturi, Scott Brown and Izenour in *Learning from Las Vegas* are dealing with a space that is overwhelmed by visual noise. On the strip, signs compete for our attention, burdening the commuter with the task of navigating through the visual pollution, seeking out signs that will point them in the right direction. Venturi and Scott Brown claim that in 'spite of "noise" from competing signs we do in fact find what we want on the strip' (Vinegar and Golec 2009: 12). *Learning from Las Vegas* does not aim to reduce this din – the authors manage to withhold judgement as they ride through the visual storm. The perceived neutrality or objectivity of the 'New Topographics' work provides a quiet harbour for the viewer to contemplate the approaching din of human settlement. In contrast to the subject of Las Vegas, the 'New Topographics' provides a relative 'sanctuary' for withholding judgement.

7 The book that accompanies the new version of the exhibition begins with a transcription of a conversation between two viewers at the 1975 exhibition. The conversation illustrates a polarising reaction.

> Chris: *I don't like them – they're dull and flat. There's no people, no involvement, nothing. Why do you like them?* Jack: *Because I've been there. This is what people have done. [The pictures are saying,] 'This is it, kid – take it for its beauty and ugliness.'* Chris: *I don't like to think that there are ugly streets in America … but when it's shown to you, without beautification, maybe it tells you how much more we need here. What do you think Jack?* (Salvesen 2009: 9)

Richard Woldendorp's Badlands

Aerial photography has a long history of association with the military and industry. In chapter 2 we saw how it was successfully employed in World War I to identify bombing targets. More recently the technology has worked effectively in the aerial mapping of potential ore bodies in the mining industry. Despite the medium's tendency to create abstract renderings of landscape, industry has still managed to read these pictures for strategic advantage. As Rod stated, it is 'only a hop, skip and a jump from abstraction to militarisation'; or additionally, from abstraction to big mining profits. Abstraction, however, tends to be associated much more with art than industry. And the aerial photography that is produced for public viewing is generally found in art photography. In Australia, Richard Woldendorp's aerial photography has grown in profile in recent years, even featuring in some of the country's more prominent art galleries – a recognition perhaps that landscape photography can be more than just politics and environmentalism in this country. This chapter considers what is being offered, or even evaded, by photographing landscape from a high vantage point by looking specifically at the work of Richard Woldendorp.

Woldendorp's aerial photographs provide an abstract rendering of the Australian continent. They have been noted for their painterly quality, particularly in their

allusions to abstract expressionism, colour-field painting and Aboriginal painting. Woldendorp's abstractions can seem to be evading some common anxieties that have emerged out of our relationship with the Australian landscape over the past 200 years. Australia's vast interior and desert regions constitute what Gibson (2002) calls its original Badland, a mythical quarantine zone that isolates many of the nation's misdeeds, misadventures and misgivings from the populated coastal zones of the country. Woldendorp (2009) suggests that his images may be seen as landscapes of instruction. However, what they reveal is not the uneasy and unsettling interior, but rather topographic forms that transform the Badland into a series of visual delights that act as a virtual Rorschach test for the viewer to decipher. With society's heightened environmental conscience, and Woldendorp's tendency to showcase the pattern and repetition of form in the landscape, the 'ink blots' tend to reveal a country of an ancient, natural (and supernatural) order that is in delicate balance. Woldendorp clearly calls into question the part that we play in this order. However, the attention to natural history tends to diminish the effect of the Badland. The difficult histories of European settlement give way to the environmental concerns of today. In the process the Australian landscape of daunting prospects is tamed.

The campaigns of Tourism Australia would seem to suggest that Australians have settled comfortably into the landscape. They advertise a country that has been seemingly created for mass recreation. It is large enough to accommodate the local population, and large enough for the growing numbers of international tourists that wish to share in our fortune of comfort and pleasure. In recent years the Australian 'outback' has grown into one of the nation's most fruitful exports.[1] However, the local and international love affair with the landscape is only a recent development. Records from the early colonial period of Australia provide us with accounts that are much more disparaging of the landscape. The colonial explorers of Australia reveal in their journals a landscape of disappointment and failure (Genoni 2004).

In 1829, Charles Sturt, on an expedition to trace the course of the Murrumbidgee River, wrote in his diary:

> Our route during the day was over as melancholy a tract as ever was travelled … It is impossible for me to describe the kind of country we were now traversing, or the dreariness of the view it presented. Neither beast nor bird inhabited these lonely and inhospitable regions, over which the silence of the grave seemed to reign. (Cumpston 1951)

Sturt encountered a land indescribable and hostile to his European sensibilities. It would take many more years of settlement before this transplanted European penal colony began developing cultural responses that figured the land in more positive terms. Even many of the names given to any distinguishing landmarks encountered during that period reveal the effect of the landscape on the settler psyche: 'Mount Hopeless, Forlorn Hope Range, Mount Misery, Mount Barren, Mount Disappointment, Refuge Rocks' (Genoni 2004: 33). Robert Hughes identifies the landscape in this early colonial period of Australia as a prison. In a bleak aphorism he states: 'You walk across the country, find nothing, then die' (Hughes 2000). Embedded in the Australian legend are mythical and tragic figures like Burke and Wills who represent the failures of negotiating this new and confounding landscape. But of course, early troubles were not just confined to encounters with a new land.

Despite early European and settler identification of the continent as 'terra nullius', as a land free of possession, and hence free for the taking, encounters and battles with the indigenous population on the frontiers of settlement suggested otherwise. For the settlers, the conflict was not just with the landscape, but also with the original inhabitants over what they saw as their rightful occupation of the troubled land. The trauma that arose in these early encounters and disturbances in both sides of the frontier has since subsided and settled into the landscape. Such history rarely gets an airing in popular representations of Australian landscape today, particularly in tourism campaigns and landscape calendars. Instead, the landscape has been seemingly tamed, with no sign of the country's history of conflict with the land and its people. Absence, in this case, operates as an act of repression. Yet, this trouble tends to resurface in some form or another in modern encounters with the land, in both fiction and real life.

The 'dead heart' of the Australian landscape can be identified as a 'badland'. For Gibson (2002), a badland is a zone that is isolated from the main populace, a place where repressed histories can freely surface. It is a mythical place that exists to reassure citizens 'that the unruly and the unknown can be named and contained even if they cannot be annihilated' (Gibson 2002: 178). Through the process of naming and containing, the badland allows the population to simultaneously acknowledge and deny 'the insufficiencies that are a part of everyday social and psychic reality' (Gibson 2002: 178). While the popular images of the Australian outback usually work to deny these insufficiencies, the badness of the land regularly surfaces in the psychodrama of news stories and Australian gothic cinema. Demented characters, of the likes of Ivan Milat and Bradley John Murdoch, are

borne out of this landscape, and then dramatised in films like *Wolf Creek* and *Wake in Fright*. Toohey (2007: 36) provides an account of this character type that crawls the landscape:

> Brad Murdoch is not just Brad Murdoch. He's a breed, a kind. There are Murdochs all across northern Australia and they run to type: fastidious men with pissed-off, resentful minds, white or beige Toyota Land Cruiser HZJ75 utility, non-standard, all-terrain oversize 16-inch tyres on wide, non-standard white Sunraysia rims, amphetamines, dope, full survival toolkit in the back, maybe a winch, definitely a kangaroo jack, compressor for pumping tyres, three kinds of heavy rope, towing chains, long-range tank, don't mind a cup of tea, prefer a beer, whack your nose over this, Jim Beam on ordinary nights but Jacks to celebrate. Love their mates but always disappointed with women.

Even in subtler depictions, like *Picnic at Hanging Rock*, the badland retains a threatening role. In Peter Weir's 1975 film adaptation, a group of girls on a school excursion mysteriously disappear into the landscape. The reason for their disappearance is never explained, leaving open the possibility that natural or supernatural forces were involved. Following Weir's film, in the 1980s, the Australian landscape becomes a real-life setting for disappearance. The missing body of nine-week-old Azaria Chamberlain resulted in the most publicised trial in Australian history. The popular news media avoided subtlety for the paper selling power of sensationalism. Azaria's mother's claims that a dingo had taken the baby are doubted; instead the police, prosecution and media air more bizarre claims that include a pronouncement that Azaria's name literally meant 'sacrifice in the wilderness'. The popular imagination easily latched onto the possibility that supernatural forces were at play in the central landscape of Australia.[2] Such narratives of Australia's badland seemingly follow a common pattern – the badland corrupts the minds of adults and consumes the bodies of children.

It is often in the far-reaching plains of Australia's remote lands where trauma is located. Fear, real and imagined, seems to drift across long and isolated stretches of road. This fear can figure in the mind of a driver as a worn-out horror story that most often can be easily dismissed. However, from time to time these myths get recharged by new events that register in the national media. Yet, perhaps these events only reveal part of the horror. Much of inland Australia provides an encounter with a vast and permanent horizon that can be equally horrifying. As an existential experience, this is the democratised landscape, where no clear hierarchy

or distinction can be made between the various elements that lie dormant under the infinite expanse of sky. Between the unrelenting sky and uncensored earth, the mind seeks to garner some form of control over the landscape, and all the time the horizon cruelly lurks at some indeterminable distance. This is the *horror vacui*. Or as Patrick White may have termed a part of the 'great Australian emptiness'.[3]

Height, however, can provide moments of comfort. There is a great existential relief to be found in places like Uluru and the Bungle Bungles. This is perhaps a reason why the indigenous request not to climb Uluru is often ignored. The western 'enlightened' mind seeks to take command of its surroundings, and an elevated position provides a ready opportunity to achieve this. The gasps of relief at reaching the summit of Uluru may indicate the climbers' fitness levels, but they also usefully conceal sighs of relief at finally attaining a position that allows some visual command of the landscape.

Carter (1987: 197) notes the solution to the horrors of the plain, which he describes as 'an imprisonment without walls', is the mountain.[4] At ground level it provides visual relief from the monotony of the horizon line, and at its summit it provides commanding prospects of the surrounding plains. However, the internal landscape of Australia offers few natural solutions. One of the attractions of Uluru is its rare position in the landscape. Without the assistance of such rare monoliths, we are left to rely on our own faculties for the relief that the mind and eyes seeks. Carter (1987) acknowledges the success of the map-making mind in bringing the horrors of the plain under control. He offers the achievements of Matthew Flinders as an example. Growing up in the fens of Lincolnshire, he had no high vantage point from which to take visual command of his surroundings. The cartographer, in effect, needs to imagine himself out of the landscape, and away from the oppressive horizon. In mapping the coastline of Australia in the early nineteenth century, Flinders adopts an imagined position above the land (see figure 16). The first complete maps of Australia that he submits for publication eventually have their accuracy confirmed by satellite images 150 years later; subsequently this elevated perspective provides one of the defining and most common views of Australia today. It is an image that eschews the horrors and mysteries of the horizon in Australia for the topographical unity of the continent fully contained within a single gaze.

Foster (2006) identifies a lack of general and professional interest in Australian landscape photography. In seeking out the most important landscape image of Australia, he received no conclusive responses. Resorting to an online image bank,

the most popular image of Australia was deemed to be a satellite image of Australia. Foster (2006: 61) speculates that

> perhaps landscape just takes too much time to absorb and consider and, if one does, their message is too overwhelming and scary … We find solace in the satellite images of Australia, reassured in the knowledge that nature conforms to our man made maps.

Abstract Earth showcases Woldendorp's decades long contribution to Australian landscape photography (see figures 17-20). The images from the nationally touring exhibition and book linger in a space between the earth and the satellite. Essential to Woldendorp's aesthetic is the view offered from the plane. It is a perspective that rids the problems of the horizon, and takes the preferred physical position of the map-making mind. Considering the popularity of web applications like Google Earth today, Woldendorp is well positioned in the landscape to accommodate the latent sensibilities of the viewing public. However, Woldendorp does not employ this perspective to achieve images of topographical accuracy. Instead, his framing choices render the landscape into abstract forms obscuring the content and materiality of the landscape. The allure of his images lie in the pleasures of abstraction, the freedom of encountering this trampled world in surprising ways, especially via a medium that we usually trust for its production of visual evidence. However, Woldendorp's intentions are not for abstraction to overwhelm the documentary capacity of the photographic image, instead he sees his abstractions as evidence, as 'truthful' images that reveal the strength of the landscape via its form. Woldendorp (2008) suggests that this privileged perspective can provide insights into the evolution of the landscape, and invite questions about our position within it. These questions tend to be framed around issues of environmental sustainability and stewardship of the land. This is to be expected particularly in an era when fears over climate change escalate, and we begin to consider the impact of human exploitation of the landscape. Humans are existentially threatened in an era of global warming and the landscape is often looked upon as the harbinger of disaster.

If Woldendorp's images are to be encountered as landscapes of instruction, then they sway between two identifiable poles of influence. At the first pole our vision is aligned with modern natural science and mathematics, where the abstractions repeat the fractal geometry that we encounter in popular images often used to illustrate aspects of chaos theory. Here, Woldendorp's images work as photographic

evidence of the fractal geometry of nature, and invite questions about the impact industrious humans have on the natural order. At the second pole we gain insight into Woldendorp's abstractions via the psychologists' couch. A popular image of modern psychology is the ink-blot of the Rorschach test, often used to determine the emotional functioning of patients. Woldendorp's landscapes do not necessarily mimic the form of the ten cards used in medical practice, but they do invite the viewer to use the images in a similar manner, namely to seek out recognisable patterns, figures and forms from the abstract offering. At the second pole the landscape is rendered as an idiosyncratic, or even supernatural, space.

The first pole attracts issues of sustainability, pulling into focus the economic, social and environmental factors that impose themselves on the landscape. This reading recognises that these elements have been out of balance, and that there is an increasing urgency to raise the profile of the environment in any assessment of general wellbeing. Such concerns have been more broadly adopted in the corporate sector in recent years in the measure of the triple bottom line, represented in the tripartite accounting of people, profit and planet. Wolderndorp's images may be employed loosely as a part of this measure. His abstractions retain occasional pieces of evidence of the impact of mining and agriculture on the landscape. Yet, this evidence is absorbed into the fractal forms that dominate his images. If we are to obtain a documentary account of the condition of the landscape, we need to trust the abstract form as suitably instructive. These abstractions may illustrate themes of natural order and design through the repetition of fractal forms, and they may subsequently promote better stewardship of the land as the natural order is increasingly threatened by overzealous intervention. In such a case Woldendorp's abstractions would achieve a political utility beyond the usual scope of abstract art.

A more common encounter with abstraction figures the image as a piece for private contemplation. At this pole Woldendorp provides a platform for self-analysis, an image-bank that can be used to unveil the nature of the bonds we have with the landscape. The analysis is attenuated by Woldendorp's identification of each of the landscapes with the geographical location they were photographed in. The terraform can thus take place in accordance to the character of the individual's experiences with the space – both direct and vicarious. But, like the Rorschach test, it could be expected that the abstractions in Woldendorp's work will provide a common set of responses. If we are to take on board the assertion of Gibson's that much of Australia's interior constitutes a badland, then we may well encounter figures or moods in the abstractions that reflect this notion: the surfacing of fears, apprehensions, grievances and doubts about the landscape that are normally

repressed. Alternatively, the surfacing emotions do not necessarily need to be a part of a collection of miseries; a viewer may instead encounter more welcoming responses, perhaps of a kind that evoke the pleasures of the landscape found in tourism advertising.[5]

For this author, some abstractions can at first seem quite innocent. One image recalls memories of overcooked roadhouse food on long journeys between the towns that dot the Australian bush. The aerial view of a turkey nest dam, a landmark that was actually common on these drives, looks peculiarly like a fried egg cooking in the sun. Another image recalls more memories of the scant range of food available in Australia in the post-war period: in the 1970s three-tone Neapolitan ice cream was the exotic dessert upgrade from the banality of plain vanilla, and is now seemingly repeated in the land formed from the carotenoids in Hutt Lagoon. Other images clearly show patterns of a fractal nature that seem more like animal hide than landscape: a coastline at low tide looks like the close-up of a reptile, a mudflat has the leathery appearance of a shark in formaldehyde. There are clearly some landscapes that have celestial links, either astrological fantasies and their mythological associations or simply the marking out of new constellations. One image appears as a large-scale geometric scratching of the earth's surface as a message for astral visitors: the wheel tracks on a saltpan roughly trace out the lines of a golden curve. A more ominous image transforms sheep tracks to a water trough into a landscape of warfare in its resemblance to a bomb crater. Or for those sensitive to recent Australian gothic film, it may recall a meteorite crater – a site of kidnap, torture and murder.

Woldendorp sees the vast Australian landscape as frightening, but it is not necessarily its large scale or the condition of the horizontal sublime that produces such an effect. The landscape is also intimidating in its association with both fictional and real-life horrors. The latter lingers in the murky home-brew shallows of temperamental rivers that occasionally feed into the rip-scattered, wind-blown ocean. These sparsely populated locales have been the regular setting for fatal events, continuing the legacy of frontier violence in the form of disappearances, drownings, suicides and axe-murders; elements of a horror show that are recounted in private conversations and memories, but register little in the public domain after the event.

One figure of interest in the abstractions provided by Woldendorp is a parasite-like figure, something akin to a hookworm, which works as an interesting motif for the series of images. As a pathogenic microscopic figure, it can work as a

metaphor to the discomfort that lingers in the landscape. The parasite not only figures the hidden traumas of the land, but it also represents modern industrial exploitation of the land. Donald Horne's critical account of Australia as the lucky country famously describes the origins of Australia's fortune. Horne contends that Australia's position in the world has been attained more by a result of plain luck rather than innovation. And that 'it has exploited the innovations and originality of others and much of its boasting is that of a parasite' (Horne 1964: 7). But it is not only through the exploitation or import of foreign innovations that produces this image, the pock-marked landscape of mining also recalls a feeding parasitic figure.

The aerial view has served an important role in the mining industry, particularly in geological surveys that look for anomalies in the land for clues to its mineral content. Once suitable resources have been identified, the extraction (or feeding) can begin. Woldendorp rightly asserts that the aerial view can reveal the evolution of the landscape, but it has also an essential part in the ongoing evolution of the landscape. One plane flight that is now a part of Western Australian mining folklore is recognised as initiating the post-war mining boom in the country. The legend of Lang Hancock as an iron-ore magnate begins with a low-level plane flight through some Pilbara Gorges to avoid thick cloud and the chance discovery of a vast seam of iron ore. In the same post-war period that Hancock descends in his aeroplane to discover mineral wealth, Woldendorp begins to use the aeroplane as a platform to mine the aesthetic treasures of the land.

Woldendorp's photography can be seen as a part of this post-war transitional period for Australia. It is tied in with changes in Australian industry, population, migration and perceptions of its landscape. As its economic fortunes grew, so did Australia's confidence in distinguishing itself as a nation culturally and socially independent from Europe. McDonald (2008: 3) writes, in 1968 'while demonstrations raged in Paris and the Russian tanks rolled into Prague', Wolderndorp co-published his first book *The Hidden Face of Australia*. McDonald (2008: 3) continues:

> Far away from the uproar and turmoil of the old world, Australia seemed like an oasis of peace. Its ancient rocks, its distinctive wildlife and plants, were presented as reasons to be proud of a country that had always seemed isolated, too hot and too dry.

This landscape at the heart of Australia, while not necessarily visible from the verandas where the beer bottles chimed, was gaining in popularity in photographic and televisual form in the 1960s and 1970s.

One of Woldendorp's images provides a counterpoint to the combination of natural and industrial abstractions by showing Australians at leisure on the beach. Here, Woldendorp clearly identifies the landscape that Australians prefer to inhabit. While the interior of the country is suitable for vicarious aesthetic pleasures and industrial exploitation, it remains largely uninhabited compared to the populated fringes of the continent. Woldendorp upholds this distinction between an unpopulated interior and settled coastal region by eschewing the human form. The one exception of Australians uniformly spaced on the beach, facing the ocean with their backs to the interior, indicates confidence in their position in the world. Seemingly, the vast landscape of the interior requires little contemplation after the spoils have been collected. In the 1960s Donald Horne announced that this confidence was misguided. For Horne (1964) the post-war prosperity that Australia was enjoying was not a result of superior innovation, originality or intellect, but was rather a result of plain luck. Some of this luck is evident in Australia's geological circumstance, where minerals and energy are increasingly providing a glow to the country's balance sheet. Horne was concerned that Australia could not ride its luck for much longer, expecting the gambler's good run to end. He particularly feared that Australia lacked the adaptability to respond to global forces, thus placing the country's prosperity at risk. Subsequently the ironic tone of the book's title would be reshaped by the popular imagination. In an innovative feat of anti-intellectualism, 'the lucky country' became employed more readily as a term of communal gratitude for one's lot.[6] The beach has provided a comfortable and relaxed setting for this shift to occur.

The mythical Australian landscape that emerged from the post-war era is a unique, beautiful and lucky country. The history of colonisation suggests something different. Following Gibson, the new myth may resolve, or displace, contradictions in the historical narrative that critics and historians like Ross Gibson and Henry Reynolds identify. Woldendorp's images have served a part in developing this more recent myth. His images present the landscape as a part of some broader universal plan. His abstractions allude to both a terrestrial and celestial space, and suggest the presence of tensions or fault lines between our economic aspirations and the environmental realities we encounter in the landscape.

I have provided some alternative readings from Woldendorp's abstractions (some of which could be accused of being fanciful), for consideration of the possibility

that abstraction does not necessarily mean the abandonment of context, to show that the Australian landscape can prevail as a badland even when presented in abstract forms. Yet, there is something in Woldendorp's abandonment of the horizon line that suggests there is some form of unburdening taking place. A moment in Woldendorp's *Abstract Earth* exhibition video illustrates the freedom of abstraction. The video contains many images that are also a part of the print exhibition and book. However, one of the images from the show has been inverted in the video. Without the presence of a horizon line in the image, the landscape is free to escape the regulations of gravity. The removal of the horizon line cuts the anchor that unites all landscapes. The horizon is a datum line; without it the landscape is apparently free to turn and any edge of the frame can operate as a surrogate to the horizon. The extension of this is that the abandonment of the horizon line risks the abandonment of context.

Eliminating the horizon is a type of visual liberation; it not only frees the Australian landscape from the burdens of the horizon, but also, for a photographer, it frees them from the persistent burden of negotiating the horizon in the viewfinder. The horizon reminds the photographer of the burden of context. The camera is by its mechanical function a tool of abstraction. It takes a fragment of the world, a piece of space and time selected from an infinite number of possible alternatives, yet so often in landscape photography the horizon lingers on in the background. It is the frontier of the landscape image, irresistible and unyielding. It can work as a lingering reminder that something needs addressing, namely, context – the postmodernist's burden.

Removing the horizon follows the established pattern of repression or forced forgetting that Gibson recognises has been used as a coping mechanism for the settler societies in Australia. It can operate as a metaphor for the suppression of trauma that is peculiar to the Australian interior – trauma that has occurred via Aboriginal dispossession of the land and also the peculiar effect that the landscape has had on the settler psyche. These traumas linger in the plains, but they can be pushed out into the distant horizons. The horizon is a permanent frontier. Taking to the air can seemingly remove these traumas all together, lifting the burdens of both the horizon line and context. It is a strategy that enables the landscape to be reshaped by the popular imagination, to be visualised in a way that resembles something more akin to a 'lucky country'.

There are of course a multitude of contexts that affect the Australian landscape. Histories of conflict at the frontiers of colonial settlement and Aboriginal dispossession should figure heavily in the cultural memory. And there have been

symbolic and practical interventions in modern Australian culture and law that acknowledge these histories. The recent history of post-war industrial exploitation of the land also needs reckoning, not only with the visible impacts of mining, agriculture and tourism (the media is replete with examples of an environment under increasing stress from industrial exploitation), but also with the growing disconnect the working population has with the local landscape, as displayed in the popularity of fly in/fly out programmes in mining regions. Today, reconciliation with the land is dependent on a number of histories – traumas associated with colonial settlement, environmental damage and industrial history. The significance of these histories tends to shift over time in the public sphere, promoting some at the expense of others. Today we have an enhanced focus on the stewardship of the land. Past environmental damage (which has impacted on economic output) has made this an economic and environmental necessity. But, this has not necessarily always coincided with the acknowledgement of brutal social histories. Better environmental stewardship can even operate as a sedative for the moral discomforts that may surface from time to time in the ongoing denial of history. The 'feel good' factor of dealing with environmental problems can assuage the problems of Australian 'ancient' history, particularly when some of these ecological issues are referred to as the 'moral challenge of our times'.[7]

A position against abstraction, particularly in photography, is that it effaces content for form, and in the process holds back important histories. The abstraction of the Australian landscape into a series that highlights form over content, as Woldendorp does in *Abstract Earth*, could be criticised for being part of an agenda, intentional or otherwise, that seeks to mask the landscape from unpleasant histories. But perhaps, on the contrary, the strength of the land, which Woldendorp identifies in an interview, lies in the fact that even when turned into abstract landscape, it remains charged with histories and associations, both positive and negative. While the abstraction may not be forthcoming with accounts that are readymade for public consumption, it can still motivate memories that linger in private conversations and occasionally register in the popular media.

Gibson has noted if we wish to take instruction from our badlands, we need to be alert to those particular histories and characteristics of the landscape that channel discomfort. He sees a benefit in societies that develop techniques of mourning where guilt and threat are 'lived out', and its people 'start to earn some kind of worldly wisdom, scars and all' (Gibson 2002: 159). As an example, the Australian polity has in recent years recognised some of those scars and sources of discomfort. However, a current risk is that concerns over environmental stewardship and the

visual abstraction of the country's interior can provide a useful distraction, or even denial of the ongoing discomfort we can feel when we encounter the 'dead heart' of Australia. In such a case Woldendorp's abstractions pacify the landscape. We need to question whether we have done enough to make peace with the landscape.

1 Australians also are largely tourists of this landscape. Even in non-leisurely pursuits, connection with the land is temporary at best. The resources sector relies increasingly on an itinerant population in the form of FIFOs (fly in – fly out).

2 Mepham (1993: viii) identifies isolated and uninhabitable places as possible twilight zones in the popular imagination. In his commentary on Shelley's *Frankenstein*, he sees the character of Walton as an archetypal explorer, one who travels with the

> hope or fear that they might come across the presence of the supernatural, or where there might take place some leaking of supernatural force into the human world.

3 Such an experience can be habit forming, and it can prolong into built up urban spaces. Baudrillard (1988: 69) notes that

> when you emerge from the desert, your eyes go on trying to create emptiness all around; in every inhabited area, every landscape they see desert beneath.

This experience seems unavoidable in a place like Western Australia with its small population density. Driving into Perth from the north, the suburban enclaves gradually appear from out of the scrub and farmland, and the city is quickly negotiated via the freeway, falling away as quickly as it appears, ceding authority to the horizon. In such moments even a city can appear as a mere aberration in the landscape.

4 Carter (1987: 197) notes that while the overbearing horizontality of Australia's interior can incite dread and fears of annihilation, it can also appeal to a sense of freedom. The plain 'open in all directions [is] the place where all futures are possible'. The Australian landscape can be considered both muse and monster. (This dual aspect of the landscape is evident in religious narratives where the prophet ventures into the desert; while it is a place of suffering it simultaneously offers a path toward redemption.)

5 In the period of high modernism in Australian literature, writers like Randolph Stow also saw a relationship between the landscape and human existence. However, the landscape for them was a site for metaphysical exploration, a means for exploring the purpose of human existence (Hassell 1986). The belief was that the landscape could provide clues into the workings and characteristics of the human psyche. The landscape could help in the existentialist's wilful exploration of determining how to live. The question introduced by Woldendorp in a period of high anxiety over climate change is more akin to 'will we live?'

6 In the past decade the conflicting functions of the 'lucky country' have re-emerged. With the recent resources boom, we find ourselves in a position of global economic advantage due to geological circumstance and Chinese economic expansion. In its positive use luck implies a blessing, but it can also indicate fortune that is undeserved, and potentially at risk. At the turn of the last century, years of depressed prices in mining and farming products revealed the limitations in Australia's heavy reliance on primary industry. There was a growing call for Australia to become a clever country, to invest in technology and raise its profile in intellectual industries, and limit its exposure to the fluctuations of global demand in resources and agriculture. Ten years later the mining industry is booming and playing a large role in sheltering the country from the global economic downturn, silencing the voices that maintain the need for industrial diversity. Yet speculation over the threats of sovereign risk, excess capacity and property bubbles may bring those voices to the fore again.

7 In the case of Queensland's Wild Rivers Act, designed to protect the rivers of the Cape York Peninsula, Noel Pearson, the former director of the Cape York Institute, sees something even more sinister. He has noted that after symbolic and legal recognition of Aboriginal rights to land in the Mabo and Wik decisions, the Wild Rivers Act now effectively removes a lot of the freedoms granted, particularly around rights that would allow for the economic development of land by the local Cape York population. It is much easier to pass acts of environmental stewardship into law when they do not impact on the political and economic centres where the majority of the vote is cast.

CHAPTER 10

Wastelands

While representations of wilderness and the unspoilt natural environment remain popular in our culture's image bank, there has been a growing interest in bleaker interpretations of landscape. The more dismal landscapes of the city that wilderness photography tends to placate have become increasingly popular among photographers. The economic and industrial expansion of the post-war era has provided photographers with plenty of subject matter to explore this darker side of landscape (see figures 21-26).

It was during this period that the artist Robert Smithson began noticing the alluring and peculiar characteristics that are common to the industrial zones of a city, particularly when they start to lie dormant and abandoned. Like some of the 'New Topographics' photographers of the time, Smithson was alert to the redeeming qualities of spaces that are often viewed negatively, and as a consequence he challenges the implicit hierarchies of landscape. Smithson (cited in Sobieszek 1993: 34) states:

There was not much room for contemplation in solitude in [urban spaces, nor in wilderness areas such as Yosemite] … Yosemite is more like an urbanised wilderness with its electrical outlets for campers, and its clothes lines between the pines. In many ways the more humble or even degraded sites left in the wake

of mining operations offer more of a challenge to art, and a greater possibility for being in solitude.

Smithson recognised the possibility of transforming some of our commonly held views of landscape. This chapter observes how attitudes to landscape have shifted over time. Most recently, particularly through the lens of photography, there has been a shift in the way we perceive the wastelands of modernity. In recent years many photographers have taken up Smithson's challenge and made the wasteland a significant part of their work, raising the public profile of the space. The challenge of wastelands may be an opportunity to more broadly consider how we negotiate and plan our urban environments. This chapter will consider the role of wastelands in our urban environments in a period of late modernity. It also considers what these new images of wastelands may be demanding of us, particularly through the photography of Edward Burtynsky.

Wastelands are often viewed as spatial anomalies that represent the corruption and corrosion of economic and civil order, and as a consequence they tend to be corrected or hidden from view to limit the threat they pose. Wastelands are a threat on two fronts: firstly, as an incursion into the perceived order of the built environment and systems of exchange – a threat to culture; and secondly as icons of the natural world in decline – a threat to nature. When industrial spaces are operating effectively in systems of production, their impact on the natural world can be dismissed on utilitarian grounds. But as idle space, falling to ruin, they also impact negatively on the economic world, potentially implicating the surrounding social space as effete, deficient and depressed. These signs of inefficiency reveal a society in decline. And as they merge with signs of the natural world in decline, the call to remove these signs grows louder, not just from green groups but also from concerned citizens who demand the maintenance of traditional economic and spatial order. Wastelands are landscapes which simultaneously represent the downfall of culture and nature. The common reaction is to remove the evidence of decline; ameliorating the wasteland acts as a tonic for our anxiety. But we should not confuse the symptom for the cause. This tonic will do nothing to assuage the destruction that comes with progress; in fact, it may even exacerbate the problem by masking ongoing ill-effects.

Meanwhile, some recent photography of wastelands can also be similarly accused of taming the landscape. A trend has developed where the traditionally derided, erratic and incomplete space of wasteland is often made aesthetically whole by adopting an aesthetic language more at home in images of picturesque and sublime natural scenes. A conflict emerges in the image between our expectations of the subject and its presentation. Lifting the wasteland to aesthetic realms normally reserved for the valorisation of natural wilderness challenges conventional hierarchies of landscape. This chapter promotes such challenges; new encounters with wastelands, even vicarious ones, may inspire new ways of ordering and creating space that go beyond the didacticism of current urban trends where renewal of a city often means the erasure of the unique properties that many people

and photographers see as the attraction of wastelands. However, such action is not without criticism: it has the potential of redeeming the destructive tendencies of industrial capitalism, and it can also marginalise or mask social conditions that are pertinent to the history of the wasteland.

Wastelands are one of the necessary outcomes of modernity. However, in recent decades as cities in the West have developed, city planners have done their best to either hide or erase their presence. Berman (1983: 35) has effectively documented the turbulent experience of modernity that gives rise to wastelands. Quoting Octavio Paz, he writes:

> Modernity is 'cut off from the past and continually hurtling forward at such a dizzying pace that it cannot take root, that it merely survives from one day to the next: it is unable to return to its beginnings and thus recover its powers of renewal'.

Berman espouses a reconnection to the modernisms of the past that is necessary to 'give us back a sense of our modern roots' (Berman 1983: 35); 200 years of traumatic global change, facilitated by industry, capital and technology, can be illuminated by returning to the roots of modernism in early modernist thinkers like Neitzsche, Baudelaire, Dostoevsky and Marx. He suggests that going back is necessary to move forward. However, I do not see the recent popularity of photography in wastelands as an effort towards unifying a disintegrating or displaced society. On the contrary, I see it, in part, as a reaction against the increasing levels of order and unity that are displayed in the cities of late modernity. These cities have bunkered down through their deployment of design and surveillance strategies that intentionally discourage signs of disorder; this allows progressive modernity to continue unfettered. The destructive forces that accompany progress (or economic growth) are seemingly restrained, but these forces are increasingly hidden from view, or exported to developing countries. The cracks in the urban armour that wastelands represent are reminders that the tempest of modernity continues despite attempts to create urban spaces that suggest the contrary.

Berman remains optimistic in the face of the maelstrom of modernity: the contradictory forces of progress and destruction, which inspire and torment, while impossible to stop, have a potential unifying quality particularly as they impact on all humanity. Berman thinks we can embrace this tempest as our own, as a unique feature of our times that we all experience. However, in late modernity, rather than embracing the storm, we have battened down against it. We make

our best attempts at denying its presence through the implementation of ordered urban design practices that assume all is well. Societal order is not a negative per se, however, too often we create ersatz orders as anxious responses to destructive forces unleashed in our drive for progress and economic growth. As we do so the wreckage of modernity is increasingly pushed to the fringes – out of sight and out of mind – into the city's margins or further still across the oceans into the developing world. Meanwhile, we the modernised can assume an absence of destruction. Recognising wastelands forces us to face this destruction.

Photography has played a large role in shaping the city in our memory and imagination. The modern city, as an American invention, coincides with the popularity of American street photography undertaken by the likes of Weegee, Robert Frank, Garry Winogrand, Lee Friedlander and Joel Meyerowitz. At the heart of much of their imagery is the visual and social relationship between people(s) and the city. These images sway between poles of criticism and celebration of the modern American city. The people in them appear alienated, anxious, remote, proud, enduring. A range of adjectives describes the way they relate to the city. Architectural photography has also shaped the modern city by celebrating its grand structures and designs. The familiar and functional parts of the city are promoted as progressive and modern by its civic leaders and architects. However, increasingly, photographers have been focusing on the marginal and maligned spaces of the city. The subject matter is still figured in the urban, but the spaces are no longer ordered, legible or functional. The city cracks along numerous fault lines of accidents, redundancies and failures and reveals a face seemingly unrelated to the progressive city. The historical link of photography to the progressive city enables the medium to comfortably enter the wasted spaces of the city also. But the tradition of the city as a populated space is contested here; instead the city is often figured as empty. These images provide a useful challenge to the established order of the city.

The nomenclature used to identify the abandoned and marginal spaces of the city varies. Sola Morales (1995) figures these areas as *terrain vague* and Picon (2000) labels them a city's anxious spaces. A more common interpretation is ruin. A large component of the modern wasteland is the industrial ruin. Currently, there are a multitude of websites dedicated to the subject of industrial ruins; many of them contain photographic documents of personal journeys into the space. And many photographers have revealed their fascination with the space: Burtynsky, Miyamoto, Koudelka, Polidori and Kobayashi are some photographers who have published monographs on the subject. Each approaches the subject with varying

mixes of criticism and aesthetic celebration. The interest in modern ruins has also spread to academia: Edensor (2005) explores the aesthetics and materiality of industrial ruins, believing these sites can inspire new forms of urban design. Despite variations in the way the subject is tackled, most, however, acknowledge their subject as ruins. For example Edensor (2005) has titled his book *Industrial Ruins* and Kobayashi (2001) simply *Ruins*.

Yet, this category of ruins can often feel inadequate to describe the modern abandoned industrial space; there is seemingly more than ruin and industry at play in these sites. Firstly, reading these spaces as industrial ruins limits their scale. Ruins are largely about buildings and structures in entropic decline; they rarely induce the imagination to consider more broadly the space that surrounds the ruin. Ruins are enclosed space, yet the space that surround some industrial ruins can continue for miles. The ruins may be a focal point, but you cannot isolate it from its context; the surrounding landscape was often as important as the ruin. Sometimes the landscape itself is the industrial ruin. For example, in the Western Australian Wheatbelt, salt-affected farmland creates unique landscapes that avoid description as ruin in a traditional sense. There is little evidence of built structures. Instead, all one often encounters is open horizontal space. Similarly, the exploitation of the Aral Sea for cotton farming in the Soviet era has created a desert-like landscape where the water has receded. Evidence of ruin is limited to the ships that remain stranded on the old sea floor. Changing focus from industrial ruins to wastelands provides a way for space to be more broadly incorporated into the discussion. Ruin does not encompass land as effectively as land encompasses ruin.

Another limitation of the categorisation of industrial space as ruin is the way in which the historical application of ruins contrasts with the way the broader public generally perceives industrial ruins and surrounding land. Traditional ruins harbour a certain level of cultural authority and authenticity while industrial ruins often do not; these modern ruins are largely a derided space. The categorisation of this space as wasteland provides a necessary distinction from its counterpart of ruin. It has a much stronger and exclusive connection with contemporary spaces of modernity. Ruin, although still very evident in modernity as the accompaniment to progress, also carries strong historical connotations that place the term in sites that existed prior to the industrial revolution. Ruin is particularly concentrated on sites of antiquity. Waste differentiates our epoch from earlier ones. Although waste is not exclusive to modernity, its abundance is.

The perceptions of modern and ancient ruins are further affected by their prevailing composition. Roth (1997: 1) notes 'that the meaning of the word "ruin"

has its origins in the idea of falling and has long been associated with fallen stones'. Masonry dominates ruins of antiquity; the remnants and rubble, largely unprocessed compared to modern ruins in wastelands, is welcome to return to the bosom of nature. Roth (1997: 5) continues:

> The poet walking among the ruins does not feel the terror of the sublime but instead is swept along by nature's capacity to integrate different stages of human development into a balanced whole.

In contrast to this Picon (2000) identifies a transition from ruin to rust in the abandoned sites of the industrial revolution. Rust is an apt distinction, but it does not end there. Other by-products of the industrial revolution also linger, for example, in the form of slag heaps and tailing ponds. This transition, then, is not just from ruin to rust, but also to waste. Picon (2000) recognises that modern sites of abandonment and decay incite different responses to older ruined sites of antiquity. There is an aesthetic and psychological shift in the way we respond to them. Roth (1997: 1) notes:

> In the European traditions the classical ruin is elevated out of oblivion into a particularly exalted position of contemplation or even worship.

This is hardly the case for modern ruins that reside in the domain of the wasteland. As progeny of the industrial revolution, Dickensian images of urban destitution project easily upon them. In contemporary ruins of rust, we no longer move in exalted realms, but rather anxious ones. Waste induces anxiety, especially when the world begins to strain under ever-increasing amounts of it. And waste manifest in land creates the anxious landscapes of modernity as Picon (2000) identifies it, a response that is quite distinct from those produced by ancient ruins.

In wastelands we are witness to ruin that is too close to our own existence and time to view them simply with the wonder and awe that is normally associated with ancient ruins. A more problematic response is elicited in the ruins of wastelands. Traditional ruins are symbols of cultural virtue, longevity and value while ruins of wastelands are symbols of cultural, social and economic decline. What becomes apparent is that through the emergence and influence of wastelands, ruins acquire a split personality. We can begin to identify this split along these lines: ruins are ancient and medieval history while wastelands are modern history, especially industrial history. This split is developed further in the table below.

Ruins	Wastelands
Celebrated	Denigrated
Monuments	Problems
Balanced	Unbalanced
Poetic	Prosaic
Tamed	Feral
Cultural	Post-Cultural
Vertical	Horizontal
Enclosed	Open
Excesses of the past	Excesses of the present
Warning	Threat
Chronological	Limbo

Ruins warn against hubris and ideas of continuity and eternity, while wastelands are an imminent threat to existence now. This threat can linger either as a symbol, or more accurately, as an index of a general decline in the health of our environments, or, rather more directly as in the cases of places like Chernobyl, as a direct and immediate danger. Wastelands are a greater challenge to beliefs of continual chronological progress. They are sites in limbo: a time and place between the extremes of annihilation and regeneration, lingering in loss and expectation. Ruins and wastelands diverge at the point of value, but this distinction is not necessarily permanent.

Neither wilderness nor ruin can lay claim to a permanent hallowed ground. The value that I have attributed to ruin as a distinguishing feature opposing wastelands has not always been present. Cultural value, like currency value, fluctuates. For example, Edensor (2005) discusses the cultural transition of the Coliseum in

Rome in the nineteenth century. The Coliseum was once unappreciated by the local population. Centuries of neglect had covered the Coliseum in verdant undergrowth. Non-Romans saw its romantic potential: unkempt and unpoliced, it provided a rich sensory experience. The development of photography in the nineteenth century along with the expansion of the archaeological sciences and burgeoning tourism raised the awareness of Roman ruins globally. Italian nationalism saw an opportunity to promote a unique and continuing heritage through its ruins and eventually the site was reinterpreted to serve the interests of nation, tourism and modern archaeology.

Similarly, wilderness has not always been a valorised space. Today, wilderness is often a representative of perfected unspoilt nature, but the natural world has not always held a noble and lofty position. As Seddon (1997: 7) affirms:

> The view that nature was inferior to … the Divine world, co-existed with its opposite, that Nature itself is Divine, through most of the Middle Ages and beyond … Contempt for the natural world – the *contemptus mundi* – was exemplified by the lives of the saints; in its extreme form, it denied value to the natural world, to the self, and to all pleasure.

In the Australian context the shifting ground of nature is exemplified in the landscape of the Snowy River.

> The Snowy River was often described as a 'wasted resource'. It is now a 'national heritage', although it was a much more powerful river during its days as a 'wasted resource' than it is now as a 'national heritage'. (Seddon 1997: 22)

A shift towards nature revered is also evident in nineteenth-century United States. Giblett (2004) and Wilson (1991) have both documented how the United States, lacking in cultural heritage in comparison to its ancestral Europe, could turn to its natural heritage to symbolise the nation's moral and cultural authority. Ultimately, ruins as representatives of culture, and wilderness as representative of nature, are malleable concepts that fluctuate and shift according to the wants and needs of communities and nations. It would also follow that as our perceptions of wilderness and ruin have been susceptible to change, our perceptions of wastelands are liable to change also. Recent photographic interventions into the space suggest this is already occurring.

Of the photographers working in this field, landscape photographer Edward Burtynsky is perhaps the best known, and the one whose publications have been consistently aligned with the subject of wastelands. Burtynsky photographs a range of industries that have a heavy impact on the local landscape, providing the viewer with multiple permutations of industrial space. He often presents the destructive features of the industrial landscape in a picturesque manner that at times merges with the sublime. The aesthetic attitude adopted is usually more at home in presenting wilderness and nature uncontaminated by human presence as sites of Eden and natural paradise. Burtynsky's images also adopt and adapt representations of nature as sublime. Human invention and intervention seemingly challenge nature's claims as an awesome force beyond understanding and control. Often in his images the natural sublime is supplanted with the human marvel of the technological sublime. The scale, terror and wonder of the industry that he photographs is at times a match for the sublime images we usually associate with the natural world. The terror that is a part of the aesthetic of the sublime is further compounded by the threat of nature retaliating in the guise of what we now know as climate change.

One of the criticisms of Burtynsky's photographic documentation of industrial sites and wastelands is that it aesthetically performs a redemptory role for spaces that are broadly considered undesirable. These spaces sit at the opposite end of the spectrum to scenes of spectacular wilderness, yet Burtynsky manages to render the spaces in a way that produces similar affective responses. Destruction and excess are presented as spectacular and awe-inspiring landscapes, showing the subject matter to be in clear conflict with our expectations for the chosen mode of representation. The aesthetic transformation of the subject in Burtynsky's images can upset the normal relationship the viewer has with the subject, making the viewer uncertain of the photographer's intentions. Yet Kingwell (in Burtynsky 2005: 18) asserts that Burtynsky is not presenting confusing images as an end in itself, but does so to generate 'dialectically new insights about our relations to technology, to beauty, to production and consumption'. The danger is that 'beauty' acts as a masking agent to hide the social and environmental realities of the sites he photographs. Aesthetic aggrandising may actually trump any concerns about our relations to technology, production and consumption.

Pamuk (2005: 231–232) identifies a shared characteristic between people who find beauty in degraded sites. He suggests that

those who take pleasure in the accidental beauty of poverty and historical decay, those of us who see the picturesque in ruins – invariably, we're people who come from the outside.

Pamuk's choice of pronoun identifies himself as an outsider, but it also makes assumptions about the readers' position. The outside position is invariably the one that most people occupy in reading Burtynsky's images. Any adverse impacts of the industrial site are contained to the local area, allowing the viewer to more freely ponder the relationship between beauty and decay. This is also part of the argument that Jerry Herron takes up against Jose Camillo Vergara's images of urban decline in central Detroit. Vergara's fascination for Detroit's ruins has led him to make an ironic call for the creation of an urban ruins park, something in the order of an American Acropolis (Vergara 1999: 15). Yet the city centre remains populated by those that did not take part in the flight to the surrounding suburbs in the 1970s. For the people that remain the ruin is anything but a theme park. The outsider's view is a privileged one, they get to choose how they negotiate the space, and they can also leave; for the insider, or the resident, it remains home.

The reclassification of a wasteland as beautiful, or even as an archaeological ruin of significance, recoups some value from it, especially if the site is no longer economically viable. Pamuk and Herron both suggest that it is the outsider that is most capable of performing such a feat. Mayer (2005), however, recalls how his first viewing of Burtynsky's images of his hometown filled him with nostalgia. Sudbury, Ontario, is known for its nickel industry and the Burtynsky photographs from the region helped Mayer (2005: 10) recall a

fondly-remembered youth spent among slag dumps, open pit mines, vast and arcane industrial sites and the broad ring of barren blackness that once made Sudbury NASA's surrogate moon.

Instead of the images filling him with horror at the environmental damage, or even wonder at the photographer's technique, nostalgic memories were recalled of a pleasant childhood in a lunar-like wasteland. For some people, their home is an environmentally abject place. The presentation of these spaces as beautiful can be an affirmation for those who live there. Mayer's account fits in with the image of derelict sites as playgrounds for the youthful. Young eyes need not necessarily focus on the implications of environmental degradation; instead they see a space of potential freedom, a site of free expression and activity, void of the supervision

and surveillance they are normally subjected to in populated areas of the city; such freedom is expressed regularly by urban artists and urban explorers.

Mayer holds his viewpoint as a deeply personal account that is not shared by many others, at least by those who do not live in these locations. Mayer (2005: 10) recalls the loss of his unique landscape to a rehabilitation project:

> When you spend a lifetime hearing your place of origin described as the 'armpit of the universe', you begin to take it for granted that you may well be alone in finding it beautiful. And when you return to the same place after many years, having seen the world's capitals and a number of its great parks and gardens, only to find that the sweet, unique wasteland of your youth has since been forested … well, the sense of alienation is sharp.

Common sense reactions to wastelands can limit the way we imagine the space, but these limits are not fixed. Partly out of necessity, Mayer, in his childhood, was able to refigure wasteland as playground and home. He not only disrupts common assumptions about wastelands in the process, he also disrupts Pamuk's assertion that it is the outsider that invariably takes pleasure in the accidental beauty of degradation. But it was not just necessity that drove Mayer to this view; there is a sense of inevitability also. Affections for home can make a person sympathetic to their local environment.[1] Home in any condition can be a source of authenticity and identity. These sympathies are enhanced when these affections are developed in childhood. What we need to recognise is that to render a traditionally maligned landscape as spectacular and unique does not necessarily marginalise history – in Mayer's case it returns it to centre stage.

The aestheticisation of wastelands evokes necessary ethical questions. And photography has a significant role to play in the ensuing tug-of-war. Aesthetic traditionalists, with their cameras, may unite on one side of the rope, and the materialists on the other with their feet firmly grounded in social histories; but there is no guarantee that all battles will be played out like that. Landscape aesthetics are also embedded in the historical and social, as Mayer's example reveals. Aloof romantics and outsiders may use aesthetics as a springboard to escape the gravitational pull of historical responsibility, but it can also be used as a viewing platform from which we are enticed to view damaged landscapes in new ways. The choice is up to us whether we choose to get off the platform and engage with them in new ways, or remain on the platform and continue enjoying the spectacle. Ethics then emerges with how we acknowledge history. For Sontag

(2004: 103), 'remembering is an ethical act, [it] has ethical value in and of itself'. A positive aspect of wastelands is that they entice us to remember, not with the nostalgic glaze of ruins, but with an eye firmly maintained in late modernity, upon the balance sheet of progress and destruction.

This chapter promotes new encounters with wasteland. Re-imagining this space in new ways weakens the limits implied by classification, not just in the wasteland, but also in the broader urban environment. New bodily encounters with modern spaces in decline may inspire new ways of reordering the space and broaden the ethical scope we base these decisions on. Mayer discovered to his dissatisfaction that the prevailing 'green' ethic had erased the site of his childhood playground. Many assumptions about wasteland are a manifestation of the moral dichotomy of nature as good and the deeds of man as bad. Such an ethic is limiting and problematic. It discounts the relevance of the lived and living human experience that was and is possible only on such a land and it dismisses the cultural context of nature. To consider the effect of wasteland upon the mind and body outside of prevailing clichés built on limiting ethical assumptions can in turn renew our ethical base.

Romantic aesthetics of the picturesque and the sublime have traditionally played on the side of the environmentalists: images of nature impressive, majestic and untouched, as in Peter Dombrovskis's Morning Mist, Rock Island Bend (see Figure 10), are often employed to reveal what is at stake in contests between the environment and development.[2] Images of defiled nature that remain impressive begin to undermine the traditional aesthetic monopoly. These images are unlikely to be incorporated into the arsenal that economic interests use to gain control over natural realms, but they do reveal that aesthetics is a shifting language. It is not a law cast in stone, permanent and unchanging, but is instead adaptable and malleable. The application of aesthetic language then becomes an ethical issue. Some legitimate questions emerge: is destruction excused, or our moral discomfort displaced, through aesthetics? Is obtaining pleasure from the traditionally displeasurable justified? But what such questions reveal is a material and aesthetic conservatism at the heart of some of this criticism. The aesthetic about-face in some photographic representations of wasteland has challenged the conventional and limiting narrative normally found there. Like aesthetics, narrative does not need to remain fixed and closed. Wastelands are not tamed, but are uncaged by such representations; destruction is still questioned; it is the answer which is displaced.

1 In another example, in Queenstown, Tasmania, many of the residents opposed calls to revegetate the denuded hills that dominate the entrance to the town. The effects of mining, pollution and soil erosion over many decades had created a unique lunar landscape. In recent years, greater public awareness of environmental issues has coincided with the amelioration of many damaged industrial landscapes. Yet, for some residents of Queenstown, their barren hills provided their town with a unique identity, in a part of the country that is recognised for its natural beauty and wilderness. Hay (2002: 62–63) recounts one resident's response: 'if the reveg goes ahead … this'll be just another town with no real attraction. Like Roseberry'.

2 The Dombrovskis image Morning Mist, Rock Island Bend was successfully employed in the 1980s environmental campaign to stop the damming of the Franklin River in Tasmania. The development was a part of that state's ongoing expansion into hydro-electricity. The appearance of the image in the national broadsheet, employed by the Green movement to show the landscape that was threatened by flooding, swung popular opinion their way.

Challenges to the Established Tradition

ROD GIBLETT

Nuclear Landscapes

The tying together of American nature and nation in Ansel Adams's work becomes unravelled in the work of the 'explicitly activist' nuclear landscape photographers who mounted what Mike Davis (2002: 39) calls 'a frontal attack on the hegemony of Ansel Adams, the dead pope of the "Sierra Club school" of Nature-as-God photography' with 'his apotheosized wilderness vistas'. They were also murderous sons who killed their own father (as Rebecca Solnit (2003: 91) considers Adams to be 'the Great Oedipal Father of American Landscape Photography') and married their own mother earth or nature in an incestuous relationship. They also re-established an alternative lineage (on their (great) mother's side?) with Timothy O'Sullivan whose photographs of what Solnit (2003: 66) calls 'an array of weird formations and geological wonders' hang like a ghost over this work and its predecessors in the 'New Topographics' (as Juha discussed in chapter 8), not merely for the clarity and precision of his depiction of the deserts of the American West, but also for his invocation of the uncanny underside of the earth (as discussed in chapter 5 above). Yet whereas O'Sullivan was able to see, as Davis puts it, 'the West pristine and unspoiled', the nuclear landscape photographers saw 'the poisoned, terminal landscapes of Marlboro Country', the result of the testing of nuclear bombs in the American West (Davis 2002: 40 and 35), especially at the 'Nevada Test Site'.

Ironically and recently Michael Lundgren (2008) has been able to see the West, including the Barry M. Goldwater Bombing Range, as pristine and unspoiled, or at

least he has transfigured (*Transfigurations* is the title of his book) the West back into the landscape of Timothy O'Sullivan's wilderness photographs with cones, fissures and vents. Lundgren's photographs also mark an ascension and resurrection from the wounded and crucified earthly body of the desert of the nuclear landscape photographers into a sublime, eternal, enraptured and perfected heavenly body.

Located 60 miles north of Las Vegas, the 'Nevada Test Site' is described by Solnit (1994/1999: 208; 2007: 1 and 128) as the 'most bombed place on earth' with 1000 nuclear bombs having been detonated there between 1951 and 1991. Between 1951 and 1963, 100 of these detonations were carried out above ground creating what Bourke (2005: 262) euphemistically calls 'severe problems with radioactive fallout' with all Americans becoming 'down-winders' and some Utahns in particular suffering severe consequences to their health, lives and livelihood. These impacts have not been documented by any of the nuclear landscape photographers who depict lands and animal bodies, but not human bodies, and not lands as bodies. These photographers are unlike the Utahn nature writer Terry Tempest Williams (1991; see also Davis 2002: 46) who in *Refuge: An Unnatural History of Family and Place* evokes these impacts and figures the body of her mother as land, and her motherland as body (as we will see below).

This difference between nuclear landscape photography and Williams's nature writing highlights and adumbrates a difference between landscape photography (akin to landscape writing) and nature writing. Landscape writing and photography aestheticise the static surfaces of nature. Both can be contrasted with nature writing that celebrates its dynamic depths. Elsewhere I define nature writing as the creative, written tracing of the bodily and sensory enjoyment of both the processes and places of nature (see Giblett 2011: chapter 1). Nature writing defined in these terms is thus much more than simply the writing of place, or the expression of a sense of place. It is the celebration of the flows of life and energy in and between a body, a place and their natural processes. The work of Henry David Thoreau (as I have shown previously; see Giblett 1996: chapter 10; 2009: chapter 1) and Terry Tempest Williams (as I will show below) are exemplary in this regard, whereas the work of William Wordsworth is a prime example of landscape writing (as I have shown previously in Giblett 2011: chapters 3 and 4) and that of Ansel Adams and Carlton Watkins of landscape photography (as I showed in chapter 5). I define landscape writing as the creative, written inscription of the visual appreciation for the surfaces of nature in the aesthetic modes of the sublime, picturesque and beautiful. Similarly I define landscape photography as the creative, photographic inscription of the visual appreciation for the surfaces of nature in the aesthetic

modes of the sublime, the picturesque and the beautiful. Such photography runs up against its limits in the deserts of the American West, whether it be in Timothy O'Sullivan's photographs of the grotesque and uncanny fissures and vents of its geological monstrosities, or Richard Misrach's photographs of the blasted and blighted carcasses and craters of its thermonuclear fallouts.

For Solnit (1994/1999: 5, 15) the Nevada rehearsal (rather than test) site is 'the place where the end of the world had been rehearsed since 1951'. As this was the year in which I was born, the beginning of my life in the rainforests of Borneo has the dubious distinction of being contemporaneous with the rehearsals for the end of the world on the opposite side of the world in the deserts of Nevada. My entire life has thus been lived in the shadow of the bomb and its threat of death, and under the reign of nuclear terror. Rather than making 'nuclear war a terrible possibility', these rehearsals made the rehearsal site into 'an ongoing regional catastrophe' as Solnit (2007: 128) goes on to point out. They also made the rehearsal period into an omnipresent global threat. As these rehearsals 'shook the earth' and created 'limited earthquakes' as Solnit (2000: 7; 1994/1999: 16) points out elsewhere, the rehearsal site was a quaking zone remade with human hands, as was the period of the rehearsals from 1951 on.

Drawing on the work of Henry David Thoreau, elsewhere I have developed his concept/metaphor of 'the quaking zone' by distinguishing between feral and native quaking zones (Giblett 2009: chapter 1). Feral quaking zones are landscapes where the earth quakes and terror is experienced as a result of the inscription of modern industrial technology on the surfaces and depths (and sometime heights) of the body, earth and mind. The features of feral quaking zones and the quality of the human sensory experience of being in them is quite different, though, from quaking zones not made by modern human hands, or native quaking zones, such as swamps which are home to the fearful and horrific alligator and crocodile, and to death, decomposition and new life. Modern, industrial, even post-industrial, quaking zones are flooded, fire-ravaged or polluted cities, towns or suburbs, watery wastelands, industrial ruins, toxic dumps, irradiated test-sites, muddy trenches, rust belts and urban slums. They are feral quaking zones in which the natural elements of earth, air, fire and water have not only been displaced from their proper places and disrupted from their creative mixtures, but have also been mixed destructively, and have run amok, caused havoc and made wastelands. Pre-industrial, and pre- and post-modern, quaking zones are dismal swamps, melancholic marshes, miry bogs, despondent sloughs and other exquisite wetlands. They are native quaking zones in which the elements of earth, air, fire and water are mixed creatively and

are at home in their own place. Thinking about some landscapes as quaking zones gets away from the culture/nature, human/environment, artificial/natural divides and develops new ways of thinking and being that involve both culture and nature, people and place, body and earth, and body, mind, earth and water.

In 1946, and so before the middle of the last century, Albert Camus (2006: 257) claimed that the twentieth century already was 'the century of fear'. Sixty years later, and after the turn of the century, Bourke (2005: ix) confirms his diagnosis by arguing that fear is 'the most pervasive emotion of modern society'. Given that 'modern society' is much older than the twentieth century, Camus's 'century of fear' has much earlier beginnings. Camus (2006: 258) went on to suggest that that there are those who 'quake in fear' and who hide their quaking from themselves. He concluded that 'we live in terror' (258). The long twentieth century from 1900 to the present (which does not seem like ending any time soon) is a feral quaking zone of fear and terror considered in terms of both time and space, period and place. In *Landscapes of Culture and Nature* (2009) I focus on places and experiences of terror, or what I call 'terror-ism', the experience of terror arising in and from a place. For Camus, 'most people, broadly speaking, are deprived of any future' (257). Why? Partly because for Camus, writing in the shadow of Hiroshima and Nagasaki and at the beginning of the Cold War, the practical applications of science 'threaten the entire earth with destruction' (257). These applications also produced the nuclear-bombed wastelands of the American West, a particularly destructive modern quaking zone.

O'Sullivan evoked the quaking zone of fissures and vents not made with human hands, whereas the 'New Topographics' and the nuclear landscape photographers portray the quaking zone of the American West remade with human hands. The 'New Topographics' did so in what Davis (2002: 39) calls 'the suburban wastelands of the New West' (as Juha discussed in chapter 8) and the nuclear landscape photographers did so in what Davis calls 'the rural West as the national dumping ground'. More to the point, as Gallagher (1993: xxiv), one of the nuclear landscape photographers, indicates the non-urban West is the federal government's dumping ground as it 'retains 68 per cent of the land and air rights in the West'. For this reason it seemed appropriate to Gallagher to include in the final pages of her book 'images of the land' in the hope that

> the beauty of the land as seen through my lens could provide the reader some healing and restoration from the preceding tragic segments [focussing exclusively on people], although it should be kept in mind that the hidden secret

of each and every one of these landscapes is the presence of radioactive toxins that are certain to be there.

Gallagher's photographs aestheticise wastelandscape as beautiful in consolation for the terror of the Cold War, just as wilderness aestheticised as sublime was a consolation in Adams's for the same terrors decades before. Both photographers aestheticise the land as a site of solace; both separate people and the land and both render war invisible. Just as the Cold War is invisible in Adams's photography, so is it invisible in Gallagher's photography as the atomic ruination of the land is invisible to the lenses of her eyes and cameras.

Not so in Richard Misrach's photography. Misrach for Solnit (1994/1999: 39) is 'the pre-eminent landscape photographer in the country', partly because for her 'the unnatural disaster is his most persistent theme' (Solnit 2003: 96). In his photographs of what Kozloff (1994: 205) calls 'a cratered landscape, barren of all but the most stubborn plant life', the atomic ruination of the land is plain for all to see. Misrach's photos of bomb craters, some of which are filled with pink or orange water, depict a lunar landscape reminiscent of modern battlefields from the Crimean War to World War I (see Figure 27; see also Misrach 1990: 56, 67, 71, 72, 73, 75). Yet, as Kozloff (1994: 205) goes on to suggest, this 'moralized landscape' is 'not a battlefield but a practice zone'. In this zone 'a macho culture has literally vomited all over the very same environment that in yesteryear it had held up as the territory of its heroic aggressions'. Orally sadistic industrial capitalism has greedily consumed the land faster than it can digest it in what I have elsewhere called a psychogeopathology (see Giblett 2011). Unable to process the good things of the earth properly, it has regurgitated bad things back onto the earth from whence the good things came in the first place. The place that had once been the theatre for heroic wars of conquest against indigenous peoples becomes a wasteland. Heroic aggressions against Amerindigenes and the frontier were also perpetrated against the land itself and this aggression is not confined to yester*year*. It continued in the heroic aggressions of yester*day* against the land in the rehearsing of nuclear bombs and will continue in the future for many tomorrows with the half-life of nuclear waste. The West was a practice zone and not a battlefield, but it was also a modern, man-made quaking zone in which the militarisation of civilian life (including non-human life) took place both in space and time. The transition from the pleasing prospect of the traditional European pastoral landscape to the terrifying prospect of the contemporary American western wasteland represents a development not

only in terms of space but also in terms of time. The land and the future have been colonised and militarised.

Misrach has also photographed dead livestock lying about where it fell, or heaped-up in piles, or half-buried in the nuclear wastelands and feral quaking zone of the American West, such as in his 'Dead Animals #327' (see Figure 28 and Misrach 1992: figure 37). For Timothy Druckrey (1991: 7) what he calls Misrach's 'eerie landscapes' are reminiscent of:

> a photograph by Timothy O'Sullivan at Gettysburg, *The Harvest of Death* [see Figure 5]. A corpse, amongst many, lies bloated in the soggy field, while burial crews, overtaxed by the 10,000 dead, work to inter the bodies. The carnage of Gettysburg is but a fraction of the carnage of nuclear contamination. *The Pit*, Misrach's series of images of fallen animals, records a more easily hidden consequence of nuclear testing. Pits 'all over the state of Nevada' have been opened as 'trash dumps' … He [Misrach] writes [that] 'something strange has been seeping into my work'.

Is not the uncanny this something strange that seeps? Is not the uncanny something associated with death and life? With death in life? Of something with a strange kind of half-life? A bloated corpse of a soldier in a soggy field lies in the wet wasteland of a Civil War battlefield just as in Misrach's photograph 'Dead Animals #327' a desiccated corpse of an animal lies half-buried in the dry wasteland of a Cold War battlefield. *The Pit* reminds Druckrey of O'Sullivan's 'Harvest of Death', for Jurovics (2010: 14) 'one of the most visceral images of the Civil War' of fallen heroes on the field of battle struck down by the grim reaper of death; *The Pit*, one of the most visceral images of the Cold War of dead animals on the site of the rehearsal for the end of the world (Misrach 1992: 39–59), reminds me of O'Sullivan's photos of the fissures and chasms of the American West, the earth opening up and leading into its bowels. Both are uncanny quaking zones. Yet both 'Harvest of Death' and *The Pit* are photos of modern, man-made quaking zones, whereas O'Sullivan's photos of the fissures and chasms of the American west are of a quaking zone not made by human hands.

Moreover, unlike O'Sullivan's 'Harvest of Death', the nuclear landscape photographers do not photograph the impact of nuclear war rehearsing on human beings and bodies. A nature writer has, however, traced this impact, and in the process Terry Tempest Williams has not only produced one of the most visceral accounts of the Cold War but also created a new genre of nuclear nature writing,

just as Gallagher, Misrach and others did with nuclear landscape photography. In *Refuge* Terry Tempest Williams figures her mother's body in terms of the rising and falling water levels of the Great Salt Lake. In the mid-1980s with the rising waters 'the pulse of Great Salt Lake, surging along Antelope Island's shores, becomes the force wearing against my mother's body ... Antelope Island is no longer accessible to me. It is my mother's body floating in uncertainty' (Williams 1991: 64). If water is the life-blood of the body of the earth, then land is its torso and limbs, or more precisely for Williams (1991: 109) 'there is musculature in dunes. And they are female. Sensuous curves – the small of a woman's back. Breasts. Buttocks. Hips and pelvis. They are the natural shapes of Earth'. The body is the earth. Where land and water, dune and wetness meet in the wetland is the womb of the world. Although Williams (somewhat surprisingly) does not make this connection, she does acknowledge that 'marshes are among the most productive ecosystems on the planet' (111). Also for her 'wetlands are refuges' (254) for herself and for waterbirds. Yet 'wetlands have a long history of being dredged, drained, and filled, or regarded as wastelands on the periphery of our towns' (265). Wetlands are not only wombs that give new life but also tombs that take dead matter and transform it into new life (see Giblett 1996). They can also become wastelands when they are dumping grounds for the detritus and rubbish of industrial capitalism as Misrach's photographs show.

Just as the land has been subjected to surveying, to the grid of longitude and latitude, and to the grid-plan town and grid-iron drains, so is her mother's body. Her abdomen is 'tattooed ... with black dots' and her belly has 'a grid' drawn over it with 'a blue magic marker'. Williams's mother comments that the technicians had 'turned my body into their bull's-eye' which they then 'zap'. Williams asks her mother how she feels to which she replies 'I feel abused' (Williams 1991: 77). The earth too has been abused by patriarchal industrial capitalism, raped by mining and stripped by agriculture, pastoralism and soil erosion (see Giblett 2011) and irradiated by nuclear-bomb testing.

The earth, and terrestrial space more generally, has also been militarised. On a field trip to some caves used by the Fremont people for a millennium, an archaeologist friend reminds Williams that 'if you look straight up that's not blue sky you see – that's military airspace'. Blue sky has not only been mined for spectrum auctions but it has also been militarised for surveillance and bombing (see Giblett 2008b). And not only has blue sky been militarised but also brown earth as it has been bombed with devastating consequences, often decades afterwards. Williams's

friend could have equally said 'if you look straight down that's not brown earth you see – that's a bombing range. Or it was'.

In the epilogue to *Refuge* entitled, 'The Clan of One-Breasted Women', Williams relates how above ground atomic testing in Nevada from 1951 to 1962 resulted in radioactive fallout drifting downwind into Utah. Utahns were called 'downwinders', though as the commander of the elite Air Force squadron responsible for monitoring the nuclear test clouds during the 1950s and who was suffering from cancer said, 'there isn't anybody in the United States who isn't a downwinder' (cited by Davis 2002: 46). Williams remembers the flash of one test when she was young and she and her family were driving in the desert early one morning in 1957. Her father reminds her that light ash fell on their car. Her mother developed cancer 14 years later, the same period as an authority on radioactive fallout says radioactive cancer needs to become evident (Williams 1991: 286). Williams is thus not only telling the story of her mother's illness, but also the story of the earth's illness without necessarily ascribing a cause-effect relationship between the two:

> I cannot prove that my mother … or my grandmothers … along with my aunts developed cancer from nuclear fallout in Utah. But I can't prove they didn't. (Williams 1991: 286)

Williams may not be able to prove anything, but she can dream anything she likes. She can dream that nuclear tests on the body of the earth meant that 'stretch marks appeared. The land was losing its muscle'. The dunes were being bombed into obliteration as the photographs of the nuclear landscape photographers show, the womb of the world repeatedly impregnated with poisonous seeds and giving birth to mutant children. The earth was in labour pains, but instead of giving birth to new life 'the red hot pains beneath the desert promised death only, as each bomb became a stillborn' (288). The development of the bomb, and the bomb itself, 'fathered the unthinkable' as Brian Easlea (1983) calls it in his study of the development of the nuclear bomb; every bomb engendered a new world from the father's brain without reference to, or reverence for, the mother's body or the body of the earth.

The blasted and blighted wastelands of the test site are the product of the sublime nuclear bomb. Solnit (1994/1999: 44) finds the power of the bomb 'fascinatingly terrible' and associates it with the sublime. The bomb itself demonstrates, as Solnit (43) puts it, that 'humans have managed to make stars', but 'an exploding nuclear bomb is a kind of star come to earth' with catastrophic and uncanny consequences

as Misrach's photographs show. The destructive force of the bomb is fascinatingly horrible, a shorthand definition of the uncanny. The bomb encapsulates the two ruling passions of modernity: terror and horror: the terror of explosion and the horror of mutilated bodies and lands. The bomb could not remain a star in the heavens but came to earth in the hypermodern s(ub)lime of the nuclear bomb rehearsals. Solnit (1994/1999: 207) describes aerial views of them in which:

> the earth shuddered … as though it were made of thick liquid … Aerial photographs of the Ground Zero region show an arid surface pockmarked with depressions and crisscrossed by roads like long slashes, a surface that looks more like the devastated skin of an ancient plague survivor than the familiar surface of the earth.

The earth becomes a feral quaking zone made with human hands and the surface of the earth is inscribed with the marks of a modern plague against the earth and its inhabitants.

The Civil War, the Crimean War, World War I and the Cold War: the shadow of war hangs like a pall over the land and the mind, over the lands of the American West and over the American mind. World War II does too in Peter Goin's photographs of nuclear landscapes. These landscapes are not only located in the continental western US but also further west on the Bikini and Enewetak Atolls in the Marshall Islands. The resonance with World War II is especially strong in his photographs of ruined bunkers on these atolls as they are reminiscent of the German bunkers of World War II along the northern coast of France (Goin 1991: 107, 109, 111, 115, 129, 131, 137). In the 1950s Paul Virilio (1994a) undertook what he called 'an archaeology of the German bunkers'. He photographed them and wrote about his experience of visiting them and about their function in architectural, cultural and military history. Stylistically, architecturally and structurally (with the use of concrete), the German and US bunkers came from the same modernist mindset, specifically from the same brutalist politics and aesthetics, irrespective of the political and cultural differences between Nazi Germany and democratic America (see Figures 29 and 30). Virilio, as a theorist of architecture, is quick to point out the obvious similarities between the bunkers and le Corbusier's work (Virilio 1994a: 12). Besides the obvious similarities, they point not only to 'this architecture's modernness' as Virilio (1994a: 12) put it, but also to a common militarisation of civilian life and of terrestrial and extraterrestrial space.

Like the German bunkers built on 'the European littoral' (Virilio 1994a: 12), the US bunkers were built on the American littoral of the atolls of the Marshall Islands. Writing about the German bunkers Virilio (1994a: 12) argues that

> these concrete blockhouses were in fact the final throw-off of the history of frontiers … the bunkers, as ultimate military surface architecture, had shipwrecked at lands' limits … they marked off the horizontal littoral, the continental limit.

The same could be said of the US bunkers for they were a throw-off of the US's fascination with frontiers and were the ultimate military surface architecture shipwrecked at lands' limits. The US frontier, which began historically and geographically with the crossing through the Cumberland Gap and closed supposedly with the 1890 Census, has never really been closed just as the frontiers of science and space still remain open for the US militaristic mindset (see Giblett 2008b). The Bikini bunkers, out on the western territorial limit of the US, were the first line of defence facing the old, defeated enemy of Japan and the new, threatening Cold War enemy of the USSR. As the site of nuclear bomb testing, they were both visible signs of defence against a possible second Pearl Harbour attack coming from the eastern USSR and stark reminders of Hiroshima and Nagasaki. The German bunkers on the European littoral for Virilio (1994a: 29) were 'from the start the funerary monuments of the German dream'. Are not the Bikini bunkers on the American littoral the funerary monuments of the American dream? Here the American dream of the 'conquest of nature', the crossing of the terrestrial and scientific frontiers, and the building of a heavenly paradise on earth gives birth to the hell and nightmare of thermonuclear annihilation. Goin's photographs of the bunkers, just like Virilio's, are documentary memorials of these monuments, stark reminders of the destructive power of grandiose nationalistic and nature-conquering dreams. The bunker for Virilio (1994a: 46) is 'the last theatrical gesture in the end game of Occidental military history'. How much more so are they than in the end game of the 'mutually assured destruction' of a possible nuclear war?

The Cold War and World War II were not only the context for Ansel Adams' swork but also its repressed which returns in the work of the nuclear landscape photographers and which returns the viewer to it, or at least its aftermath. Behind, or beside Adams's American wilderness, just out of shot, lurk the American wastelands of the 'New Topographics' and nuclear landscape photographers. Adams's work evokes the sublimity of God's and Nature's nation whereas the

nuclear landscape photographers return to the stark 'beauty' of 'Man's' bunkered, blasted and blighted lands. Positing wasteland against wilderness as the 'New Topographics' and nuclear landscape photographers do, and wilderness against wasteland as Adams did, locks photography into the binary opposition of a sterile antinomy in which each is constructed as a presence on the basis of the other's absence. Each relies on the other to constitute itself. Deconstructing the binary involves decolonising and historicising the construction of the terms 'wilderness' and 'wasteland'. Ironically, wilderness was once considered wasteland (see Hall 1992; Giblett 2011).

Out of this deconstruction and decolonisation a new photography could perhaps emerge, photography for environmental sustainability. Perhaps some of the photographs produced by the US Farm Security Administration (FSA) during the Great Depression provide a useful exemplar and historical precedent for the development of photography for environmental sustainability. Dorothea Lange and Walker Evans produced photographs for the FSA of both aesthetic value and ethnographic quality that moved a nation. However, neither of them documented the link between the environmental disaster and land pathology of soil erosion in the Dust Bowl, the economic disaster of the Great Depression and the human disaster of mass unemployment and psychological depression, nor showed any sort of alternative in terms of land conservation as propounded by some of their contemporaries, such as Aldo Leopold. By aestheticising the ethnography of rural depression, the nation was indeed moved – moved to pity and charity, but it was moved neither to adopt a land ethic, nor to practice land conservation. The FSA photographers principally depict portraits of rural dwellers abstracted from the land in static poses against the land as literally background. They do not show them working the land, let alone in an environmentally sustainable manner. Photography for environmental sustainability is something else again, and the topic of the final chapter.

Minescapes and Disaster Zones

Rather than the placid pastoral and picturesque landscape photographs in the pictorialist tradition, much recent landscape photography has depicted the landscapes of ruination, such as Australian minescapes, and the aftermaths of disasters, such as Australian bush fires, the Asian Tsunami, 'Chernobyl' and '9/11'. The Asian Tsunami in December 2004 off the coast of Sumatra took hundreds of thousands of people to their death in the deadliest earthquake in recorded history. This chapter begins by reflecting on the photographic portrayal of this natural disaster and compares it to that of the aftermath of the bush fires on the Eyre Peninsula in South Australia and other recent bush fires in Australia, in some cases caused by arson, a national disaster and not a natural disaster. Photos of mud-covered, dead children in the aftermath of the Tsunami were published whereas no photos of burnt Australian children were published. This amounts to what could be called an orientalist pornography of death. The death of 'the other' is an object of legitimised fascination whereas the death of 'the same' is taboo.

Asian Tsunami

In the old cliché, a picture is worth a thousand words, but pictures without words can be relatively worthless as they do not provide the means to understand or articulate what they depict. They leave a sense of loss or deficit that makes speech difficult or impossible. The drive to make sense can sometimes thankfully be stilled or stopped by the immediacy and viscerality of a picture. Then, almost by a reflex action, the mind kicks into language mode and wants to make sense.

Rather than privileging pictures over words (as in 'a picture is worth a thousand words') or its mirror opposite (a picture is worthless without words), words and pictures can enter into a dialogue. The difficulty then lies in finding a common language with which to engage in that dialogue. The language of aesthetics, especially painting, provides one obvious point of commonality with its terminology of the sublime, picturesque and beautiful. The sublime may be applicable to some photographic depictions of natural and other disasters as they may evoke the awesome power of nature. The picturesque and beautiful are largely inappropriate or inapplicable in terms of subject matter, but not in composition.

With what terms then could one begin to articulate Dean Sewell's confronting photograph of dead children from the Tsunami disaster? At the level of subject matter, this is an anti-aesthetic photograph because is it not sublime, nor picturesque, nor beautiful. At the level of composition (form, expression and colour), however, it brings together these elements in a pleasing whole. Although this photograph is not beautiful in a conventional sense, its point of view of looking down at small objects is in the realm of the beautiful. At the level of the subject matter and the viewer, the photograph could be considered as pornography of death, not only because of the barely covered genitalia of one of the children which may evoke a prurient, paedophilic fascination, but also because of the fact that this image is a revelation of the hidden. It reveals what the mainstream media hid in its depiction of the Tsunami disaster. This aspect involves fascination and horror, not only fascination with the bodies, but also horror at death and the Tsunami disaster (see Figure 31). This combination of fascination and horror is, in a word, the uncanny. A simple definition of the psychodynamics of the uncanny is a return *to* the repressed. This photo returns the viewer to the repressed of death (death is repressed) and to the repressed of the media representations of the disaster.

It also returns the viewer in visual terms to the human scale of the event. The mainstream media pictorially hid this aspect. It reran tourist video footage of the event from which the victims were largely absent. It did not show victims in the

aftermath; it showed survivors. In a sense, it did not show the natural disaster per se, as a natural disaster is primarily a human disaster and takes place at the point of impact on humans. A volcano erupting on an island uninhabited by humans and causing torrents of lava to flow down its sides destroying plants and animals in its wake is not really a natural disaster. It is a natural event. Disaster is a human category. Humans surmise it is a disaster for the plants and animals it destroys. An undersea earthquake is a natural event; a Tsunami that hits human habitats is a cultural disaster. A natural disaster is thus a bridge between the natural and the cultural worlds linking both in a very immediate and bodily way. Photos of natural disasters can do the same and Sewell's do this.

Australian bush fires

What might constitute a natural disaster is a vexed question. Arguably a bush fire started by arsonists is not a natural disaster, but an unnatural or cultural disaster. It is a disaster of people's, or at least of some people's, relation to place, and to other people, of their culture of nature. Yet the reportage of bush fires, including the recent ones of 'Black Saturday' of 7 February 2009 in Victoria, Australia, refers repeatedly to them as 'Australia's worst natural disaster' when many of the fires were lit deliberately by arsonists. Doing so seems to absolve arsonists of responsibility for the consequences and aftermath of their actions. Fire is natural, and once lit takes a natural course to consume flammable material. Yet all big bush fires start as little fires, many of which are the work of arsonists, not 'nature', though, of course, humans are part of nature; on the other hand, it is hardly 'natural' to light fires that destroy public and private property, human and non-human lives. Using the rhetoric of the natural disaster also highlights the problematic nature of the concepts of nature and culture and the need to rethink and develop new terms, such as feral quaking zone (see Giblett 2009). Black Saturday was Australia's worst feral quaking zone.

The depiction of the human scale and impact of the event, such as a bush fire and its aftermath in a photograph, provides a point of identification between viewer and the subject. Photographs of a bush fire that show humans threatened, fascinated, confronted or sheltering from it (as in Nick Moir's series; see Figure 32) are qualitatively different from photographs of ruined houses or of the fire itself (as in Michael Langford's; see Figure 33) from which humans are absent. Moir's

series shows people in context with the disaster, engaging with it in their everyday lives. Langford's series shows the ruinous and humanless aftermath and is a kind of wilderness experience of fire from which people have been removed. Arguably this produces a sense of the land from which people are absent and with which they do not engage. Moir's and Sewell's photographs show a disaster, an event of natural forces (fire and Tsunami) at, or shortly after, their point of human impact. Sewell's pornography of death is also an orientalism of death as it depicts dead 'Asian' children; to show blackened bodies of burnt Australian children following a bush fire would be unacceptable.[1] Disasters are culture and nature. The media record and disseminate them and communication technologies produce them.

Chernobyl

The three series provide the material for a dialogue between words and pictures which enable us to articulate the human experience of what could be called the age of disasters which has been going on for a century or so. They also provide the visual archive for undertaking a tentative taxonomy in the natural history of natural and unnatural disasters, as does Juha Tolonen's journey photography of city sites in the Chernobyl exclusion zone which represent the aftermath of an accident (see Virilio 2003; for other photographs of the exclusion zone see Polidori 2003). The residents of the zone have been evacuated; the victims of the accident are dead or dying elsewhere; the residents could be the next victims. Chernobyl is a kind of Auschwitz for our time. Adorno said that poetry was dead, or could not be written, after the horrors of the Holocaust; with Chernobyl, the fabric of biological life was rent and the routines of everyday life overturned by the terrors of the meltdown. It is a limit case of the unthinkable. After Chernobyl the unthinkable is alive, or at least has a half-life of 200 years.

The half-life unthinkable has a story though, and Juha's photos tell part of the story. Chernobyl may be unthinkable but it is not untellable as these photos and the stories of Chernobyl collected by Svetlana Alexievich (1999) show. The words and pictures can be read together. The words give a commentary on the pictures, but the pictures are worth a thousand words.

For Tolonen the city sites of Pripyat he has photographed are industrial ruins in the sense that these sites were the product of industrial society and are now its ruins and are in ruins. The photograph of the cityscape exhibited here for context

looks normal enough, and just like any other modernist city, but it is a ghost city, and a city of ghosts. Even though the photos are of an abandoned city, the sites have, and are, industrial products – the mouldering bumper-cars, the sinking hulks, the trashed buildings, the dirty glass and rusting steel. These materials and products have been domesticated and used for consumption, but now they have been discarded, or more precisely their consumers have been forcibly and 'temporarily' removed.

The overall mood and lighting is of decay and mould, of decrepitude and rust. This is a world that has gone awry, even the earthworms have gone, burrowing deeper into the earth or been irradiated, nuked out of existence (Alexievich 1999). In one of Juha's photos dying sunflowers dot a sculpture park of Triffids in a nucleated exclusion zone, surely one of the most bizarre images ever spawned by science fiction (see Figure 34). Perhaps metallic Triffids are the only thing that can survive in this place of science fact become grotesque farce.

The exclusion zone is a war zone and Juha's photos are war photography. He has arrived in the battle zone after the battle has been fought – and lost (there were no winners). Even the meaning of war has changed. Chernobyl was a war fought against citizens, and against the earth, by an industrial accident – if that makes sense, and if it does not, it is because after Chernobyl it is hard to make sense, certainly about Chernobyl. After Chernobyl and with Chernobyl sense cannot be made.

9/11

No more so than with '9/11'. During '9/11' and at 'Ground Zero' with exploding aeroplanes and burning, collapsing skyscrapers, thousands of people plummeted to their deaths, or were burnt alive, or were overcome by smoke in the worst terrorist attacks on US targets or 'assets'. Earth, fire and air were mixed in an exploding and burning, dirty and dusty disaster zone of elements brought about by the collision of technologies not in their normal place. Photographers and mobile phone users were on hand to record the most photographed event and its aftermath in history.

With '9/11' humans were thrown into a different sort of maelstrom of crashing and exploding planes, and falling and burning buildings. Earth, fire and air were mixed in an artificial quaking zone of elements brought about by the collision of technologies. The aeroplane, as what Bourke (2005: 358) calls 'the previous century's

symbol of technological prowess', was flown into the previous century's symbol of architectural and structural-engineering prowess, the skyscraper, in particular into the World Trade Center (WTC), which she later calls 'the architectural symbol of America's corporate greatness' (369). The results were cataclysmic. One eyewitness said 'the ground was shaking' (Brondolo cited by Friend 2007: 7). One photographer of the aftermath, Joel Meyerowitz (2006: 24), said 'the stench from the combination of burning elements overcame me'.

The attacks on the WTC on 11 September 2001 made it 'the most deadly murder scene in American history' (Friend 2007: 52). It did not have the dubious honour of being the site of the biggest mass killing in American history as that honour belongs probably to the Battle of Antietam during the American Civil War with four to five thousand fatalities (Friend 2007: 346–367). The attacks on the WTC and the Pentagon do have the dubious honour, though, of being 'the worst terrorist attacks, ever, on US soil'. Yet the soil of the WTC Towers was a long way below the site of the attacks umpteen stories above. The fact that the Towers were erected on US soil meant that an attack on them was an attack on sovereign US soil, a national symbol of blood and toil. The attacks were the worst airborne attacks, ever, in sovereign US airspace, worse than Pearl Harbour with 2400 American victims. The result was 'a national disaster' (Meyerowitz 2006: 16) just like hurricane Katrina, though the speed and scale of the humanitarian and relief effort were entirely different (see Giblett 2009: 160–165, for 'Katrina').

Like Antietam, whose aftermath was well-documented photographically, '9/11' marked a shift in the photographic recording of war as both the attacks themselves and the aftermath were well-documented photographically. 'September 11', or simply '9/11' as it became known, was for Friend (2007: 36) 'the most widely observed and photographed breaking news event in human history. And it occurred, aptly enough, at a time when image reigned supreme in world culture'. The image reigned supreme due to the ubiquity of digital cameras, especially in mobile or cell phones. '9/11' 'was a photogenic event … It coincided with the revolution of digital photography' (Shulman cited by Friend 2007: 20). It was photogenic in the sense that it generated photographs; it was not photogenic in the sense of producing photographs of beautiful scenes, or even producing beautiful photographs. The scenes did not defy aestheticisation, though, as a number of photographs show, such as that of the 'Falling Man' with its symmetrical composition as we will see.

The accessibility and ubiquity of the digital camera in the cell phone meant that 'the age of the universal lensman had arrived' (Friend 2007: 30). This was so not only on the ground, and in the air from helicopters but also from extraterrestrial orbital

space as Frank Culbertson in the International Space Station was 'the twenty-first century's first space-based war photographer' (Friend 2007: 53). '9/11' also marked a shift in the mediation of war as the attacks were 'the first such acts witnessed in "real time"' (Friend 2007: xviii) as it has been calculated that 'more than two billion people on September 11 watched the attacks in real time or watched that day's news reports about the attacks, according to David Hazinski' (Friend 2007: 32).

Echoes of war were heard or seen in one of the most famous photographs of '9/11', Thomas Franklin's 'Flag Photo' which, with its allusion to Joe Rosenthal's famous Iwo Jima flag-raising photo, 'would become the most widely reproduced news picture of the new century' (Friend 2007: 312; Image 31). Franklin's photograph for Friend (2007: 325) was 'no less than the digital-age descendant of Rosenthal's *Iwo Jima 1945*'. Both photos were taken above 'a killing field' (Friend 2007: 325) and both used 'their nation's most beloved symbol to turn a decimated landscape from a battleground into sacred ground' (Friend 2007: 326). In Rosenthal's case, his photograph was of what Sontag (2004: 50) calls 'a "reconstruction" … done later in the day with a larger flag'. In Franklin's case, the original flag in his photo went missing and was replaced by a larger flag 'shuttled around the world with a Navy escort' as 'the flag in the photo' (Friend 2007: 312). It was as if to make Franklin's photo with a smaller flag seem like Rosenthal's with a larger flag, a larger flag had to take the place of the smaller flag. Reality had to emulate the photo. Reality was not sufficient itself. It had to replicate photography.

Unlike 'Iwo Jima', however, the victims of '9/11' were civilians and paramilitary police and firefighters. Richard Drew's 'The Falling Man' (Friend 2007: Image 22) shows him 'standing in the world but the world is upside down' (Wieseltier cited by Friend 2007: 136). Drew chose this shot out of dozens 'because of its verticality and symmetry' (cited by Friend 2007: 136). This symmetry applies not only horizontally across the photo with the falling man 'positioned precisely at the juncture where the edge of one tower's facade eclipses the other's' (Friend 2007: 136), but also vertically up and down the photo as the facades of both towers look the same if the photo is turned upside down as Wieseltier suggests doing. If the carnivalesque, as Mikhail Bakhtin suggested, is the world turned upside down and inside out for a day to place the lower classes in the position of the higher, then Drew's 'Falling Man' photo shows a world turned upside down and inside out for a day with a lowly man falling to his death caused by the lowly suicide terrorist pilots of Al Qaeda attacking high class American capitalists represented by the Twin Towers themselves. For Drori-Avraham (2006: 295), 'dying so spectacularly, so calmly, the falling man awkwardly echoed his killers'. Up and down, terrorist

and terrorised, killer and killed were all mixed up in a topsy-turvy world in which the killers were killed, some of whom (not just the hijackers) killed themselves. These were 'the jumpers' (Friend 2007: 133), or were they 'the fallers'? This is not just a question of volition or intention, but also of status and value. 'A person who falls', Drori-Avraham (2006: 295) argues, is 'a victim. A person who jumps may or may not be a victim'. From the photograph of a human being plummeting through space it is impossible to tell whether they jumped, or fell, or were pushed by others, or were forced out by heat or smoke. All the people who plummeted to their deaths were victims of the terrorist attacks as they were placed in the situation where they either were pushed or fell, or in the position of having to make a choice between jumping to their death, or being burnt to death, or dying of smoke-inhalation.

Viewers of pictures of 'the event' (Friend 2007: 27) of '9/11' and its ruinous aftermath turned to previous photographs to make sense of it. David Fitzpatrick's images taken from the NYPD helicopter looked like 'pictures of London during the Blitz' for Friend (2007: 51). 'The billows [of smoke] are thunderous, apocalyptic. Buildings … might as well be gravestones swathed in fog'. Friend shifts register from the Blitz to the gothic. Both are sites of death. Graveyards are traditionally places of horror. New York on 11 September 2001 was 'the horror of horrors' for Friend (2007: xxii). Kurtz's 'the horror, the horror' of the heart of darkness in Conrad's novel of the same name and of the Vietnam War in Scorcese's *Apocalypse Now* becomes the horror of '9/11'. War and its horrors had come home. Television pictures beamed into American homes of the horrors of war became terrorism on the same side of the world unlike those of the Vietnam War on the other side of the world.

Both the Blitz and the gothic are associated with ruins: the Blitz created ruins; the gothic loves being in them and representing them. One of Joel Meyerowitz's photographs of '9/11' that is not in his book but is reproduced on the cover of *Landscapes of Culture and Nature* (Giblett 2009) is thoroughly gothic in colour, composition and subject matter with its ruinous foreground and flying ramparts like a medieval gothic cathedral. Romantic gothic landscapes for Botting (1996: 2 and 32) are often castles, 'the major locus of Gothic plots', graveyards or ruins depicted at night. They are places of death and ghosts and are 'desolate, alienating and full of menace' – all of which can be said of Meyerowitz's photograph. The castle 'up above' K in Kafka's (1997: 8) gothic novel *The Castle*, like the Woolworth skyscraper in the background of the photo, 'rose freely and airily skyward'. It sublimates base matter down below into the airy heights up above. The gothic and sublime go hand-in-hand. Gothic for Botting (1996: 3) 'signified a trend towards

an aesthetic based on feeling and emotion associated primarily with the sublime'. K later compares the castle and its tower to the church tower of his home town which rose

> neatly, unhesitatingly tapering straight upward … an earthly building – what other kind can we build – yet with a loftier goal than the squat jumble of houses and making a clearer statement than the drab working day.

Similarly the Woolworth skyscraper has a loftier goal than the squat jumble of the ruins of the Twin Towers in the foreground of this photo where many a drab working day was spent by its inmates and the clean-up crews. The castle tower for K had 'a crazy quality' about it 'with battlements that jutted uncertainly, unevenly, brittlely' – just like the ruined Towers. The Gothic and sublime, the ruins and the skyscraper, couched together in Meyerowitz's photo as foreground and background, represent both the triumph and defeat of modernity.

In Meyerowitz's (2006) main body of work, he turns explicitly to the aesthetics of the sublime. Friend (2007: 262) relates how Meyerowitz says,

> he was after nothing less than replicating Ground Zero's potential to evoke 'the sublime', using the term as it was applied in the eighteenth century: an almost unbearable awe that we experience confronting the boundless power of nature's grandeur.

Instead of the mountains, waterfalls and big trees that evoked the sublime in the nineteenth and twentieth centuries, the ruined WTC towers in the twentieth-first century confront the power of humankind's inhumanity to humankind. Just as the skyscraper overcomes the limits of horizontality by going vertical and demonstrates mankind's power, so 'the awesome monumentalness of their upheaval makes mankind powerless' (Friend 2007: 263). Using the sublime communication technology of photography, Meyerowitz photographed the upheaval and demonstrated the awesome power of mankind to master it in images, 8000 plus in all (Meyerowitz 2006: 336). Thirty-five identical copies of his exhibition of 28 photographs entitled 'After September 11: Images from Ground Zero' toured 'some 300 cities in 90 countries' 'under the auspices of the U.S. State Department' (Friend 2007: 260) on 'a four year journey around the world' (Meyerowitz 2006: 349). For Friend (2007: 261), 'even if Meyerowitz's work had become a calling card of the Bush Administration', eventually 'collected in a book of hundreds of photographs'

(Meyerowitz 2006), and was 'the ultimate State Department p.r coup [of] Ground Zero and its nameless heroes recast as an export – none of this mattered' because his 'purpose remained pure: he had gone where most others were forbidden and documented the humanity that, curiously enough, overshadowed the destruction'.

Yet Meyerowitz's purpose was compromised and tainted by the cultural baggage of the sublime, and of the history and sublime communication technology of photography, both of which he carried with him. Meyerowitz is the Ansel Adams of 9/11. Just as Adams was the modern photographer laureate of nature's nation and the mountainous sublime, so Meyerowitz is the hypermodern photographer laureate of culture's nation and the disastrous sublime. Just as the American nation sought solace in Adams's photographs of the sublime wilderness in the American West in the face of the threat of thermonuclear war represented by missile silos and test sites also in the American West, so it sought solace in Meyerowitz's photographs of the sublime American wasteland of 'Ground Zero' in the aftermath of terrorist attacks in the same place. No longer did the American nation look to the American West to heal the wounds of war; it looked into its own backyard, into the battleground itself. No longer did it displace its desire for healing elsewhere. The destruction and the images were in the same place. Unlike Adams who looked to the pristine unpeopled landscape to give solace for the threat of nuclear war, Meyerowitz looked to the peopled and ruined cityscape to give comfort for the terrorist strikes.

Meyerowitz's photographs of buildings are sublime but his photographs of people working on 'the pile', 'as the heaped wreckage of the Twin Towers was called by the workers' (Meyerowitz 2006: 16), are pastoral. For Meyerowitz (2006: 107) 'my signature memories of Ground Zero are gardening images' of some of the 1000 workers who went to work on searching through the pile for human remains often with their bare hands. 'The only way to determine whether or not they had come across human remains was by touch and smell' (Meyerowitz 2006: 30). Otherwise they used picks, shovels, rakes, etc. to deal with a mountain of remains, rubble and ruin of two million tons of debris (Meyerowitz 2006: 278). Most of this debris was transported to 'Fresh Kills Land Fill' on Staten Island that has the dubious privilege of having 'exceeded the Great Wall of China as the largest manmade object on earth' (Solnit 2003: 53 and 148). 'The act of raking' for Meyerowitz (2006: 281) 'had become emblematic of the work on the site'. Meyerowitz alludes not only visually to the sublime landscapes of the Hudson River School, but also verbally to their pastoral landscapes as well, such as Church's scene of raking hay 'West Rock, New Haven'. Yet the gardening of Ground Zero is not performed on living beings

(plants) to promote growth on the living earth but in the search for dead beings in ruins. As one of the rakers who Meyerowitz (2006: 280) photographed said, 'we're gardeners in the garden of the dead' (cited by Meyerowitz 2006: 281), and not in the garden of the living. Meyerowitz uses 'gardeners in the garden of the dead' as the caption for one of his photographs showing a group of 14 nameless rakers at work (Meyerowitz 2006: 316–317). Instead of labouring in the fields of the Lord of 'God's Nature's Nation', the rakers are labouring in 'the raking fields' (Meyerowitz 2006: 278, 281) of Hades's culture's nation.

Meyerowitz's book is published in portrait layout compared to the landscape layout of Adam's *The American Wilderness*. Both are monumental books, and Meyerowitz's book is even described as such on its flyleaf. Both depict the vertical, whether it is mountains or office buildings. Yet whereas Adams depicts rugged mountains in the context of a valley with long shots in landscape layout, Meyerowtiz often depicts ruined office buildings as single structures, and individual rescue workers and volunteers in portrait layout. This positions people against the land and abstracts them and their labour in cleaning up the pile (for example, Meyerowitz 2006: 289, 290, 297). Generally he does not show rakers raking with the one exception noted above. He shows rakers posing with their rakes with a raking field in the background after it has been raked. He does not show rakers in the act of raking. This obfuscates the relation between the raker, his or her rake and the raking field, and makes invisible the labour that made the raked field, just as the 'gentleman's park estate' obscures the labour of its labourer who made its pleasing prospects. His book occasionally has double page foldout panoramic spreads to embrace the horizontal enormity of the site. Meyerowitz's book is both the panorama and portrait of '9/11' and the American nation's culture, whereas Adams's book is the panoramic landscape of American wilderness and portrait of the American nation's nature.

Meyerowitz's photographs are also similar to the photography of the Civil War (Brady, O'Sullivan) as both are of the aftermath of war. Meyerowitz's book is entitled *Aftermath* as is Botte's (2006). Both sets of photographs are of the battleground after the battle when the living combatants have left and only the dead ones remain to be removed. The heroes of Meyerowitz's sublime wastelandscape are the pastoral firefighters and clean-up crews tending the burned and blighted garden of Eden. Unlike the sacred groves of Yosemite that Lincoln 'set aside' during the Civil War and which were photographed by Carleton Watkins as a consolation for the depredations of civil war and as a western American site unsullied by the conflict between North and South and so a symbol for national re-unification, the

sacred ground of Ground Zero of the bombed WTC was an eastern American site produced by the conflict between a different North and South than in the Civil War of the globalised world depredated by the World Trade Organization and photographed as documentation and consolation for the terrorist attacks.

Australian minescapes

Edward Burtynsky's aerial photographs of Australian minescapes also invoke the sublime in their depiction of two main types of strip-mining. In the first the earth is a vertiginous depth for digging holes to extract ore – mainly 'The Super Pit' in Kalgoorlie (see Figure 35 and Burtynsky 2009: 32–39), Mt Whaleback (42–47), and Lake Lefroy (48–49); in the second the earth is a horizontal surface for the inscription of roads, ponds and other mining activity – mainly Lake Lefroy (54–55 and 60–77) and others (80–83); or both types are depicted in the one photograph with a hole in a scarred surface – such as Lake Lefroy again (50–53 and 56–59) and others (30–31 and 78–79). Mining is aestheticised in aerial photographs as an object of sight alone. The viewer is placed above and beyond to look down upon the scene below and master it from above. The other senses are denied. The history of the place is also frozen in time and its future foreclosed in the synchronic moment in which the photograph is taken.

In a recent article on what Soenke Zehle (2008: 110) calls Burtynsky's 'grand tour of industrial landscapes' in a special issue of *Media International Australia* devoted to 'Ecomedia', Zehle remarks on 'the de-emphasis of the geographical specificity of the sites Burtynsky's documents'. This effect can partly be attributed to the aerial point of view he adopts in many of his photographs. Zehle goes on to note that 'from nineteenth century photographers like Carleton Watkins he retains the elevated hovering viewpoint' (112). This point of view can be related to the sublime, yet whereas Watkins produced what Marien (1993) called 'the corporate sublime', Burtynsky produces what has been called the 'industrial' or 'toxic sublime', or what Zehle calls the 'documentary sublime'.

What all these proliferations of the sublime miss in their emphasis on subject matter and style is the spatial and temporal orientation of Burtynsky's photography. The sublime is often evoked by looking up at vertical forms and terrifying heights, such as mountains or mountainous seas, looming above one (see Giblett 1996: chapter 2; 2011: chapter 3), whereas Burtynsky's photographs evoke the sublime by

looking down into the terrifying abyss and vertiginous depths opening up below one. His photographs of the Lake Lefroy mine freeze a moment in time, not only of its taking but also of the possibility of plunging to one's death in a hole in the ground and of overcoming this possibility so one's point of view is like a bungy jumper suspended in mid-air with no visible means of support. The sublime is evoked not only by transcending space but also by compressing time. Time and sublime rhyme as I have argued elsewhere (Giblett 2008b: 28–30). At the risk of adding another sublime to the list and proliferating more sublimes, Burtynsky's photographs are of time sublime – an empty now and a terrifying prospect, rather than a fulfilled now and resources for what Raymond Williams called 'a journey of hope' (see Giblett 2009: chapter 9).

In Burtynsky's photograph of 'the Super Pit', the black hole of Kalgoorlie, like the infamous 'Black Hole of Calcutta', threatens to swallow the whole town in its orally sadistic maw (Burtynsky 2009: 32–33). These were precisely the terms in which the Super Pit was reported in the article, 'The Super Pit gold mine in Kalgoorlie is threatening to swallow the town' (Andrusiak and Taylor 2008), published in February 2008 in the *The Weekend Australian Magazine*. The two journalists went on to describe how:

> it is Australia's biggest goldmine, swallowing what is known as the world's richest square mile of dirt. But the Super Pit, in historic Kalgoorlie-Boulder in Western Australia, is also eating the booming city it is helping sustain and literally shaking its residents to their foundations.

Kalgoorlie-Boulder is a feral quaking zone created by the orally sadistic Super Pit (for the feral quaking zone, see Giblett 2009). In his discussion of Burtynsky's minescapes, Ric Spencer (2009: 21) reiterates the reference to the Super Pit 'swallowing' the town, but adds the rider that 'it has become a monster'. There is a long history of regarding mining as an orally sadistic monster (see Giblett 2011: chapter 9).

Rather than these niceties of metaphorisation and the subtleties of the sublime, though, the local residents are much more concerned with the threat that 'noise, dust and pollution' pose to their health, lives and livelihood. The story goes on to discuss these assaults on the ear, nose and skin in some detail. This is the other, invisible side of the story to Burtynsky's photograph and the specificities of the place. In writing about some of his other photos what Solnit (2007: 138) calls 'a truly ecological photography' tracing 'the life of a commodity from extraction to

disposal' might portray this other, invisible side. Yet tracing the life of a community in its place and in its use of living beings before they become, or when they are not, or have ceased to be, a commodity might portray livelihood in Williams's terms and in what I am calling a photography for environmental sustainability, the topic of the next and final chapter.

NOTE:

1 This comment was deleted or censored from the original publication of this discussion of these photographs in 'A Natural History of Natural Disasters', *Photofile*, 76, 2006, pp.48–51.

CHAPTER 13

Photography for Environmental Sustainability

Landscape photography is one of the major ways in which modern technologically savvy people relate to the land and the land is mediated to us. Landscape photography in tourism, conservation and culture has played an important role in forming and maintaining national identity. It has played, and still plays, an important, but undervalued and misunderstood, role that is not aware of the cultural and environmental politics of pictures. What role it will play in developing environmental sustainability in Australia and elsewhere is another question. Representing the natural environment as an aesthetic object does not promote environmental sustainability.

In relation to rural landscapes, photography has been important in developing and maintaining the frontier and wilderness mythologies in the United States and the bush and mateship mythologies in Australia. These stereotypical images of a pastoral, and pastoralist, country helped to create a theory and practice of land use, a way of seeing and doing, which is increasingly being seen as unsustainable. On the other hand, touristic and wilderness images of remote or accessible sites

fuel the tourism industry and the conservation backlash of the 'setting aside' of sanctuaries of 'pristine' places both of which may be unsustainable too (see Giblett 2011). Both touristic and wilderness images exploit the land they photograph and create unrealistic expectations of aesthetically pleasing or aestheticised landscapes that bear little relation to the lives of people, indigenous and not, who live on or near them and who rely upon them for their livelihoods.

Landscape and wilderness photography are problematic and I have critiqued them for a variety of reasons in previous chapters in this book, not least for their reproduction of the aesthetic conventions of the sublime, the picturesque and the beautiful. In the conclusion to chapter 9 on Australian wilderness photography I outlined some proposals for what could be called 'photography for environmental sustainability'. I suggested that it could produce photographs focusing on people and places, landscapes and land-uses that exemplify principles and practices of environmental sustainability. Such a body of photographs could begin exploring, documenting and developing environmental sustainability by showcasing communities working the land in ways that conserve or rehabilitate biodiversity. These could include Aboriginal people living traditional lifestyles, permaculture practitioners, organic farmers and gardeners, natural energy technologists, or it could showcase products, processes and spaces designed for environmentally sustainability, etc. It could create a new genre of photography, photography for environmental sustainability. In this concluding chapter I develop further these proposals and give some instances of what such photographs could look like.

Yet the concept of the environment not only implies separation between humans and the earth, but also a relationship of mastery over, and enslaving of, the earth. A master–slave relationship between humans and the earth is hardly sustainable, especially if sustainability is defined simply as 'enough for all forever', and if 'all' includes all creatures of the earth, not just humans. The slave by definition does not have enough. Enslavement takes those who had enough and makes them the property of those who had enough, but end up with more by virtue (or more precisely, vice) of having slaves – who ends up with less than enough. Rather than environmental sustainability, a more intimate and reciprocal relationship of mutuality with the earth means providing enough for all, including humans and other creatures on the earth, and the earth, forever. Social justice entails mutuality with the earth, and vice versa, where the social is the community of all beings. Mutuality with the earth involves what I have called bio- and psycho-symbiotic livelihoods in bioregional home-habitats of the living earth (see Giblett 2011). Photography for earthly symbiosis (rather than merely for 'environmental

sustainability') would celebrate and showcase bio- and psycho-symbiotic livelihoods in bioregional home-habitats of the living earth.

The three concepts of bioregion, livelihood and symbiosis are crucial here. A *bioregion* is a geo-morphological and biological region, the watershed, the valley, the plain, the wetland, the aquifer, etc. where or on which humans live and work, and which sustains our life. Raymond Williams's concept of *livelihood* involves both work and physical surrounds, their environmental supports and effects. *Symbiosis* is both a biological and a psychological term, what could be called bio-symbiosis and psycho-symbiosis. Lynn Margulis used the term symbiosis to convey biological mutuality as distinct from parasitism. Margaret Mahler applied the term to child–mother relationships covering a continuum from the 'normal' to the psychotic and for phases of childhood development from union with the mother to separation and individuation. Elsewhere I develop further a connection between all three by arguing that a *bioregion* always sustains our *livelihood* in relationship with the living earth (see Giblett 2011: chapter 12). This relationship is situated on a continuum between mutually beneficial and 'normal' biological and psychological *symbiosis* and mutuality at one end, and parasitical and psychotic mastery at the other. Photography for earthly symbiosis could showcase bio- and psycho-symbiotic livelihoods in bioregional home-habitats of the living earth.

Livelihood

Raymond Williams is arguably the 'father' of both cultural studies and eco-criticism (and so of eco-cultural studies if it did not conjure a bizarre image of rejoined, mismatched Siamese twins). During the 1980s he developed the concept of 'livelihood' in the essays and books he published in the last years of his life (see Giblett 2011: especially chapter 12). Developing his earlier work on the country and the city and acknowledging that the distinction he drew between them was too stark and that they are, in fact, 'indissolubly linked', Williams (1984: 209; see also 1983/1985: 266–267) developed and used the concept of livelihood as a term that mediates both. Livelihood takes place in both the country and the city. The livelihood of the inhabitants of both is dependent and impact on the livelihoods of inhabitants of the other. Livelihood also deconstructs the culture/nature binary and hierarchy of culture over nature. It is both cultural and natural. Livelihood decolonises the oppression of the natural environment. Livelihood implies both

one's work and one's physical surrounds, their environmental supports and effects, as well as something like the American concept of a bioregion, one's geo-morphological and biological region, the watershed, the valley, the plain, the wetland, the aquifer, etc. where or on which one lives and works, and which sustains one's life. It also implies that the bioregion has sustained the lives of indigenes before one and still does so in places (not to forget the resource regions exploited elsewhere). It also acknowledges the life of other species of fauna, as well as flora, on which one impacts environmentally.

'Livelihood' for Williams is a concept and practice that cuts across the agricultural/country (though these cannot be simply equated, as Williams argues), the capital/city and nature/culture distinctions and divisions. Livelihood deconstructs the culture/nature binary by showing how the relationship between them is hierarchical with the former privileged over the latter. Culture is valorised over nature in culturalism and nature is denied and repressed; nature is exploited and oppressed in and by capitalism and nation states. The valorisation of nature in naturalism is merely the flip side and reactionary mirror image of culturalism. For the distinction to be made between culture and nature and the relationship between them to be established, a third party and term has to be excluded. The excluded third between culture and nature is livelihood. Livelihood is both cultural and natural. There is no livelihood that is not both cultural and natural. Livelihood is both cultural and natural.

Livelihood decolonises the hierarchical distinction between culture and nature and the unsustainable exploitation of the country by the city and of nature by capitalism. Capitalism is intimately tied up with 'capital-ism', the fixation on and privileging of the capital city, whether it is of the nation, state or province, over the margins, outskirts and outlying regions. Livelihood empowers the country to resist its exploitation and oppression by the city through creating a sense of place and a viable local economy based on local produce and local markets. Furthermore, livelihood unites city and country in common dependence and impact on a bioregion. Livelihood takes place in a particular bioregion. Country and city are part of a bioregion. Neither country nor city can survive without their bioregion. Both are dependent, if not parasitic, on it. Photography for earthly symbiosis could showcase livelihoods, people living in and with a place and working the land in eco-friendly ways in a bioregion.

Bioregion

The concept of bioregion was developed in the 1970s. In less Greco-Latinate terms and more plain Anglo-Saxon ones, Kirkpatrick Sale (1985: 43; see also Sale 2001) suggests that bioregion literally means 'life-territory'. Even plainer and simpler is 'home land' rather than 'homeland'. The disjunction between the two words signifies uncoupling the conjunction between nationalistic attachment to, and sentiment evoked by, the father- or mother-land. Elaborating on these basic definitions Thomas Berry (1988: 166; see also 86) has defined a bioregion as 'an identifiable geographical area of interacting life systems that is relatively self-sustaining in the ever-renewing processes of nature'. The bioregion is simply home-habitat.

Bioregion extends the boundaries of home outwards and inwards. Yet these boundaries are not usually extended far enough outwards to include all that humans make home, or call home, or need for home. Human settlements and cultures have increasingly extended their boundaries beyond the earth's surface to take in more of the earth's depths in mining and more of the earth's heights beyond the mountains and the atmosphere into the electromagnetosphere and orbital extra-terrestrial space by way of communication technologies, such as radio, television and satellite telecommunications. After the surface of the earth was colonised, the depths and heights are being increasingly colonised. These regions have not yet become regarded or cared for as home, though cyborgs live in them and depend on them. These regions are not only part of the earth-household but also part of the ecoregion. Ecoregion is the more apposite term today to include not only the bioregion on the earth's surface and heights in the atmosphere in which all beings live and on which they depend, but also the regions of the earth's depths and heights, the -ospheres, in which cyborgs and symbionts live and on which they depend, including other bioregions from which they 'source' goods in trade (see Giblett 2008a: chapter 9). Photography for earthly symbiosis could showcase the biodiversity of an ecoregion, its plants, animals and humans living together in a common and shared home-habitat.

Symbiosis

Biologically humans are a community. Indeed, as Theodore Roszak (1992: 154) argues citing Lynn Margulis, 'all organisms are "metabolically complex

communities of a multitude of tightly organized beings"'. For her, Roszak (155) goes on to relate, 'from the symbiotic point of view, there are no "individuals" – except perhaps the bacteria. All beings are "intrinsically communities"'. For nearly forty years Margulis (1998: 33) has been the most cogent proponent of the notion of symbiosis, 'the term coined by the German botanist Anton de Bary in 1873' and taken up by Eugene Warming (1909: 83–95) in the early twentieth century. Margulis (1971: 49; see also 1981: 161) defines symbiosis as

> the living together of two or more organisms in close association. To exclude the many kinds of parasitic relationships known in nature, the term is often restricted to associations that are of mutual advantage to the partners.

Symbiosis is also one of the key concepts of bioregionalism. One of the features of the bioregional paradigm for Sale (1985: 50 and 112), particularly as it relates to 'society', and presumably in relation to the natural environment, is symbiosis, or, as he defines it, 'biological interaction' and 'mutual dependence as the means of survival'. Symbiosis in biological terms operates primarily at a microbiological, interspecies level, though it has wider macrobiological pertinence between animals and plants. Sale (113) extends its range even further and uses it as a model for 'a successful human society' that would operate symbiotically at the macrobiological, or bioregional level, particularly when it comes to cities. Yet Sale is using symbiosis in the restricted or narrow sense of mutual benefit as all animal species (including humans) are always already in symbiosis in a broader sense with the natural environment to greater or lesser extent, with greater or lesser mutual dependency and benefit. Human beings are, whether we like it or not, in symbiosis with the oxygen-producing plants of this planet. Every breath of air we breathe re-affirms this symbiosis. As Margulis (1998: 5) puts it, 'we are symbionts on a symbiotic planet'.

Parasitism can be and has been a model for a 'successful' human society that survives, however parasitically, to the detriment of other species, habitats, ecosystems and biomes. Sale wants symbiosis to be a model (even a realisable utopian model) for a human society that is mutually 'successful' or sustainable with its bioregion. Rather than being a model for or a metaphor of a successful or better human society, symbiosis is the current state of play as humans are organisms, are biological creatures. Mutualism may be a useful model for a better human society, though all appeals to nature for a model of society are at best fraught with danger as nature is a cultural construct, and at worst imbued with class politics since nature

is an object of capitalist exploitation. Appeals to nature are to a court whose only recourse for further appeals is to refer the case on to the higher court of culture where the case is argued (and won or lost) on cultural grounds.

The modern city is founded and continues to depend on a parasitic relationship with its bioregion. Despite the parasitism of the modern city, it is still in a symbiotic relationship with its bioregion and with the earth. Perhaps, as Sale (1985: 65) suggests, it is in a pathologically symbiotic rather than healthily symbiotic relation with the world. In Margaret Mahler's terms, it is in psychotic symbiosis rather than 'normal' symbiosis. Mahler (1968: 6) could be described as a neo-Freudian psychoanalyst whose work on what she calls 'the symbiosis theory of the development of the human being' spans over three decades beginning in the 1950s. For Mahler (1972: 333) '"growing up" entails a gradual growing away from the normal state of human symbiosis, of "one-ness" with the mother'. Similarly, modernity entails a gradual growing away from the 'normal' or traditional state of human symbiosis, of 'one-ness' with the earth. Modernity is thus a pathology, a land pathology and a psychopathology, a psychogeopathology. Indigenous people's oneness with the earth is the norm from which modern people have deviated pathologically, both physiopathologically and psychopathologically. Photography for earthly symbiosis could either depict critically the psychotic and pathological symbiosis of cities and their citizens with the earth, or showcase the normal state of human symbiosis, of 'one-ness' with the earth.

Photography

The psychotic and pathological symbiosis of cities and their citizens with the earth is taken up in and by a couple of recent photographs by two prominent contemporary Australian photographers. I read Mike Gray's 'This Monkey's Gone to Heaven' (see Figure 36) as a visual metaphor for global warming/climate change in which all breathing beings are suffocating to death on the greenhouses gases produced by modern industrial capitalist technologies contained in a plastic bag of its own making. Both the greenhouse gases and plastic bags are made from petro-chemicals produced by the carboniferous resources of the earth (decaying plant matter). Instead of acknowledging and respecting the symbiosis of all breathing beings with the oxygen-producing plants of the planet earth, modern industrial capitalist technologies are suffocating all living beings to death through

their parasitic and unsustainable use of the carboniferous products of those plants inside an ecosphere of their own remaking. There seems to be no way out of this prison cell of hypermodernity.

Similarly Talhy Stotzer's 'Shopping Mall, China' takes up the themes of symbiosis of breathing beings with the oxygen-producing plants of the planet earth and of the prison cell of hypermodernity (see figure 37). I read this photograph in part as an ironic take on the simulation of nature in photographs in unsustainable shopping malls and the kind of crushing impact these malls have on the living human beings who work and shop in them. This is expressed in the photograph by the man's bowed or lowered head, his downcast gaze not addressing the camera and photographer, and his clasped hands, all signifiers of the abject. Talhy's photograph, despite, or perhaps because of, being a snapshot of the moment when the lift doors are opening or closing, is auratic in Benjamin's sense of expressing the unique appearance of an object in time and space as the man is caught in an unguarded moment. He has not composed himself to be photographed; the photograph is not posed; his aura is sustained in and by the photograph. He enters the photograph with his 'innocence intact – or rather, without inscription' as Benjamin (1999b: 512) said of the first people who 'entered the visual space of photography'. For Benjamin, habitation is the leaving of traces (as in the photograph of the man and of the patina of human hands on the edges of the lift doors). Habitation is not the marking of inscriptions (as in the photograph of the trees on the lift doors). The tracing of the lineaments of the living human being inhabiting this place in space for this moment in time is contrasted with the inscription of photograph of the trees on the lift doors that has already always frozen the dead-living trees and twice removed them from the viewer of Talhy's photograph in the hard and stark frame of the shiny recto-linear grid of the tiles on the doors' surrounds.

The opening in the lift doors is a pathway that mimics and reproduces the pathway in the forest. It leads the viewer into the photograph. The opening is also an aperture so that the space of the lift reproduces and mirrors the space of the camera. Rather than a camera obscura, the space inside the lift and the opening in the lift doors is a kind of camera bravura that simultaneously captures and displays the man in this unguarded, auratic moment in the visual space of the lift and of photography. Talhy's photograph becomes a kind of technological allegory of photography itself with the lift and the opening as a kind of counter-camera capturing the man in this moment, in this place. Aura in photographs is a function partly of the long exposure times and slow lenses and shutter speeds of old cameras, and partly of the subject's intact innocence in old photographs (as

discussed in chapter 1). Aura in Talhy's photograph is a function partly of the slow speed and small aperture of the lift doors opening or closing and partly of the brief exposure of the man with his innocence intact.

The lift doors are a kind of veil that simultaneously reveals and conceals the man and the fluoro light in the lift above the man's head is even a kind of halo. Aura for Benjamin (2002: 127n22) is 'the object *in* its veil'. The object in its veil is, in a word, Julia Kristeva's word, abject. Aura is abject. The abject is the object in its veil before it becomes object, before it is revealed as object; the abject is pre-object, and pre-subject for that matter too; the abject is in-between and before subject and object; the abject is the body in Nietzsche's terms (see Giblett 2008a: chapter 1).

Compositionally the man's dark clothes resonate or rhyme with the tree trunks in the photograph on the lift door, his trunk with their trunks, his limbs with theirs, his body with the trees', his veins and arteries branching like a tree sharing not only a common morphology but also the same *chi*, or life-energy flowing through them. Talhy's photograph is a visual reminder of the ways in which the human body was figured as tree by nature writers such as Thoreau (1854/1997: 287–288) before the body became machine, became organs. Artaud's (1965: 164; see also 59 and 61) concept of the body without organs harks back to the pre-organic body, to the time when the body was without organs, when the body was viscera, or a tree:

> The time man was a tree without organs or functions
> But only will
> And was a tree walking at will
> Will return.
> It was, and will return.
> For the biggest lie ever was to frame man as an organism.

The body without organs is a tree, not a machine. After all, like some trees, we have trunks, limbs and palms. In traditional Chinese medicine the body has stems and roots, trunks and limbs (Kuriyama 1999: 187). In *taijiquan* the performance of the graceful movements should be rooted in the feet, controlled through the trunk and expressed in the limbs and palms. Although Talhy's photograph of the Chinese man depicts him imprisoned in the prison cell of hypermodernity, his body as tree bears the traces of the Taoist body of the earth of traditional Chinese medicine and *taijiquan* (see Giblett 2008a: chapter 10). Talhy's photograph, including the photograph of the trees on the lift doors in her photograph, is formally and symmetrically arranged in strong vertical and monumental lines. The jumbled

branches and leaves of the trees in soft horizontal and supine lines contrast with, and are framed by, the harsh recto-linear grid of the lift doors and their smooth, hard surrounds. The surrounds of the lift door and the doors themselves serve to encase the man and convey his aura. For Benjamin (1999b: 328),

> the characteristic feature of genuine aura is ornament, an ornamental halo, in which the object or being is enclosed as in a case.

The auratic object is framed or contained, as the man is framed or contained in the photograph. He is marked off decoratively and spatially from other objects, such as the trees in the photograph on the lift doors, with which he shares sacrality on a continuum.

Talhy's photograph is a photograph of a landscape photograph (albeit with both in portrait format) and a portrait of a human body and trees, of living beings. To take up and return to Foucault's terms discussed in chapter 3, the exterior of the landscape photograph on the lift doors leads into the interior of the lift and the depths of the life of the living human body inside the lift. Unlike the landscape and the portrait in general in painting, medicine and photography in which surface overlays more and more dead surfaces, her photograph leads into the living depths. Instead of remaining on the surface of the landscape and the body and repressing the geo-, physio- and psycho-pathologies lurking in the depths, her photograph's portrayal of depths showcases the normal state of human symbiosis, of 'one-ness' with the earth. Her photograph, like Mike Gray's, is a reminder that all breathing beings are in symbiosis with the oxygen-producing plants of the living earth. It ironically enacts this symbiosis between the living body of the man and the dead matter of the photograph of living trees on the lift doors. He is in symbiosis with the oxygen-producing plants of the planet, but not with these trees in the photograph on the lift doors in the moment depicted in Talhy's photograph. The non-auratic photograph of the trees on the lift doors is fourth nature, nature hyperworked in and by the communication technology of photography (see Giblett 2011: chapter 1). The auratic photograph of the man is first nature, nature worked by a living organism in its habitation (see Giblett 2011: chapter 1). As it is a photograph about photography and landscape, it is an appropriate final figure for a book about photography and landscape. As it is also a photograph for earthly symbiosis, it is a fitting conclusion for a chapter on this topic.

Conclusion

Talhy's photograph marks the end of the journey in this book from the birth of photography in landscape and portrait photography to perhaps the rebirth of photography in photography for earthly symbiosis. At the beginning of this journey the cultural history of photography, the role of the camera as a sublime communication technology and the political history of the concepts of landscape and the sublime were considered as providing the tools and techniques for empire in settler societies that coalesced in landscape photography. On the next step of the way the use of the aesthetic modes of the sublime, the picturesque and the beautiful in American and Australian landscape and wilderness photography were explored and critiqued for their complicity with colonial and nationalist political and cultural agendas. These modes had their alternative, if not reaction, in the counter-aesthetic mode of the uncanny, not only in American wilderness photography but also in nuclear landscape photography, in which the history and politics of lands as anti-landscapes opened up possibilities for photographing the land differently with a radical politics and aesthetics.

Such lands for some of the 'New Topographics' photographers include suburban wastelands, the lands of the American West no longer the frontier of national manifest destiny to occupy and exploit, nor the site of nuclear tests to blast and blighten, but of the suburban sprawl of little boxes made of ticky-tacky containing and emanating domestic ennui. In the wake of the 'New Topographics', wastelands became the bread and butter of much contemporary landscape photography, whether it be of industrial ruins, minescapes or disaster zones to the point that

it would be more precise to no longer refer now to landscape photography but to wastelandscape photography. Despite, or perhaps because of, the subject matter and the need to aestheticise its ugliness, to assuage the horrors or terrors these disasters elicited for the people caught in them (or working in these places, or living next to them), to create a rallying point for battered national pride and to recreate a common national identity, the sublime raised again its ugly head as if these photographers had amnesia about the history and politics of photography and aesthetics and wanted to resurrect their dead Oedipal father in Ansel Adams. This book has not only remembered and critiqued this history and politics but also proposed and discussed a new photography for earthly symbiosis.

References

Adams, Ansel (1985), *An Autobiography*, London: Thames and Hudson.

——— (1990), *The American Wilderness*, Boston: Little Brown.

Adams, Robert (1994), 'In the Nineteenth-Century West', in *Why People Photograph: Selected Essays and Reviews*, New York: Aperture, pp.133–154.

Adorno, Theodor and Benjamin, Walter (1999), *The Complete Correspondence: 1928–1940*, H. Lonitz (ed.) (trans. N. Walker), Cambridge, MA: Harvard University Press.

Alexievich, Svetlana (1999), *Voices from Chernobyl: Chronicle of the Future* (trans. A. Bouis), London: Aurum Press.

Alinder, James (1985), 'Ansel Adams, American Artist', in *Ansel Adams: Classic Images*, Boston: Little Brown, pp.7–23.

Andrusiak, Kevin and Taylor, Paige (2008), 'The Super Pit Gold Mine in Kalgoorlie is Threatening to Swallow the Town', *The Weekend Australian Magazine*. Available online at: http://www.theaustralian.com.au/news/nation/the-mine-thats-swallowing-a-town/story-e6frg6pf-1111115511984, accessed 26/6/08.

Angus, Max (1980), *The World of Olegas Truchanas*, eighth edition, Hawthorn: Australian Conservation Foundation.

Artaud, Antonin (1965), *Anthology*, second edition revised, J. Hirschman (ed.), San Francisco: City Lights.

Arthus-Bertrand, Y. (2005), *The Earth from the Air*, third edition, London: Thames and Hudson.

Barrell, John (1972), *The Idea of Landscape and the Sense of Place 1730–1840: An Approach to the Poetry of John Clare*, Cambridge: Cambridge University Press.

——— (1980), *The Dark Side of the Landscape: The Rural Poor in English Painting 1730–1840*, Cambridge: Cambridge University Press.

Barthes, Roland (1972), 'The World as Object', in *Critical Essays* (trans. R. Howard), Evanston: Northwestern University Press, pp.3–12.

——— (1981), *Camera Lucida: Reflections on Photography* (trans. R. Howard), New York: Farrar, Straus, Giroux.

Batchen, Geoffrey (1992), 'Terrible Prospects', in A. Shiell and A. Stephen (eds), *The Lie of the Land*, Clayton: National Centre for Australian Studies, Monash University, pp.46–48.

——— (1997), *Burning with Desire: The Conception of Photography*, Cambridge, MA: The MIT Press.

——— (2001), 'Australian Made', in *Each Wild Idea: Writing, Photography, History*, Cambridge, MA: The MIT Press, pp.26–55.

——— (2008) 'Creations of a Moment: The Photography of William Henry Fox Talbot', in *William Henry Fox Talbot*, London: Phaidon, pp.5–15.

Baudrillard, Jean (1988), *America*, London: Verso.

Bean, C. (1923), *The Official History of Australia in the War of 1914–1918: Volume XII Photographic Record of the War*, Sydney: Angus and Robertson.

Bender, Barbara (1993), 'Landscape – Meaning and Action', in B. Bender (ed.), *Landscape: Politics and Perspectives*, Oxford: Berg, pp.1–17.

Benjamin, Walter (1973a), *Charles Baudelaire: A Lyric Poet in the Era of High Capitalism* (trans. H. Zohn), London: Verso.

——— (1973b), *Illumination* (trans. H. Zohn), London: Fontana.

——— (1979), *One-Way Street and Other Writings* (trans. E. Jephcott and K. Shorter), London: NLB.

——— (1994), *The Correspondence of Walter Benjamin: 1910–1940*, G. Scholem and T. Adorno (eds) (trans. M. Jacobson and E. Jacobson), Chicago: University of Chicago Press.

——— (1999a), *The Arcades Project* (trans. H. Eiland and K. McLaughlin), Cambridge, MA: The Belknap Press of Harvard University Press.

——— (1999b), *Selected Writings: Volume 2, 1927–1934*, M. W. Jennings, H. Eiland and G. Smith (eds) (trans. R. Livingston and others), Cambridge, MA: The Belknap Press of Harvard University Press.

——— (2002), *Selected Writings: Volume 3, 1935–1938*, H. Eiland and M. Jennings (eds) (trans. E. Jephcott, H. Eiland and others), Cambridge, MA: The Belknap Press of Harvard University Press.

——— (2003), *Selected Writings: Volume 4, 1938–1940*, H. Eiland and M. Jennings (eds) (trans. E. Jephcott and others), Cambridge, MA: The Belknap Press of Harvard University Press.

Berger, John (1972), *Ways of Seeing*, London: British Broadcasting Corporation/Penguin Books.

Berman, Marshall (1983), *All that is Solid Melts into Air: The Experience of Modernity*, London: Verso.

Berry, Thomas (1988), *The Dream of the Earth*, San Francisco: Sierra Club Books.

Bonyhady, Tim (1985), *Images in Opposition: Australian Landscape Painting 1801–1890*, Melbourne: Oxford University Press.

——— (1993), 'The Art of Wilderness', in W. Barton (ed.), *Wilderness – the Future: Papers from the Fourth National Wilderness Conference, 1993*, Sydney: Envirobook, pp.170–180.

——— (1997), 'No Dams: The Art of Olegas Truchanas and Peter Dombrovskis', in R. Butler (ed.), *The Europeans: Emigré Artists in Australia 1930–1960*, Canberra: National Gallery of Australia, pp.236–253.

——— (2000), *The Colonial Earth*, Melbourne: Miegunyah Press, Melbourne University Press.

Botte, John (2006), *Aftermath: Unseen 9/11 Photos by a New York City Cop*, New York: Regan.

Botting, Fred (1996), *Gothic*, London: Routledge.

Bourke, Joana (2005), *Fear: A Cultural History*, London: Virago.

Brady, Veronica (1998), *South of My Days: A Biography of Judith Wright*, Pymble: Angus and Robertson.

Briggs, Raymond (1977), *Fungus the Bogeyman*, London: Hamish Hamilton.

Bright, Deborah (1989), 'Of Mother Nature and Marlboro Men: An Inquiry into the Cultural Meanings of Landscape Photography', in R. Bolton (ed.), *The Contest of Meaning: Critical Histories of Photography*, Cambridge: MIT Press, pp.125–142.

Brown, Bob (1998), 'Peter Dombrovskis', in *Dombrovskis: A Photographic Collection*, Hobart: West Wind Press, pp.6–15.

——— (2004), *Memo for a Saner World*, Camberwell: Penguin.

Brown, Norman (1959), *Life Against Death: The Psychoanalytical Meaning of History*. Hanover, NH: Wesleyan University Press.

Burke, Edmund (1958), *A Philosophical Enquiry into the Origin of our Ideas of the Sublime and Beautiful*, J. Boulton (ed.), London: Routledge and Kegan Paul.

Burtynsky, Edward (2009), *Australian Minescapes*, Welshpool: Western Australian Museum.

Cadava, Eduardo (1992), 'Words of Light: Theses on the Photography of Light', *Diacritics*, 22 (3–4), pp.84–114.

Camus, Albert (2006), *At Combat: Writings 1944–1947*, J. Lévi-Valensi (ed.) (trans. A. Goldhammer), Princeton: Princeton University Press.

Carew, Jenny (1999), 'Richard Daintree: Photographs as History', *History of Photography 23* (2), pp.157–162.

Carter, Paul (1987), *The Road to Botany Bay: An Essay in Spatial History*, London: Faber and Faber.

——— (1988), 'Invisible Journeys: Exploration and Photography in Australia 1839–1889', in P. Foss (ed.), *Island in the Stream: Myths of Place in Australian Culture*, Leichhardt: Pluto, pp.47–60.

Caygill, Howard (1998), *Walter Benjamin: The Colour of Experience*, London: Routledge.

Chevrier, Jean-Francois (2009), 'A World without Irony', in R. Adams, *Tree Line*, Gottingen: Steidl, pp.101–109.

Coetzee, J. M. (1974), *Dusklands*, Johannesburg: Ravan.

——— (1988), 'Reading the South African landscape', in *White Writing: On the Culture of Letters in South Africa*, New Haven: Yale University Press, pp.163–177.

Comolli, Jean-Louis (1980), 'Machines of the Visible', in T. de Lauretis and S. Heath (eds), *The Cinematic Apparatus*, London: Macmillan, pp.145–153.

Conrad, Peter (2003), *At Home in Australia*, London: Thames and Hudson.

Cosgrove, Denis (1993), 'Landscapes and Myths, Gods and Humans', in B. Bender (ed.), *Landscape: Politics and Perspectives*, Oxford: Berg, pp.281–305.

Crimp, Douglas (1989), 'The Museums Old/The Library's New Subject', in R. Bolton, (ed.), *The Contest of Meaning: Critical Histories of Photography*, Cambridge, MA: MIT Press, pp. 3–12.

Cumpston, J. H. L. (1951), *Charles Sturt: His Life and Journeys of Exploration*, Melbourne: Georgian House.

Davies, Alan and Peter Stanbury with Con Tanre (1985), *The Mechanical Eye in Australia*, Melbourne: Oxford University Press.

Davies, Alan (2004), *An Eye for Photography: The Camera in Australia*, Carlton: Miegunyah Press/Sydney: State Library of New South Wales.

Davis, Mike (2002), 'Ecocide in Marlboro Country', in *Dead Cities and Other Tales*, New York: The Free Press, pp.33–63.

Dombrovskis, Peter (1998), *Dombrovskis: A Photographic Collection*, Hobart: West Wind Press.

Downer, Christine (1999), 'Photography in Australia: A Select Bibliography', *History of Photography 23* (2), pp.192–197.

Drori-Avraham, Adi (2006), 'September 11th and Mourning After: Media Narrating Grief', *Continuum 20* (3), pp.289–297.

Druckrey, Timothy (1991), 'Blasted Allegory', in *Nuclear Matters*, San Francisco: AF Camerawork, pp.5–7.

Dyer, Richard (1987), *Heavenly Bodies: Film Stars and Society*, London: Macmillan.

——— (1998), *Stars*, new edition, London: British Film Institute.

Easlea, Brian (1983), *Fathering the Unthinkable: Masculinity, Scientists and the Nuclear Arms Race*, London: Pluto.

Ebury, Francis (2002), 'Illuminating the Subject: Towards a Distinctive Australian Pictorial Photography', *History of Photography 26* (1), pp.34–41.

Edensor, Tim (2005), *Industrial Ruins: Space, Aesthetics, Materiality*, Oxford: Berg.

Ennis, Helen (1999), 'Postwar Australian Landscape Photography: Olive Cotton and Max Dupain', *History of Photography 23* (2), pp.136–140.

——— (2004), *Intersections: Photography, History and the National Library of Australia*. Canberra: National Library of Australia.

——— (2007), *Photography and Australia*, London: Reaktion Books.

——— (2009), 'Edward Burtynsky's Minescapes', in E. Burtynsky, *Australian Minescapes*, Welshpool: Western Australian Museum, pp.17–19.

Flew, Antony (1983), 'Event', in *A Dictionary of Philosophy*, second revised edition, London: Pan, p.115.

Foster, Alasdair (2006), 'Keeping Our Distance', *Photofile*, 76, pp.60–61.

Foucault, Michel (1973), *The Birth of the Clinic: An Archaeology of Medical Perception* (trans. A. Sheridan), London: Tavistock.

——— (1977), *Discipline and Punish: The Birth of the Prison* (trans. A. Sheridan), London: Penguin.

Friedberg, Ann (1993), *Window Shopping: Cinema and the Postmodern*, Berkeley: University of California Press.

Friend, David (2007), *Watching the World Change: The Stories Behind the Images of 9/11*, New York: Picador.

Gallagher, Carole (1993), *American Ground Zero: The Secret Nuclear War*, Cambridge, MA: MIT Press.

Garrard, Greg (2004), *Ecocriticism*, London: Routledge.

Genoni, Paul (2004), *Subverting the Empire: Explorers and Exploration in Australian Fiction*, Altona: Common Ground Publishing.

Giblett, Rod (1985), 'Watching TV, Watching Yourself: The Viewer and the Gaze', *Australian Journal of Cultural Studies*, 3 (1), pp.120–127.

——— (1996), *Postmodern Wetlands: Culture, History, Ecology*, Edinburgh: Edinburgh University Press.

——— (2004), *Living with the Earth: Mastery to Mutuality*, Cambridge: Salt.

——— (2007), 'Shooting the Sunburnt Country, the Land of Sweeping Plains, the Rugged Mountain Ranges: Australian Landscape and Wilderness Photography', *Continuum 21* (3), pp.331–146.

——— (2008a), *The Body of Nature and Culture*, Houndmills: Palgrave Macmillan.

——— (2008b), *Sublime Communication Technologies*, Houndmills: Palgrave Macmillan.

——— (2009), *Landscapes of Culture and Nature*, Houndmills: Palgrave Macmillan.

——— (2011), *People and Places of Nature and Culture*, Bristol: Intellect Books.

——— and Webb, Hugh (eds) (1996), *Western Australian Wetlands: The Kimberley and South-West*, photographs by Simon Neville and others, Perth: Black Swan Press/ Wetlands Conservation Society.

Gibson, Ross (2002), *Seven Versions of an Australian Badland*, St. Lucia: Universtiy of Queensland Press.

Goin, Peter (1991), *Nuclear Landscapes*, Baltimore: The John Hopkins University Press.

Gore, Al (2008), 'Foreword', in B. McKibben (ed.), *American Earth: Environmental Writing Since Thoreau*, New York: Library of America, pp.xvii–ix.

Hall, Colin Michael (1992), *Wasteland to World Heritage: Preserving Australia's Wilderness*, Carlton: Melbourne University Press.

Hambourg, Maria (1999), 'Carleton Watkins: An Introduction', in *Carleton Watkins: The Art of Perception*, New York: Harry N. Abrams, pp.8–17.

Hammond, Ann (2002), *Ansel Adams: Divine Performance*, New Haven: Yale University Press.

Hassell, Anthony (1986), *Strange Country*, St. Lucia: University of Queensland Press.

Hay, Peter (2002), 'These Blarsted Hills', in T. Bonyhady and T. Griffiths (eds), *Words for Country*, Sydney: UNSW Press, pp. 52–67.

Hills. E. (1991), 'The Imaginary Life: Landscape and Culture in Australia', *Journal of Australian Studies 29*, pp.12–27.

Hirsch, Eric (1995), 'Landscape: Between Place and Space', in E. Hirsch and M. O'Hanlon (eds), *The Anthropology of Landscape*, Oxford: Clarendon Press, pp.1–30.

——— and Michael O'Hanlon (eds) (1995), *The Anthropology of Landscape*, Oxford: Clarendon Press.

Horne, Donald (1964), *The Lucky Country: Australia in the Sixties*, Ringwood: Penguin.

Hughes, Robert (2000), Interview: Beyond the Fatal Shore. Available online at: http://www.pbs.org/wnet/australia/qa.html. Accessed 31 August 2011.

Hurley, Frank (1917), *My Diary, Official War Photographer Commonwealth Military Forces*, Canberra: National Library of Australia, MS 883.

Jenkins, Bill (1975), *New Topographics: Photographs of a Man-Altered Landscape*, Carlisle: Pentacle Press.

Jolly, Martyn (1999), 'Australian First-World-War Photography: Frank Hurley and Charles Bean', *History of Photography 23* (2), pp.141–148.

Josef Lebovic Gallery (nd), *Pictorialism to Modernism: Australian Photographers from the 20th Century*. Available online at: http://joseflebovicgallery.com/catalogue/Archive/Cat-105-2003/index105.html. Accessed 24 August 2011.

Jurovics, Toby (2010), 'Framing the West: The Survey Photographs of Timothy O'Sullivan', in T. Jurovics, C. Johnson, G. Willumson and G. Stapp, *Framing the West: The Survey Photographs of Timothy O'Sullivan*, Washington/New Haven: Library of Congress/ Smithsonian American Art Museum/ Yale University Press, pp.9–43.

Jussim, Estelle and Elizabeth Lindquist-Cock (1985), *Landscape as Photograph*, New Haven: Yale University Press.

Kafka, Franz (1926/1997), *The Castle* (trans. J. Underwood), London: Penguin.

Kant, Immanuel (1952), *The Critique of Judgment* (trans. J. Meredith), Oxford: Clarendon.

Kern, Stephen (1983), *The Culture of Time and Space 1880–1918*, Cambridge, MA: Harvard University Press.

Kingwell, M. (2005), 'The Truth in Photographs: Edward Burtynsky's Revelations of Excess', in E. Burtynsky, *China*, Gottingen: Steidl, pp.16–19.

Kobayashi, S. (2001), *Ruins*, Tokyo: Magazine House.

Kozloff, Max (1994), 'Bad News from Epic Landscapes', in *Lone Visions, Crowded Frames: Essays on Photography*, Albuquerque: University of New Mexico Press, pp.192–206.

Kuriyama, Shigihesa (1999), *The Expressiveness of the Body and the Divergence of Greek and Chinese Medicine*, New York: Zone Books.

Lakin, Shaune (2008), *Contact: Photographs from the Australian War Memorial Collection*, second edition, Canberra: Australian War Memorial.

Laplanche, J. and Pontalis J-B. (1973), *The Language of Psychoanalysis* (trans. D. Nicholson-Smith), London: Hogarth.

Leopold, A. (1991), 'Land Pathology (1935)', in S. Flader and J. Callicott (eds), *The River of the Mother of God and Other Essays*, Madison: University of Wisconsin Press, pp.212–217.

Lloyd, David (1998), *Battlefield Tourism: Pilgrimage and the Commemoration of the Great War in Britain, Australia and Canada, 1919–1939*, Oxford: Berg.

Longinus (1965) 'On the sublime', in *Classical Literary Criticism* (trans. T. Dorsch), Harmondsworth: Penguin, pp.99–158.

Lundgren, Michael (2008), *Transfigurations*, Santa Fe: Radius.

Lyotard, Jean-François (1984), 'Answering the Question: What is Postmodernism?' (trans. R. Durand), in *The Postmodern Condition: A Report on Knowledge* (trans. G. Bennington and B. Massumi), Manchester: Manchester University Press, pp.71–84.

——— (1989). 'The Sublime and the Avant-Garde', in A. Benjamin (ed.), *The Lyotard Reader*, Oxford: Basil Blackwell, pp.196–211.

Mahler, Margaret (1968), *On Human Symbiosis and the Vicissitudes of Individuation, volume 1, Infantile Psychosis*, New York: International Universities Press.

——— (1972), 'On the First Three Sub-Phases of the Separation-Individuation Process', *International Journal of Psychoanalysis*, 53, pp.333–338.

Margulis, Lynn (1971), 'Symbiosis and Evolution', *Scientific American*, 225, pp.49–57.

——— (1981), *Symbiosis in Cell Evolution: Life and its Environment on the Early Earth*, San Francisco: W. H. Freeman.

——— (1998), *Symbiotic Planet: A New Look at Evolution*, New York: Basic Books.

Marien, Mary (1993), 'Imaging the Corporate Sublime', in A. Rule (ed.), *Carleton Watkins: Selected Texts and Bibliography*, Oxford: Clio, pp.1–34.

Max Dupain's Australia (1986), Ringwood: Viking.

Max Dupain's Australian Landscapes (1988), Ringwood: Viking.

Mayer, M. (2005), 'Burtynsky in China', in E. Burtynsky, *China*, Gottingen: Steidl, pp.10–11.

McDonald, John (2008), 'Richard Woldendorp' in R. Woldendorp, *Abstract Earth: A View from Above*, North Fremantle: Sandpiper Press, p.3.

McDonald, Roger (2009), *Australia's Wild Places*, Canberra: National Library of Australia.

McLean, Ian (2002), 'Sublime Futures: Eco-Art and the Return of the Real in Peter Dombrovskis, John Wolseley and Andy Goldworthy', *Transformations 5*. Available

online at: http://transformations.cqu.edu.au/journal/issue_05/editorial.shtml. Accessed 24 August 2011.

McLuhan, Marshall (1964), *Understanding Media: The Extensions of Man*, London: Routledge and Kegan Paul.

McMahon, Michael (2003), Producer *Wildness*, St Kilda: Big and Little Films.

Mepham, John (1993), 'Introduction', in M. Shelley, *Frankenstein*, Ware: Wordsworth, pp.v–xi.

Metz, Christian (1982), *Psychoanalysis and Cinema: The Imaginary Signifier* (trans. C. Britton, A. Williams, B. Brewster and A. Guzzetti), London: Macmillan.

Meyerowitz, Joel (2006), *Aftermath: World Trade Center Archive*, New York: Phaidon.

Misrach, Richard (1990), *Bravo 20: The Bombing of the American West*, Baltimore: The John Hopkins University Press.

——— (1992), *Violent Legacies: Three Cantos*, New York: Aperture.

Morris, Meaghan (1988), 'Two Types of Photography Criticism Located in Relation to Lynn Silverman's Series', in *The Pirate's Fiancée: Feminism, Reading, Postmodernism*, London: Verso, pp.137–149.

Mulligan, M. and S. Hill (2001), *Ecological Pioneers: A Social History of Australian Ecological Thought and Action*, Cambridge: Cambridge University Press.

Neale, Steve (1985), *Cinema and Technology: Image, Sound, Colour*, London: Macmillan.

Newton, Gael (1988), *Shades of Light: Photography and Australia 1839–1988*, Canberra: Australian National Gallery, Collins Australia with assistance from Kodak.

——— (2004), 'Framed: The Australian Landscape: An Historical Overview of the Australian Landscape as Portrayed through Photography', *Landscape Australia 26* (2), pp.12–18.

Nickel, Douglas (1999), 'An Art of Perception', in *Carleton Watkins: The Art of Perception*, New York: Harry N. Abrams, pp.18–35.

Nordstrom, Alison (2009), 'After New: Thinking about New Topographics from 1975 to the Present', in *New Topographics*, Gottingen: Steidl, pp. 69–79.

Novak, Barbara (1980), *Nature and Culture: American Landscape and Painting 1825–1875*, London: Thames and Hudson.

Palmquist, Peter (1983), *Carleton E. Watkins: Photographer of the American West*, Albuquerque: University of New Mexico Press.

Pamuk, Orhan (2005), *Istanbul: Memories of a City*, London: Faber.

Parish, Steve (nd), *Wild Places: Australia from the Heart*, Archerfield, Queensland: Steve Parish Publishing.

Picon, A. (2000), 'Anxious Landscapes: From the Ruin to the Rust'. Available at: http://www.gsd.harvard.edu/people/faculty/picon/texts.html. Accessed 29 September 2006.

Picture Australia. Available online at: http://www.pictureaustralia.org/.

Pitkethly, Anne and Don (1988), *N. J. Caire: Landscape Photographer*, Rosanna, Victoria: Published by the authors with the assistance of Kodak (Australasia) Pty Ltd.

Polidori, Robert (2003), *Pripyat and Chernobyl: Zones of Exclusion*, Göttingen: Steidl.

Quartermaine, Peter (1987), '"Speaking to the eye": Painting, Photography and the Popular Illustrated Press in Australia, 1850–1900', Ph.D. Thesis, University of Exeter.

Respini, Eva (2009), 'Discoverers, Dreamers and Drifters', in *Into the Sunset: Photography's Image of the American West*, New York: The Museum of Modern Art, pp.10–31.

Robins, Kevin and Webster, Frank (1999), *Times of the Technoculture: From the Information Society to the Virtual Life*, London: Routledge.

Rossiter, Ned (1994), 'Narratives of Emergence: Late Nineteenth-Century Landscape Photography in Western Australia', *Studies in Western Australian History* 15, pp.67–80.

Roszak, Theodore (1992), *The Voice of the Earth*, London: Bantam.

Roth, M. (1997), *Irresistible Decay: Ruins Reclaimed*, Los Angeles: Getty Research Institute.

Ryan, James (1997), *Picturing Empire: Photography and the Visualization of the British Empire*, London: Reaktion Books.

Sachs, Wolfgang (1992), *For Love of the Automobile: Looking Back in the History of Our Desires* (trans. D. Reneau), Berkeley: University of California Press.

Sale, Kirkpatrick (1985), *Dwellers in the Land: The Bioregional Vision*, San Francisco: Sierra Club Books.

——— (2001), 'There's No Place Like Home', *The Ecologist* 31 (2), pp.40–43.

Salvesen, Britt (2009), 'New Topographics', in *New Topographics*, Gottingen: Steidl, pp.11–67.

Sandweiss, Martha (1983), 'Foreword', in P. Palmquist, *Carleton E. Watkins: Photographer of the American West*, Albuquerque: University of New Mexico Press, pp.ix–xvii.

——— (2002), *Print the Legend: Photography and the American West*, New Haven: Yale University Press.

Schama, Simon (1995), *Landscape and Memory*, London: HarperCollins.

Seddon, George (1997), *Landprints: Reflections on Place and Landscape*, Cambridge: Cambridge University Press.

Sekula, Alan (1984), 'The Instrumental Image: Steichen at War', in *Photography Against the Grain: Essays and Photo Works 1973–1983*, Halifax, Nova Scotia: Press of the Nova Scotia College of Art and Design, pp.33–51.

Snyder, Joel (1981), *American Frontiers: The Photographs of Timothy H. O'Sullivan 1867–1874*, New York: Aperture.

——— (1994), 'Territorial Photography', in W. Mitchell (ed.), *Landscape and Power*, Chicago: The University of Chicago Press, pp.175–201.

Sobiesek, R. (1993), *Robert Smithson: Photo Works*, Alberquerque: University of New Mexico Press.

Sofia, Z. (1992), 'Hegemonic Irrationalities and Psychoanalytic Cultural Critique', *Cultural Studies* 6 (3), pp.376–394.

Sola Morales, Ignasi de (1995), 'Terrain Vague', in C. Davidson (ed.), *Anyplace*, New York: Anyone Corporation, pp.118–123.

Solnit, Rebecca (1994/1999), *Savage Dreams: A Journey Into the Landscape Wars of the American West*, Berkeley: University of California Press.

——— (2000), *Wanderlust: A History of Walking*, London: Penguin.

——— (2003), *As Eve Said to the Serpent: On Landscape, Gender and Art*, Athens, Georgia: University of Georgia Press.

——— (2007), *Storming the Gates of Paradise: Landscapes for Politics*, Berkeley: University of California Press.

Sontag, Susan (1977), *On Photography*, New York: Farrar, Straus and Giroux.

——— (2004), *Regarding the Pain of Others*, London: Penguin.

Spencer, Ric (2009), 'The Politics of Landscape and the Origin of the World', in E. Burtynsky, *Australian Minescapes*, Welshpool: Western Australian Museum, pp.21–23.

Stegner, Page (2010), 'Introduction', in T. Jurovics, C. Johnson, G. Willumson and G. Stapp, *Framing the West: The Survey Photographs of Timothy O'Sullivan*, Washington/

VSW TR 660 .P568 2012

Photography and landscape

Index

Juha Tolonen

Photography and academia rescued me from a life of looming middle-class prosperity. Adrift on the ocean of middle Australia, with only the siren song of television, tabloids and sport as a guide, I was fortunate to flounder upon the Photomedia course at ECU many years ago. Thanks to Norm Leslie, Kevin Ballantine and Max Pam, and everyone involved with the programme for providing me with the charts and ballast necessary to navigate this strange ocean.

Rod Giblett was my supervisor as I charted a course into international waters and began research for my doctoral thesis. With its successful completion, my craft now has a steering house and sturdy rudder. Thank you Rod. Many past and present colleagues have also played an important role, sharing knowledge and experience that has guided me and enriched the journey, most recently James Hall, Emma-Kate Dowdell and Talhy Stotzer. I also thank Rod Giblett again for the offer of co-authoring a book; his experience has eased the journey towards my first significant publication.

Most importantly, my companion, Kate de Bruin, has weathered many journeys with me, consistently showing she is more than just competent crew. She has regularly repaired damage to the raft, volunteered watch duties when I have been unable and maintained a good supply of cheer and inspiration. This journey would not have been possible without her. Thank you Kate. And welcome aboard cabin boy Ari and baby Maija.

Shipmates Bella and Oscar have also played important roles. Unfortunately Bella was lost to the sea just prior to the publication of this book – your presence was always special.

afterwards, on earlier versions of some of the chapters, some of which appeared in previous publications in a catalogue, proceedings, magazine and journal:

'Shooting the Event: The Camera is a Gun', *Ethics, Events. Entertainment: Annual Conference of the Australian and New Zealand Communication Association: Program, Abstracts and Refereed Papers 2000, Ballina, NSW*, pp.184–191;
'Zone: City of Ghosts', *FotoFreo 04*, 2004, p.24;
'A Natural History of Natural Disasters', *Photofile*, 76, 2006, pp.48–51 (copyright Rod Giblett and *Photofile*);
'Shooting the Sunburnt Country, the Land of Sweeping Plains, the Rugged Mountain Ranges: Australian Landscape and Wilderness Photography', *Continuum* 21 (3) 2007, pp.331–346;
'Wilderness to Wasteland in the Photography of the American West', *Continuum* 23 (1) 2009, pp.43–52;
'Terrifying Prospects and Resources of Hope: Minescapes, Timescapes and the Aesthetics of the Future', *Continuum* 23 (6) 2009, pp.781–789.

Articles first published in *Continuum* are reprinted by permission of the publisher (Taylor & Francis Ltd, http://www.tandf.co.uk/journals).

I am grateful to Juha for the opportunity to write this book with him and to be his Ph.D. Supervisor. I am also grateful to Juha for giving me my first opportunity to write about landscape photography by inviting me to write about his own photographs for the FotoFreo catalogue for 2004 as listed above. From that small, one page beginning, my interest in researching and writing about landscape photography was sparked and this part of this book grew.

Thanks to James Hall who sought and gained permission for the reproduction of the photographs for the book. CREATEC, the Centre for Entertainment, Arts, Technology, Education and Communications, in the Faculty of Education and Arts at ECU provided funding to employ James as a Research Assistant for which both Juha and I are grateful.

Acknowledgements

The dedication of this book to Norm Leslie is a public expression of our gratitude to him for the support he has given to both of us at crucial times over more than the past decade.

Rod Giblett

Norm was my Head of Department soon after my arrival at Edith Cowan University (ECU) after a shattering and traumatising experience at another university. Norm gave friendship and support when I was thrown into the deep end of teaching Media Studies with no prior experience of doing so. I sank more than I swam in the beginning, but I would have sunk more and swum less but for Norm who threw a lifebuoy my way more than once. Over the following years, many intellectually stimulating conversations with Norm about photography and landscape acted as the catalyst for this book and cleared the way ahead. These conversations included many suggestions for reading and other references about both photography as technology and landscape photography. As I had not even heard of Ansel Adams prior to my arrival at ECU in 1997, I was on a steep learning curve, but Norm was always by my side on that curve ready with a comment, question or suggestion. Little did I (and he) know that those conversations would result in part in the writing and publication of this book over a ten-year period. He bears no responsibility for it. He also read and commented helpfully, sometimes as a referee as I discovered

Williams, Terry Tempest (1991), *Refuge: An Unnatural History of Family and Place*, New York: Random House.

Willis, Ann-Marie (1988), *Picturing Australia: A History of Photography*, Sydney: Angus and Robertson.

Wilson, Alexander (1991), *The Culture of Nature: North American Landscapes from Disney to the Exxon Valdez*, Toronto: Between the Lines.

Woldendorp, Richard (2008), *Abstract Earth* (videorecording), Perth: Art Galley of Western Australia.

——— (2009), *Abstract Earth*, North Fremantle: Sandpiper Press.

Wolin, Richard (1982), *Walter Benjamin: An Aesthetic of Redemption*, New York: Columbia University Press.

Zehle, Sonke (2008), 'Despatches from the Depletion Zone: Edward Burtynsky and the Documentary Sublime', *Media International Australia 127* Special Issue: Ecomedia, pp.109–115.

New Haven: Library of Congress/ Smithsonian American Art Museum/ Yale University Press, pp.1–4.

Stephenson, David (2001), 'Towards a Photographic Sublime, 1982–2000', Ph.D. thesis, Hobart: University of Tasmania, Tasmanian School of Art.

Tanre, Con with Alan Davies and Peter Stanbury (1977), *Mechanical Eye: A Historical Guide to Australian Photography and Photographers*, Sydney: Macleay Museum, University of Sydney.

Tassell, Margaret and David Wood (1981), *Tasmanian Photographer: From the John Watt Beattie Collection: From the Collections of the Queen Victoria Museum and Art Gallery (Launceston, Tasmania)*, South Melbourne: Macmillan.

Thoreau, Henry (1854/1997), *Walden*, Boston: Beacon.

Toohey, Paul (2007), *The Killer Within: Inside the World of Bradley John Murdoch*, Crows Nest: Allen and Unwin.

Turnage, Wililam (1990), 'Introduction', in Ansel Adams, *The American Wilderness*, Boston: Little Brown, pp.7–15.

Thwaites, John (1979), 'John Watt Beattie', *Tasmanian Tramp* 23, pp.72–80.

Vergara, C. J. (1999), *American Ruins*, New York: Monacelli Press.

Vinegar and M. Golec, Michael (2009), 'Instruction as Provocation', in A. Vinegar and M. Golec (eds), *Relearning from Las Vegas*, Minneapolis: University of Minnesota Press, pp.1–17.

Virilio, Paul (1988), 'The Third Window: An Interview', in C. Schneider and B. Wallis (eds), *Global Television*, New York: Wedge, pp.187–197.

——— (1989), *War and Cinema: The Logistics of Perception* (trans. P. Camiller), London: Verso.

——— (1991), *The Aesthetics of Disappearance* (trans. P. Beitchman), New York: Semiotext(e).

——— (1994a), *Bunker Archaeology*, (trans. G. Collins), New York: Princeton Architectural Press.

——— (1994b), *The Vision Machine* (trans. J. Rose), Bloomington: Indiana University Press.

——— (2000), *A Landscape of Events* (trans. J. Rose), Cambridge, MA: The MIT Press.

——— (2002), *Desert Screen: War at the Speed of Light* (trans. M. Degener), London: Continuum.

——— (2003), *Unknown Quantity* (trans. C. Turner), London: Thames and Hudson.

——— and Sylvere Lotringer (1983), *Pure War* (trans. M. Polizzotti), New York: Semiotext(e).

Warming, Eugene (1909), *Oecology of Plants: An Introduction to the Study of Plant Communities*, Oxford: Clarendon Press.

Weber, Eva (2002), *Ansel Adams and the Photographers of the American West*, San Diego: Thunder Bay.

The Wilderness Gallery, Cradle Mountain, Tasmania: 2003 Catalogue.

Williams, Raymond (1973), *The Country and the City*, London: Chatto and Windus.

——— (1974), *Television: Technology and Cultural Form*, Hanover, NH: Wesleyan University Press.

——— (1983/5), *Towards 2000*, Harmondsworth: Penguin.

——— (1984), 'Between Country and City', in R. Mabey (ed.), *Second Nature*, London: Cape, pp.209–219.